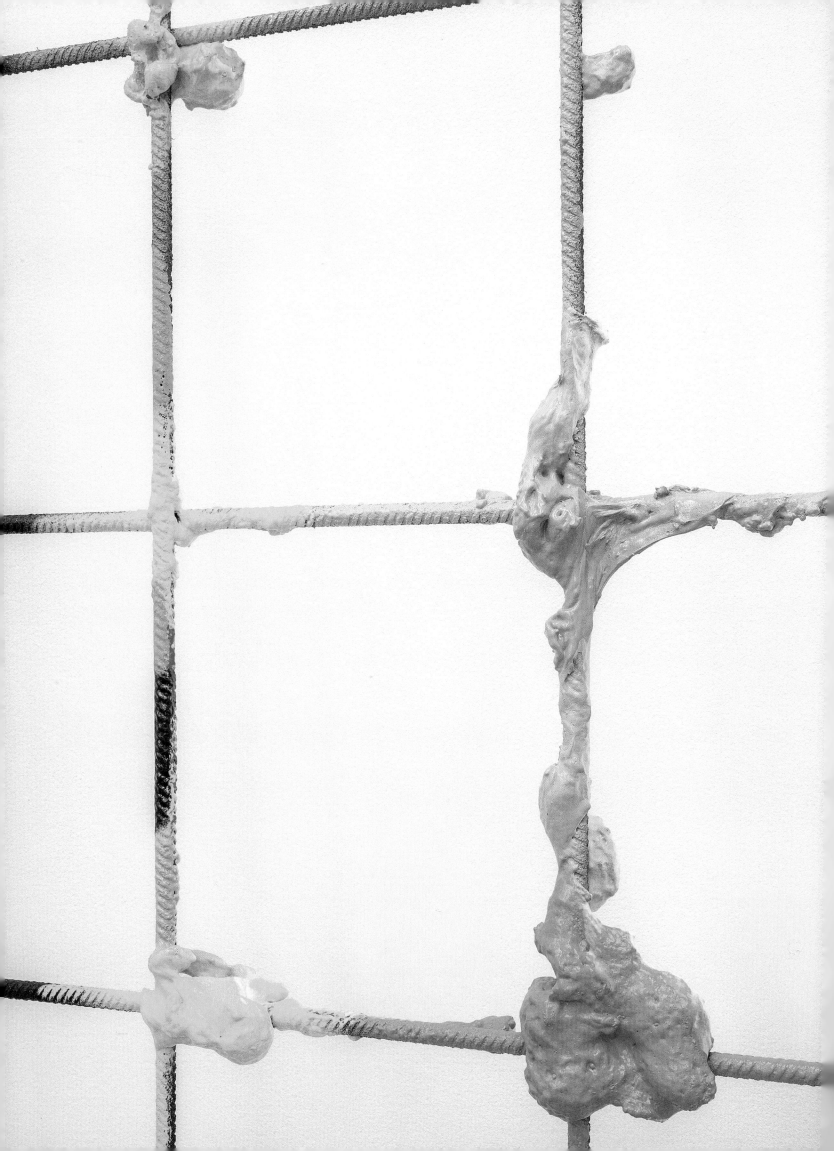

JIM LAMBIE

JIM LAMBIE

Contributions by John Giorno, Suzanne Cotter, Daniel Baumann, and Sophie Woodward

Skira_RIZZOLI_
NEW YORK

It doesn't get
better
it doesn't get better,
it doesn't get any better,
it doesn't get any better than this,
it doesn't get any more fabulous;
and as bad as it is,
it does not get any better.

Stuck in a traffic jam
and the scenery is beautiful,
irritating gusts of boredom,
and the radio is playing,
if you don't like my oceans
don't swim in my seas,
you can't hurt me,
'cause storms can't hurt the sky,
sugar skulls,
and long necklaces of rotting human skulls
of police officers, lawyers and judges
the triumph over abuse and injustice,
fat chance,
ring da alarm,
I could not save you,
you are addicted to anger
and complaining,
when you have hepatitis
everything looks yellow,
my anger ate the goose
that laid the golden eggs,
thick bacon and a little something sweet,
and a most surprising change
is being the god of your enemy,
the eagles fly below us.

The illusion
that makes life bearable
the illusion that makes
life bearable
the illusion that makes life bearable,
when you lose
the illusion
that makes life bearable,
when you lose the illusion
that makes life bearable,
when you've lost whatever it is
you believed or invented,
were imprinted or scarred by,
unthinkable loss,
deluded inside delusion inside delusion inside delusion,
everything is delusion
including wisdom,
and then, there are the illusions,
that make life
bearable
the illusions
that make life bearable,
the illusions that make life bearable,
abiding
in the continual flow,
I'm here to do
whatever is your pleasure,
empty words,
gone without a trace.

All i had to do,
was get
through it
all i had to do
was get through it
all i had to do was get through it,
i almost got
through it,
you can't win
you can't break even
and you can't even quit the game,
and happily, very soon,
I will remember nothing,
the sand is snow,
a hurricane in a drop of cum.

You will find
your true love
in the end
you will find your true
love in the end,
you will find your true love in the end,
when you die
you will find your true love
in your mind,
when you die
you will find your true mind,
in the deepest night is the brightest light,
clear,
unlocatable,
emptiness
awareness.

—John Giorno, "It Doesn't Get Better"

THE TRUE CENTER OF GLASGOW
John Giorno

The Poetry Club is a miracle made by Jim Lambie. The Poetry Club is a work of art by Jim Lambie. The Poetry Club was made in the Arches under the Glasgow railroad tracks, a performance space for poets to hear each other, make music and dance, and drink. Jim also made an art gallery several arches away to show young artists. It is Jim's gift to poets and artists, and the world. Jim is sharing the wealth coming to a great artist from the art world. It is an act of great kindness, giving to poets, who are in a nowhere zone between and rock 'n' roll stars and schoolteachers, and unlike artists, are in an economic zone that produces no money. When a person acts with great generosity, the results are an enormous magical display, the original generosity is multiplied a 100,000 times. The Poetry Center became the true center of Glasgow.

Jason Macphail organized the poetry performances with endless, tireless work, which made them happen. I was invited to perform, as part of an extraordinary series of poetry performances. Richard Hell inspired Jim to create the VoidoidARCHIVE. Performances by Saul Williams, Marshall Allen, Patti Smith, Jennifer Pardio, and Gerard Malanga, among many others followed.

I performed on June 14, 2013, and opened for Bobby Gillespie from Primal Scream. I was surprised and awed that Jim had paired me with Bobby. I was an enormous fan and he was a distant superstar. When I got to know him, he said he was long a fan of my work.

I waited in the gallery, which exhibited a Martin Boyce sculpture and a William Burroughs painting, with the other performers and many friends. Bobby's musicians were Douglas Hart from The Jesus and Mary Chain, and Lawrence. Friends had come up from London, Michael Morris and others.

I was finally standing outside the metal backstage door waiting to go on. The show had opened with Kim Moore and Griffith, and Kevin Williamson. I never get stage fright—quite the opposite, I get sleepy, as if I want to escape by dissolving away inside into nothing. The door opened to four hundred people in the hot, packed house, and Jason announced me. The energy and expectation of the audience completely woke me up. I took the mic and a deep breath, and did the inexplicable thing of performing. The poems were memorized and rehearsed, and I had discovered the musical qualities inherent in the words, which somehow become empowered by the breath and mind. I gave a really good performance, or nailed it, as said in Olympic sports. I performed for forty minutes: "It Doesn't Get Better," "The Death of William Burroughs," "Just Say No to Family Values," "There Was a Bad Tree," "Thanx 4 Nothing." The screaming ovation fed each poem.

Bobby Gillespie and the band gave a dazzling performance. Each song was sung perfectly, and magnificently profound. The audience totally loved him. There was after-party in the gallery with lots alcohol, grass and drugs, and everybody was feeling really good.

and I stepped outside the door, and there was a total eclipse of the moon. We stood in the bright Scottish night watching the eclipse. It was another glorious encore in our show, and possibly ominous. I had a strong feeling of the spirit of an ancient Celtic goddess of poetry, arising from wherever Sappho and Vajra Sarasvati come from, a primordial goddess of poetry pervading space and us.

On August 15, 2014, the Poetry Club invited me to perform at the Edinburgh Book Fair at the release of Jim's book *Not Just for Me: A Sampler of the Poetry Club* by the Fruitmarket Gallery. Jim hired a big cruiser bus to take us all from Glasgow to Edinburgh and back. There was the book presentation and reception, and I performed in the big tent of the book fair. When it was over, I was waiting near the big bus on the sidewalk with the director of Fruitmarket. We were talking and smoking a joint, passing it back and forth, and both feeling very good about the night. After about ten minutes, she said, "We are standing in front of the residence of the prime minister of Scotland." I looked up and there was a grand Georgian house. It was a splendid night.

At The Poetry Club I was very well taken care of and put up twice at the Blythswood on Blythswood Square. I am an American, and staying in a restored Georgian house and former British club was like being in a 1930s Evelyn Waugh novel, or on a set in *Downton Abbey*, and was a great pleasure. I was in a first-floor corner room with windows on the square, a once grand room divided into two separate rooms with bathrooms, done up in the worst deluxe taste, which I really liked. One night Jim and Jason Macphail took me to the dog races in a dog racetrack, which was astonishing. The dogs leapt out of the gate, and stretched their long bodies taut over and over, beating the dust from the ground. I was struck by the striving beauty of it that Jim must have felt in Glasgow every day.

I love Glasgow because many totally wonderfully things happened to me there. Jim at the heart of it all made the Poetry Club as a place for everything that is good and living and creative there to run together, for renewing and opening new paths the way the best art does and should. I am writing this in 2016, when I am eighty years old.

THE POETRY CLUB
№ 100 EASTVALE PLACE (BELOW SWC3)
2nd December 4.00 pm
£3 in advance from Monorail & Tickets Sco...
£5 on the door

VIC GODA...

MAO DISNEY
PRESENTS AFTERNOON TEA

PULL
DOWN
THE
FUTURE

SWC3

AN
GE
4th A
Gerard Mal
filmmaker w
Warhol during
in the mid-sixti
poetry and show
Malanga 'Film Not
vintage scenes fro
Underground perfor
and Bob Dylan's histo

TOTALLY WIRED: THE LIFEWORLD OF JIM LAMBIE
Suzanne Cotter

A CONTEXT

When Jim Lambie first showed his *Zobop* floor in 1999 at Glasgow's Transmission Gallery and subsequently at the Showroom in Bethnal Green in London, a new generation of artists had come of age in the optimism of New Labour Britain. Lambie's art was part Pop, part funk, its luxuriously visual materiality assembled from the "abandoned stuff of modern life,"[1] embedded in a taut formal language of space and objects and an imposed choreography of the perceiving body. Accompanying the polychromatic, taped floors were serial arrangements of anarchic paint splashes, their lush dribbles falling from plastic bags on the wall into unruly puddles on the floor, and assembled wall reliefs and hanging sculptures composed of record album covers, old turntables with the cheap punk glamour of neck chains and safety pins sprayed in the eye-shadow tones of paint and glitter of new wave glam and high camp. Exploiting the collective consciousness of pop music and club culture, Lambie's Psychedelic Soul Sticks and aluminium foil masks (*The Kid with the Replaceable Head*, 1996) constituted a shamanistic presence, all the while hinting at the narratives of art making, from the primitivism of early modernism to the conceptual and performative strategies of art making from the 1960s and '70s.

THE FIGURE AND THE GROUND

In his study of the 1990s, during which Jim Lambie developed his career as an artist, pop cultural historian, and commentator, Michael Bracewell set the stage for the closing of the twentieth century:

> Small things seemed to articulate big things (fascism, fast food, and Madonna, for instance, could be studied and assessed within the same academic language ...) while big things (the burgeoning processes of globalization, for example) were almost too big to see, like those patterns in the desert you can make out only at 37,000 feet.[2]

Lambie began his studies in 1990 at Glasgow School of Art's Department of Sculpture and Environmental Art. During the preceding year, the Berlin Wall had come down, marking the end of the Soviet Union, while the Chinese government violently cracked down on students demonstrating for democracy in Tiananmen Square in Beijing, George Bush Sr. was elected US president, and scientist Tim Berners-Lee invented the digital framework for what would become the World Wide Web. The year before, Damien Hirst, along with a cohort of graduating artists from Goldsmiths College in London, had organized a suite of exhibitions in warehouse spaces in London's largely derelict Docklands, its speculative transformation by the "wide boys" of Thatcherite property development only just beginning. In 1990, the year in which Nelson Mandela was released after twenty-seven years of imprisonment, Glasgow was named the first European Capital of Culture, marking the beginning of an era of culture as a driver for urban regeneration. In the same year, the city became the center of Scotland's campaign against the Conservative government's newly imposed "poll tax." Culturally as well as politically, the margins were becoming the mainstream as new attitudes in art in the distant metropolitan capital of London became the new rock 'n' roll, with art, music, lifestyle, and plain style all celebrated within a burgeoning creative Britain.[3]

Against the politico-economic backdrop of cultural projection, Lambie's art presented an insistent grittiness comparable to Rachel Whiteread's *House* (1993), created on the site of a Victorian terraced house in East London and demolished eleven weeks after its unveiling, and the sexual innuendo of the sculptural tableaux of Sarah Lucas, who had graduated from Goldsmiths in 1987 with Hirst, Gary Hume, Angela Bulloch, and others. Lambie has described this period in Glasgow as one of social and creative freedom, in which artists and musicians—Lambie was both—shared common interests and spaces.[4] Artists such as Douglas Gordon, Ross Sinclair, and Roddy Buchanan were visibly present but yet to become internationally recognized figures of the burgeoning Glasgow art scene; the contemporary art market was essentially absent. As a young artist of the time, Lambie intuitively looked to the stuff of his immediate surroundings and the financially possible. A regular visitor to junk shops and record stores, he sought ways with which he might use objects and materials to hand, responding to ideas that they suggested. His instincts for bricolage, for color—as an antidote to the "beigeness" of much of the art of the '90s—and for a grunge decorativeness were nourished by his exposure not only to the music and club scene but to the works of artists he could see in the art magazines of the time, an important source of information both before and after making the creative shift from being a full-time musician to a full-time artist.

Generationally and geographically closer to Lambie, Mark Leckey's video paean to the dandyism of nightclub dancing, *Fiorucci Made Me Hardcore* (1999), made from eloquently montaged found footage that loosely spans northern soul to acid house, offers a meaningful comparative context. Like Leckey, who is from Merseyside in the north of England, Lambie's lexicon of a vernacular popular culture, in his case, inscribed within the legacies of modern and post-'60s formalism and antiformalism, suggested a certain dandified position of self-affirmation and resistance to dominant cultural attitudes and hierarchies. At the end of the twentieth century in Britain, these attitudes were embodied in the shift begun in the postwar era, from a place of work and production to one of financial speculation, consumption, and leisure, a place in which the concept of culture had been assumed into the neoliberal discourse of abstracted economic reality. Looking at Glasgow and the more conceptually driven work of artists such as Gordon and Christine Borland, both graduates from Glasgow School of Art, or the excavation of legacies of modernism in the work of Martin Boyce or the critical Conceptualism of Lucy McKenzie, from a younger generation, Lambie's art made an extravagant swan dive into the physical exuberance of color and visual sound.

A KIND OF SYNESTHESIA

Color in Lambie's art is polyphonic. Its application, on the materially ignoble and the castoff, is one of electrifying lushness—its achromatic counter is to be found in the mirror, an equally important medium and anchor to Lambie's chromatically charged compositions. Color is embodied in Lambie's repertory of ready-made and found materials of electrical and vinyl tape, of album covers and sequins, and of the gloss surfaces taken from the commercial color chart applied to structural forms composed of wood, metal, foam, and plastic. The appropriated

language of monochrome and gestural painting, Minimalist sculpture, and the post-Minimal emphasis on material process is combined with the applied language of the crafted and of decor.

Lambie's use of color has been situated within the aesthetic of the factory-made commodity and the ready availability of materials associated with the commercial culture of DIY that emerged out of the postwar era in the United States[5] and, to a certain extent, Britain. Artistically, the idea of color as readymade, and keeping it "as good as it is in the can," expounded by Frank Stella[6] would find expression both in the commercial silk-screen paintings of Andy Warhol and the specific objects of Donald Judd. Lambie's work has also been compared to the paintings of Henri Matisse, who famously expressed the desire to make art for the tired businessman, in the ability of his sculptural installations to soothe and to mesmerize.[7]

Lambie's riffs on and with color pose a counter to the nonsubjective aspirations of Minimal and Conceptual art. His adoption of the language of systematization and chance procedures is coupled with color's power to produce emotion and affect. While the conception and execution of the taped floors are based on a specific set of parameters, like the stripes of Daniel Buren, or a set of instructions from Sol LeWitt, their chromatic variations project a consciously associative dimension: Black-and-white stripes inspired by the costume by David Bowie for his Aladdin Sane tour in 1973 to candy-striped mix or the metallic tones of bronze, black, and gold, offer a spatial and sensorial field of transport, comparable to the dance floor but also to a stage in which we are at once viewer and performer. Lambie's immersive tableaux are, however, not theatrical in the oft-referred sense described by Michael Fried in the late '60s in his critical discussion of Minimal art and what he observed to be a distancing of the beholder, both physically and psych-ically.[8] They offer instead an instantaneity and directness of address that invite us to revel in their opulent opticality and to marvel at their candid vulnerability of forms wrapped, leaned, balanced, and swinging.

While many of Lambie's earlier works of the late 1990s tapped into the Technicolor projections of acting out that the culture-defining songs and performances of musicians such as Bowie afforded to the suburban drabness of 1970s British life, color has continued to be a mainstay of what has evolved into a taut sculptural and pictorial language in the subsequent two decades. Color is controlled or, more aptly, directed in the work, applied but also intrinsic to the lexicon of found materials, whose textures imply a necessarily tactile and empathetic dimension. Wooden doors and elements of furniture that form sculptures and wall-based works are painted in a myriad of gloss and ice-cream tones picked straight from the commercial color chart, whereas primary shades are splashed over old mattresses and down supporting walls. Color is also improvised, mixed, and shuffled, at one with its varying supports, from the printed reproductions of old album covers, or rolls of fringing, to the Psychedelic Soul Sticks, a funky alter ego to André Cadere's *Round Wooden Bars* in their pose of leaning and seemingly random positioning in space. The Soul Sticks, created by Lambie during a residency in Marseille and his visits to the city's North African street markets and the Musée d'Arts Africains, Océaniens, Amérindians, suggest a nod to Surrealism and the pages of *Documents*, edited by Georges Bataille. In common with Cadere's color-coded wooden bars and with the fetish constructed from materials that have a relationship to living persons, be it strands of stray hair, personal trinkets, or the threads and buttons from a suit or a dress, Lambie's Soul Sticks and, indeed, all of his sculptures, reliefs, and objects draw us into a world of everyday life not only performed but also lived.

THE BEAT

It is impossible to talk about Lambie's art without making reference to music, particularly the music of the '70s and '80s, whose band names and album titles resurface in the titles of works: *Zobop, Male Stripper, Unknown Pleasures, Forever Changes, The Kinks*. The influences of glam rock bands such as Sweet, T. Rex, Slade, David Bowie, Roxy Music, and Lambie's own pre–art school rock band, Boy Hairdresser, are especially evident in Lambie's works of the 1990s with their spiky aesthetics of seduction and subversion. According to Lambie, "Music makes the hard edges disappear."[9] A *Zobop* floor flowing through the austere volumes of

Tate Britain's Duveen Galleries not only collapses spatial boundaries, it is evocative of both the drug-hazed counterculture of the artistic and the fashionable in "swinging" London, made iconic by Richard Hamilton in his painting series based on photographs of Mick Jagger and the art dealer Robert Fraser being arrested on drug charges, and the equally iconic vision of Malcolm McLaren in bondage trousers walking down the King's Road in the 1980 "mockumentary" *The Great Rock 'n' Roll Swindle*. Part Pop, part punk in attitude, Lambie's work is also rhythm and beat, the floors providing, in Lambie's words "the bass line that underpins everything else," "in the way that maybe a guitar and vocal would float over a piece of jazz."[10] Music also surfaces as formal play in works like *Totally Wired* (2014), whose array of colored guitar leads emerging out of a loosely stretched canvas support with a black gloss paint ground call to mind Eva Hesse's series *Metronomic Irregularity II* (1966), which, in the historic context of Minimalism, drew upon the expressive possibilities of abstraction.

Lambie's connection to rock 'n' roll music, while related to his biography, is related also to its immediacy and the equality that it represents as a form of popular culture. The direct appeal of music and the repertoire of "looks" and postures of particular bands and decades contribute to a form of cultural synesthesia—the spiked orange hair and embroidered satin and mesh of Bowie's Ziggy Stardust; The Sweet's silver-plated platforms; Bryan Ferry's louche lounge pose in *Let's Stick Together*. But while drawing upon the aesthetics of what is generically labeled pop music, albeit with a specificity of style and influence, from Bowie to punk to glam and postpunk, Lambie's art does not subscribe to the legacy of Pop art and its reflections on mediation and the image. When Lambie does work with images, such as his use of album covers to create montaged reliefs or his suite of photomontages and collages of counter-cultural and cultural icons such as Quentin Crisp in *Beautiful Future*, or Joe Orton in *Prick Up Your Ears* (both 2012), his process is more closely aligned to the Neo-Dadaist collage practices of artists such as Eduardo Paolozzi, Richard Hamilton, Robert Rauschenberg, and Jasper Johns, and their use of fragments of found images and objects, in contrast to the use of images used in their entirety, as in Andy Warhol's soup cans, or images of Marilyn.[11] Nor does Lambie's art relate to the iconicity of the mechanically reproduced, as with the artists we associate with Pop, from Roy Lichtenstein to Gerhard Richter. More a Baudelairean capture of modern life in its distillation of the transitory into the enduring, Lambie's art does merge nevertheless with a certain language of Pop in his conflation of the readymade and the handmade.

APPLIED ART

While what has been recognized as Lambie's "channeling of styles"[12] is embedded in the subculture of the Glasgow art and music scene, Lambie's merging of architecture, art, and design to create complete environments, and the emphasis on materials, surface, and the handmade, allies his work with a history of the applied arts and their relationship to art, society, and labor. Aesthetically, Lambie's strategies of making, in their reliance on the readymade, collage, and, to some extent, the monochrome, place his work in the lineage of the historical avant-gardes of the twentieth century and the displacement of manual labor to one of decision making, arranging, and the withdrawal of representation.[13] There is also a connection to be made with the history of the Arts and Crafts Movement, theorized by John Ruskin and applied by William Morris. The Glasgow School of Art, where Lambie was a student, was founded in 1845 as one of the first governmental schools of design for the manufacturing industries, and was to become the center of the Arts and Crafts Movement in Scotland. The Glasgow Style was a consequence of this movement, whose visionary exponents included Herbert MacNair, Margaret and Frances MacDonald, and Charles Rennie Mackintosh, whose Willow Tea Rooms in Glasgow's Sauchiehall Street are still in use. Not exactly designs for living, as was the case with the celebration of design and craftsmanship, the contemporary version of which has been translated into the lifestyle culture of the Habitat store, Lambie's objects and environmental interventions and his aesthetic of gorgeousness—in the sense of a virtuoso and jewel-like brilliance—are also ones of obsolescence and recuperation that strike a resonant chord at a time of globalized outsourcing and prefabrication, where labor and its application for the benefit of the society at large have lost their currency. There is further resonance with David Hammons's famed performance work, *Blizaard Ball Sale* (1983), for which the African American

artist sold snowballs displayed in sizes from XS to XL on a Brooklyn street corner, in a metaphoric enactment of the precarious nature of economic exchange, with respect both to the art object and the public in general. Lambie has cited the work of Hammons as important to him, along with that of John Armleder and Isa Genzken, in the immediacy of their visual and sculptural languages, their trashy glamour, and their subversive reflection back at the viewer of realities and truths that relate to race, gender, and societal values of money, style, and taste.

HERE'S LOOKING AT YOU

In considering Lambie's art over the past two decades, it is important to recognize the persistence of abstraction, amid the polyphony of explicit and implicit references. Reflection and multiplication is an important feature, as is Lambie's activation of the visual using color as form. Traditional relationships of figure to ground, of frame to support, or of sculpture to pedestal are dissolved in Lambie's mutable world. Mirrored surfaces that range from glass to polished steel, and objects that glitter and shine, from Lurex thread to household gloss paint, are ever present as are plays on reflection and doubling. His use of Rorschach shapes and the cumulative patterning that arises while working from the logic of the contours of a floor plan from the perimeter in suggest a wink to the desubjectivizing intent of Frank Stella in his *Black Paintings* (1958–59) and create a melding of support with surface that extends into the three-dimensional elements that occupy the dizzying ground as field. The language of doubling has more subtle expression in outdoor sculptural pieces like *Secret Affair (Silver)* (2007), whose stainless-steel form in the shape of an old-fashioned keyhole is projected as a shadow from the shifting sun, or moonlight. Other works achieve the state of the kaleidoscopic as color and surfaces fracture and multiply in the applied mosaic mirrored surfaces of *Danceteria* (2006) or the angled folding of painted wooden doors or aluminium sheets in *Metal Box (Dream Baby Dream)* (2011). This fracturing becomes balletic in large-scale pieces like *Train in Vain* and *Seven or Seven Is or Sunshine Bathed the Golden Glow* (both 2008), in which glossy furniture parts and mirrored handbags perform a riotous expansion horizontally as well as vertically.

As well as activating visual perception and its effect on how we experience a given space and context, reflection in Lambie's art is also about the act of looking. This is literally expressed in his use of the motif of the eye, cut from found images from record covers, from posters, and in magazines, and constituting a leitmotif in works made since the late '90s. Recalling the all-seeing eyes that look out from the wings of angels in Romanesque paintings, these emblematic body parts in Lambie's work are less about iconicity in any strict sense than they are about a simple idea of creating a work that looks back at you.[14] But if reflection creates a play on the optical, it is never specular evasion, in the way, for example, Jeff Koons has used the highly polished surface to deflect any real apprehension of the sculpture beyond its phantasmal projection of banality. With Lambie, the physical nature of things is a given.

A TYPE OF NONOBJECT

A reflection of Lambie's continued interest in the commonplace, his flirtation with a certain kitsch, together with the found and the improvised, is the absence of certain processes and materials from his oeuvre. He has never cast in bronze, unlike Jasper Johns, who applied the historically "noble" conventions of sculpture to the everyday light bulb and beer can, nor worked with the anxious language of negative space that the cast object implies, such as in Whiteread's mattresses and floorboards of bookshelves. Lambie's light bulbs are made from metal themselves, and his found metal parts are of the crushed kind, more akin to the compacted three-dimensional collages of old automobile parts in the sculptures of Richard Chamberlain. While cast concrete has recently entered into the work, it is as the simple, light-absorbing block, the sort one might find on a construction site, that serves as a plinth or ungainly weight, with other objects embedded into it, rather than a cast double of another object or form. And while a higher level of formal precision and production is apparent in more recent works, "ordinary moments and ordinary materials"[15] are still in evidence.

In his recent exhibition *Electrolux*, at the Modern Institute in Glasgow, Lambie created a new type of object that aspired to a state between what he describes as "low-fi and high production," and "gender fluid" in its perceptual slippage between object to nonobject.[16] The title of the show refers to the Swedish home appliance manufacturer whose old-model washing machines were used by Lambie as the basis of his sculptural installation. A crushed washing machine, although unrecognizable as such, made an appearance in the sculpture *Sunset* of 2010. For *Electrolux*, Lambie stripped down seven machines to their essential components before spraying them in pastel colors of lilac, lemon, mint green, powder blue, pale orange, and white. Their monochromatic forms, at once cashmere-friendly and mute, operate on the edge of recognition, neither fake nor real, between abstract and concrete structure.

LIFEWORLD

This evasion of pure abstraction or subjective association and the movement in between is allied with Lambie's project for the Poetry Club, which he established in Glasgow in April 2012. The impetus was his search for a venue for a poetry reading, on Lambie's invitation, by American poet, punk musician, and writer Richard Hell—Hell's novella *The Voidoid*, and his 1970s punk band, The Voidoids, were the source of the title of Lambie's 2004 exhibition of the same name. With no spoken-word venue in Glasgow, Lambie was offered a space underneath Glasgow's railway arches that he stripped out and furnished to become a venue for readings and live performance that would provide an open and creative space for artists, musicians, and poets. The Poetry Club, now in its fifth year, is inseparable from Lambie's broader practice, and in many ways offers a dynamic embodiment of a physical, intellectual, and subjective engagement he had been looking to address from the outset with his earlier sited sculptural environments. The Poetry Club is, for Lambie, a self-generating sculptural project, in which documentation of events and its growing VoidoidARCHIVE of photographs, films, recordings, posters, invitations, and other ephemera constitute a continued work in process. In many ways, his list of invited guests, which has included Patti Smith, John Giorno, and Primal Scream, among others, also reflects his aesthetic of recuperation applied to moments of cultural energy that have been inspirational to him. The creation of a regularly changing billboard project on the exterior and located between the Poetry Club and the exhibiting space of the VoidoidARCHIVE is a further expansion of Lambie's evolving space in Glasgow's postindustrial heartland.

While Lambie would always describe his processes in intuitive terms, they are nevertheless underwritten by an acute consciousness of the social, economic, and cultural context of Glasgow in which he lives and has continued to make his work.

The emergence of the Poetry Club and the activation of space in real time with music, the spoken word, and the group dynamics of a collective, creative culture offer some insight into the move toward a seemingly cooler and more reflective approach to object making, as is evident in the works composing the *Electrolux* exhibition, and a natural extension of the space of the studio, which has always comprised the space in which work is made in the live setting of the gallery or presentation space. We find the assembled visual and sculptural scenario based on quasi-abstract objects and structures as part of a larger project in which the sharing of ideas, and the mixing of aesthetic forms, becomes mobile and unfixed. This lack of fixity determined by a collective dynamic generates potential, open and free zones of production—what the artist and writer Liam Gillick describes as "conditions for the experimental."[17] It goes some way toward understanding more deeply Lambie's sculptural world as also a *lifeworld*, a term used by the art historian David Joselit to describe the activity of Warhol's Factory,[18] whose mixing of art with New York's underground music scene has served as reference and permission for Lambie, although dissimilar to the Factory in the Poetry Club's disassociation from the commercial circuits of the art market. From its early stages as the visual and spatial translation of an environment redolent with the potential for subjective and collective engagement, the Poetry Club has, with time, expanded into collaborative and poetically discursive modes of production—that escape the reductive mechanisms of simple commercial exchange and the status of "content providers for the leisure zone"[19]—to go beyond the realms of the object and the visual rhythm of the constructed environment to the fluidity of networked relationships of the real, among words, forms, colors, material, a rhythm, and, yes, a beat.

1 Michael Bracewell, "Reflections on the Art of Jim Lambie," in *Male Stripper*, exh. cat., ed. Suzanne Cotter (Oxford: Modern Art Oxford, 2003).

2 Michael Bracewell, *The Nineties: When Surface Was Depth* (London: Flamingo, 2002), 3.

3 Ibid.

4 Suzanne Cotter, in conversation with Jim Lambie, November 21, 2016.

5 Ann Temkin, "Color Shift," in *Color Chart: Reinventing Color, 1950 to Today*, exh. cat., ed. Temkin (New York: Museum of Modern Art, 2008), 17.

6 David Batchelor, *Chromophobia*, (London: Reaktion Books, 2000), 98.

7 Temkin, "Color Shift," 17.

8 See Briony Fer's discussion of Michael Fried, "Art and Objecthood," *Artforum* (June 1967), reprinted in *On Abstract Art* (New Haven and London: Yale University Press, 1997), 127–28.

9 Tate Britain, "TateShots: Jim Lambie—Studio Visit," August 21, 2009, https://www.youtube.com/watch?v=MXweVvuU-MY.

10 Martin Coomer, "Jim Lambie," *Art World* 11 (June 2009): 68.

11 For an eloquent and scholarly exposition of this perspective, see Hal Foster, *The First Pop Age: Painting and Subjectivity in the Art of Hamilton, Lichtenstein, Warhol, Richter, and Ruscha* (Princeton, NJ: Princeton University Press, 2012), 5.

12 Nana Asfour, "Review: Jim Lambie 'Spritualized,'" *Time Out New York*, November 29, 2011, https://www.timeout.com/newyork/art/review-jim-lambie-spiritualized.

13 I am inspired here by David Joselit, "Reassembling Painting," in *Painting 2.0: Expression in the Information Age*, exh. cat., ed. Manuela Ammer, Achim Hochdörfer, and David Joselit (Munich, London, and New York: Prestel Books, 2016), 169–70.

14 Cotter, in conversation with Lambie.

15 Ibid.

16 Ibid.

17 Liam Gillick, *Industry and Intelligence: Contemporary Art Since 1820* (New York: Columbia University Press, 2016), 113.

18 Joselit, "Reassembling Painting," 174.

19 Gillick, *Industry and Intelligence*, 119.

Ultra-Glow, 2016. Painted rebar mesh, expanding foam, painted wire basket, colored cable ties. 222 × 161 × 43 cm

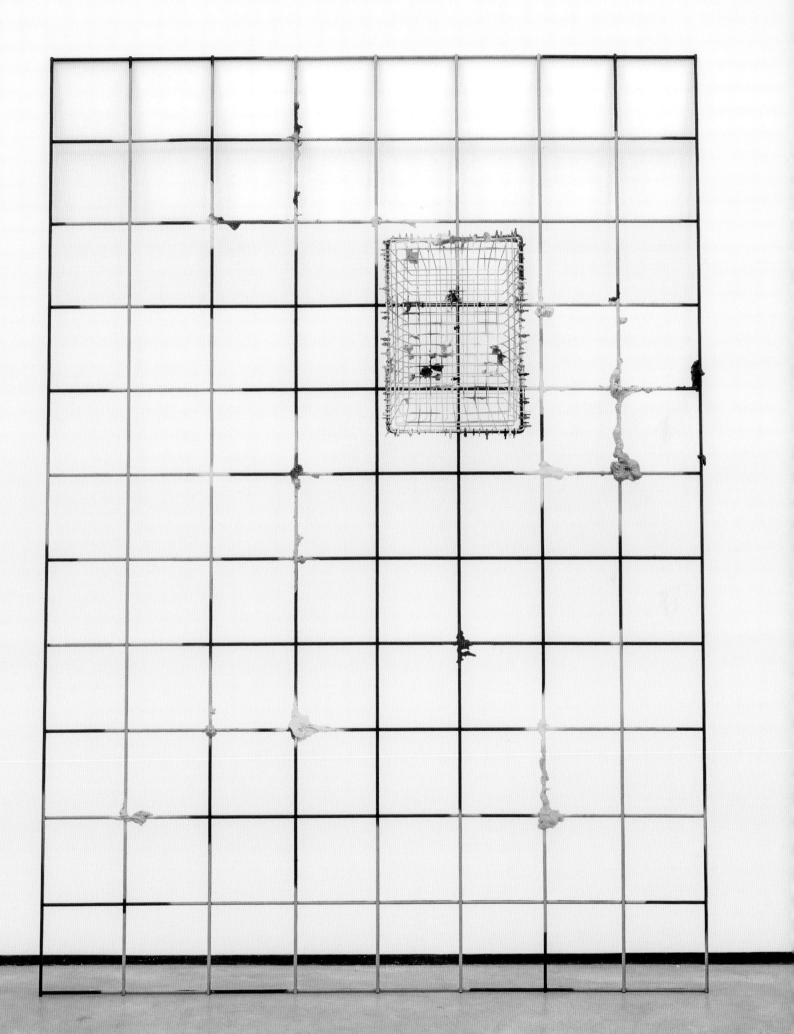

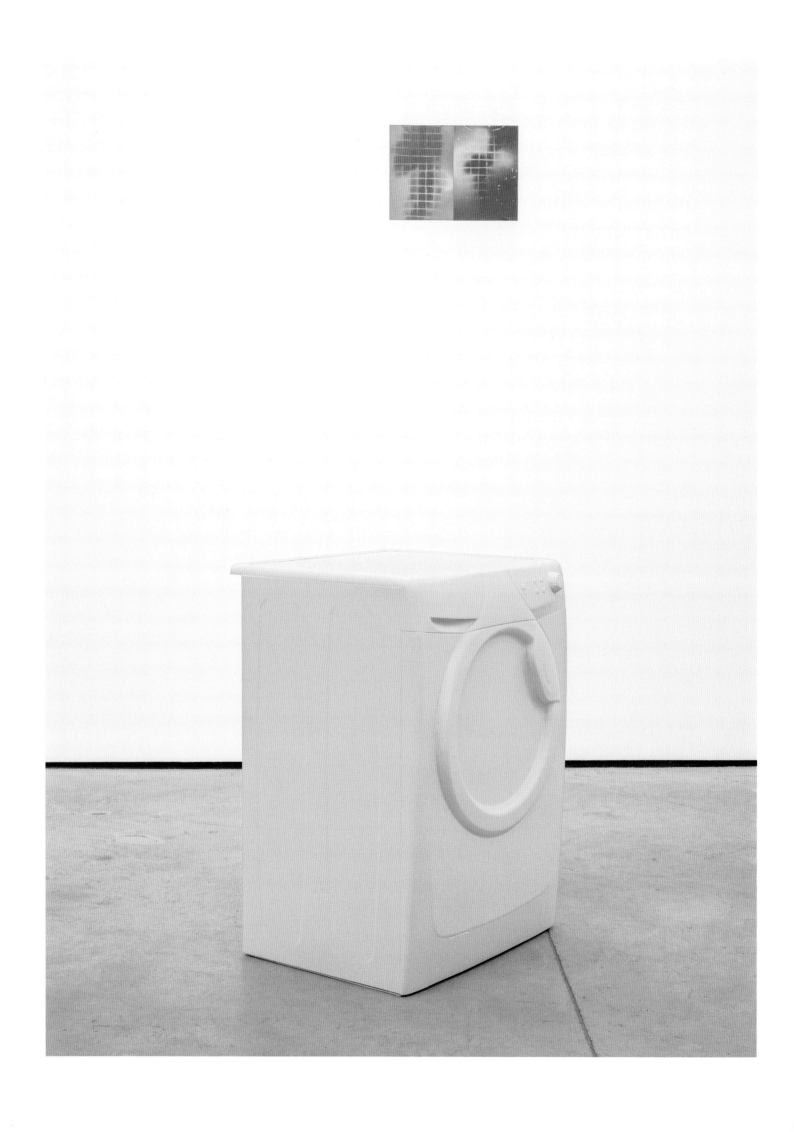

Installation view *Electrolux*, The Modern Institute, Osborne Street, Glasgow, 2016

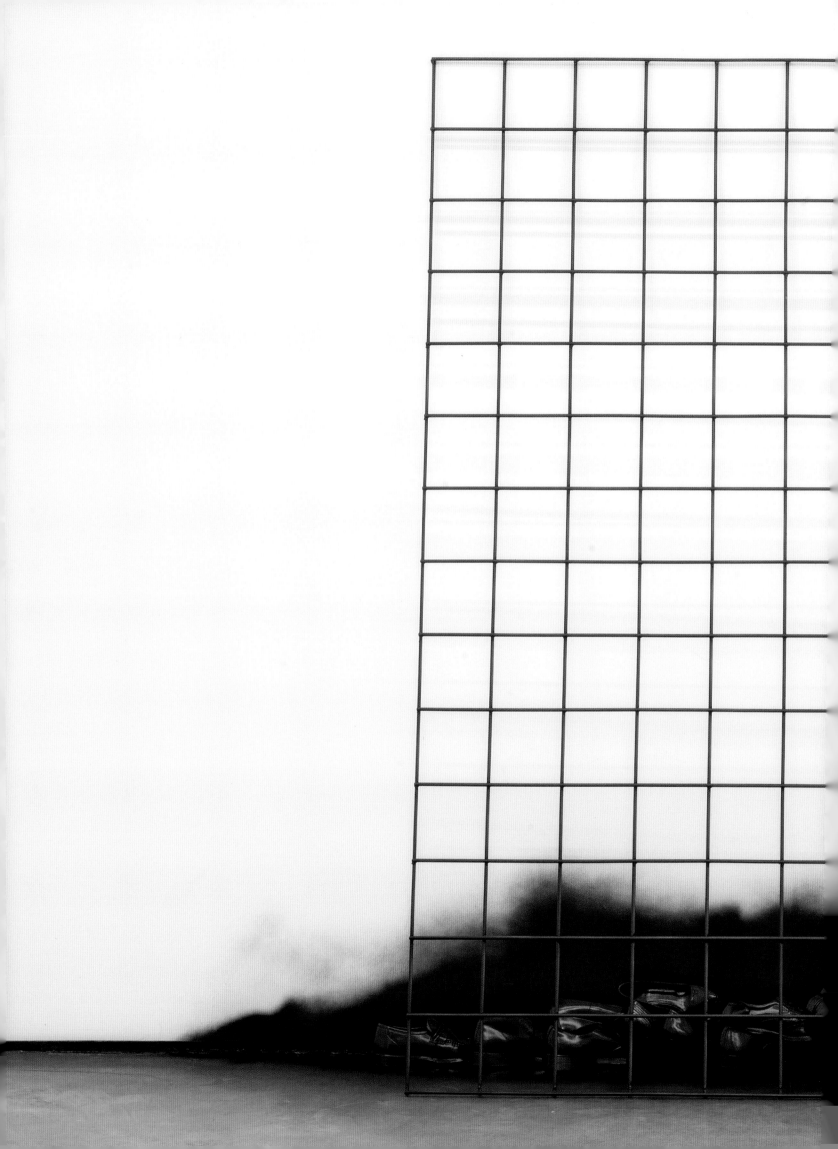

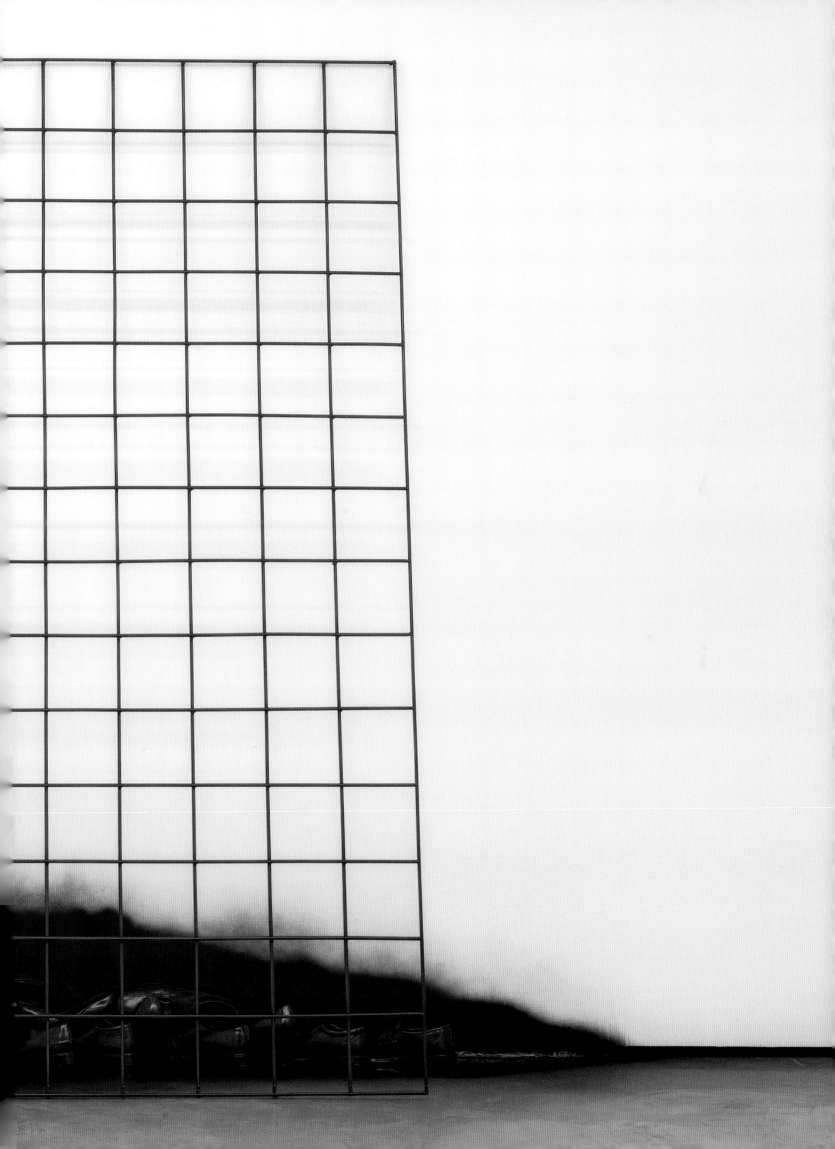

previous: Latitude, 2016.
Steel bar grid, shoes,
pigmented lacquer.
220 × 350 × 52 cm

Installation view *Electrolux*,
The Modern Institute,
Osborne Street, Glasgow, 2016

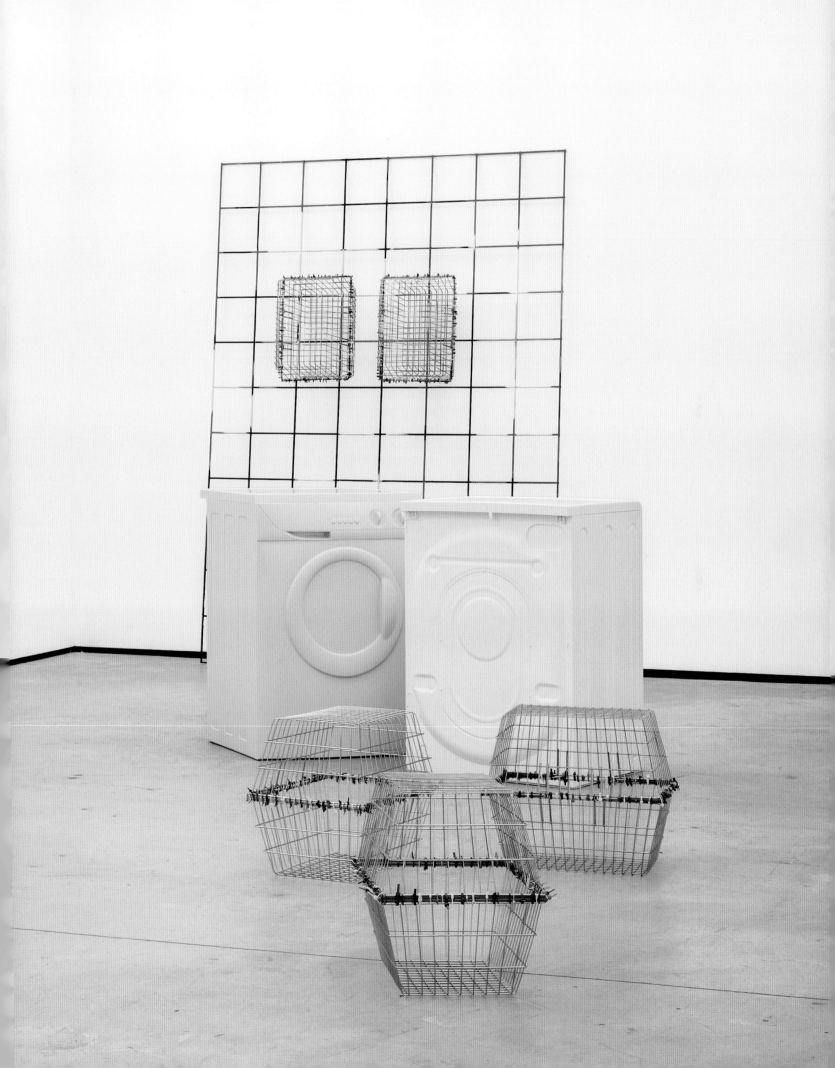

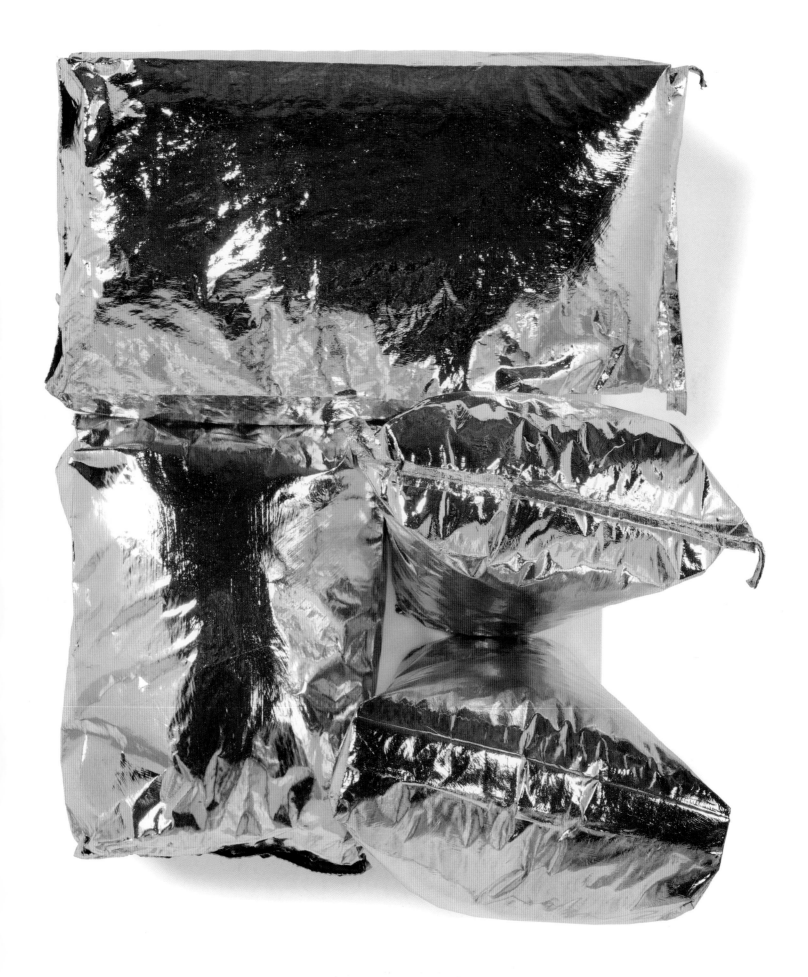

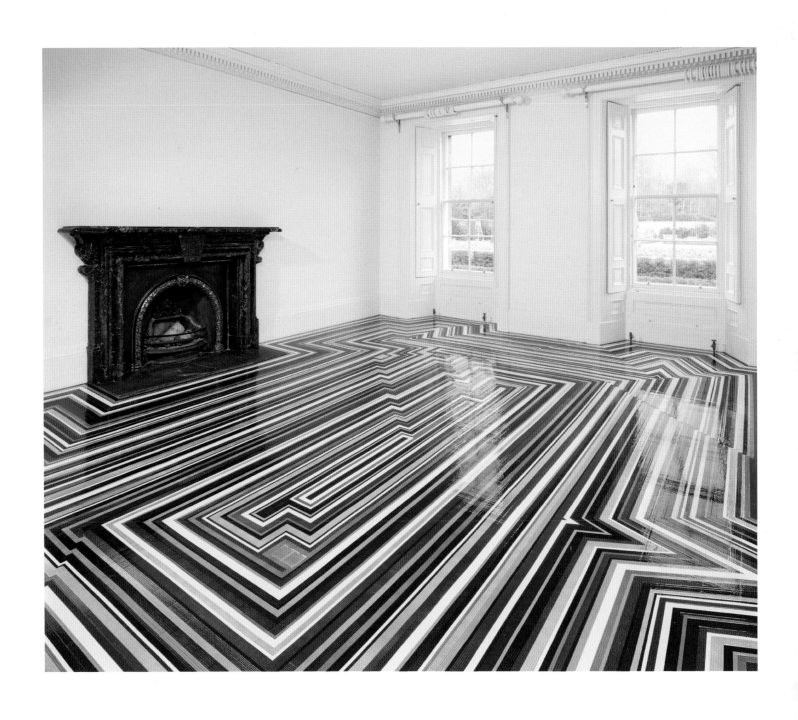

Zobop (Prismatic), 2016. Colored prismatic vinyl. Dimensions variable

opposite: Zobop (Prismatic) (detail), 2016. Colored prismatic vinyl. Dimensions variable

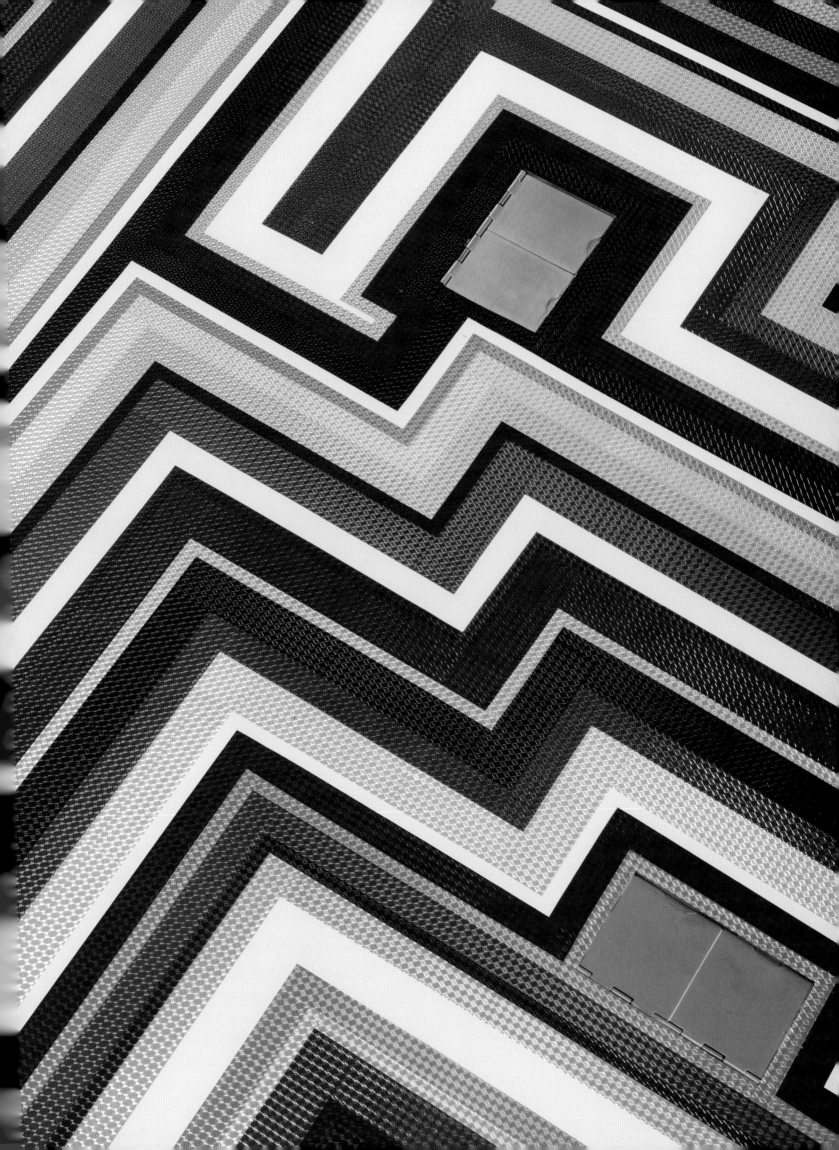

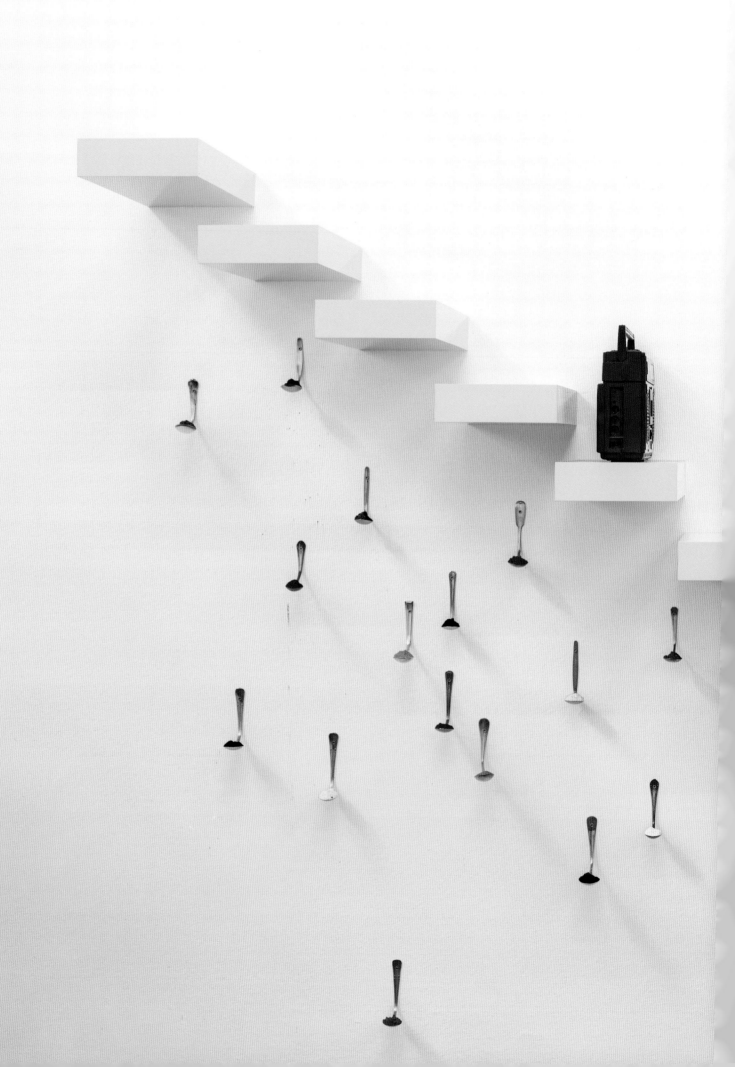

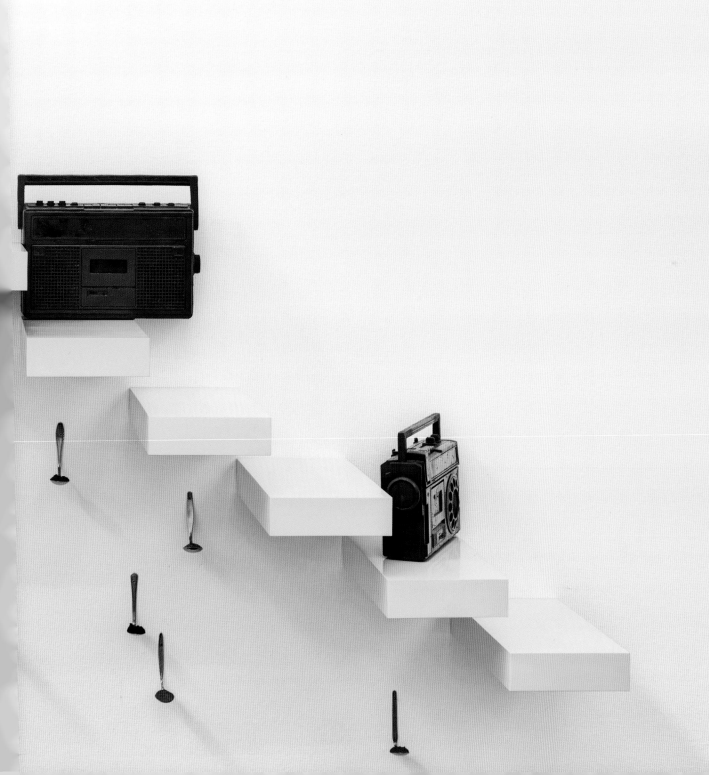

previous: Teardrop Boombox (La Scala), 2016. Lacquered aluminium, spoons, colored paint pigment, cast rubber boombox. 270 × 180 × 60 cm

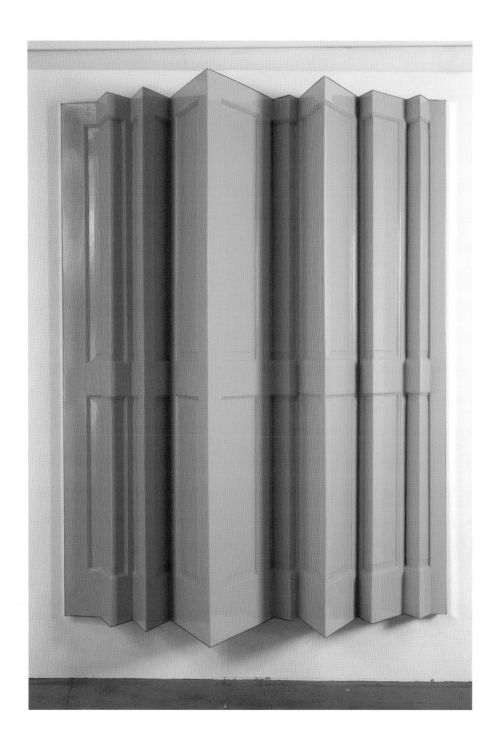

This is Tomorrow, 2008. Wooden door, gloss paint, mirrors. 203.6 × 157.7 × 51 cm

Zobop (Fluorescent), 2006. Vinyl tape. Dimensions variable

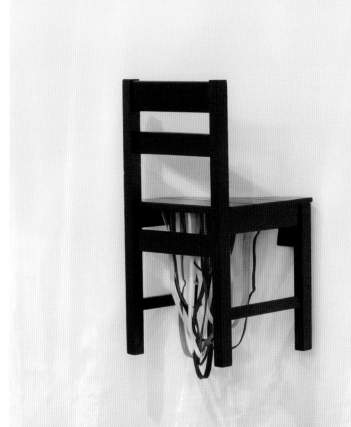
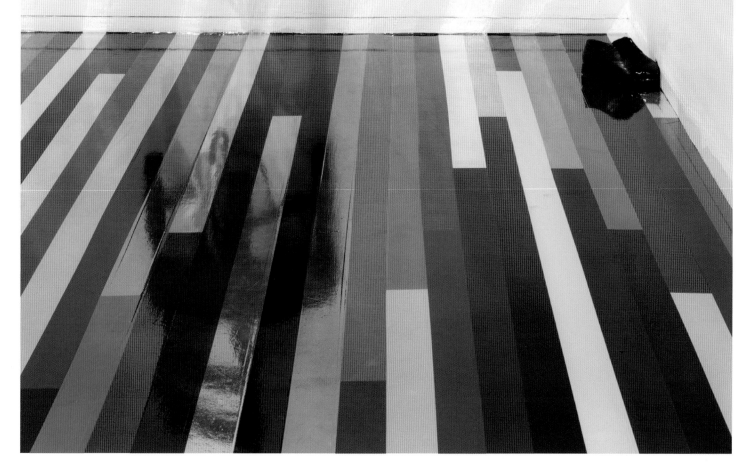

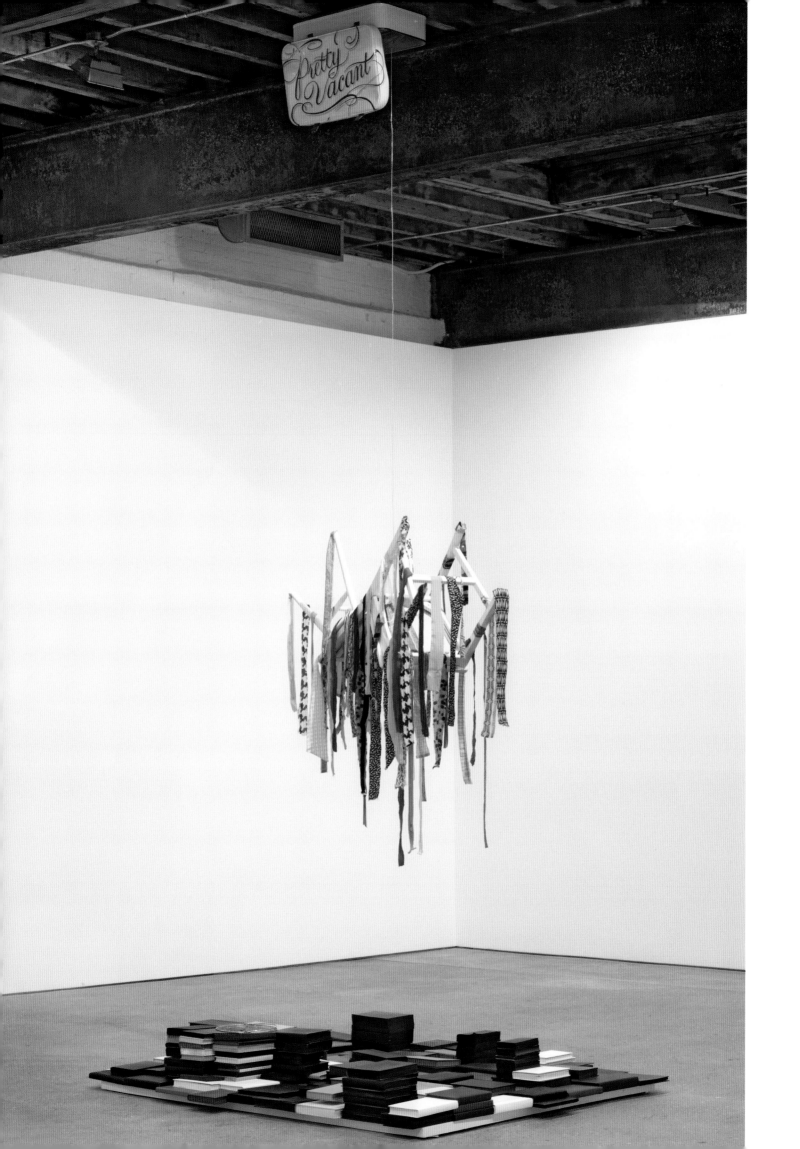

Bookcase (Pretty Vacant), 2015. Chairs, rags, wire, books, bucket, straws, concrete, mirror, suitcase. Dimensions variable

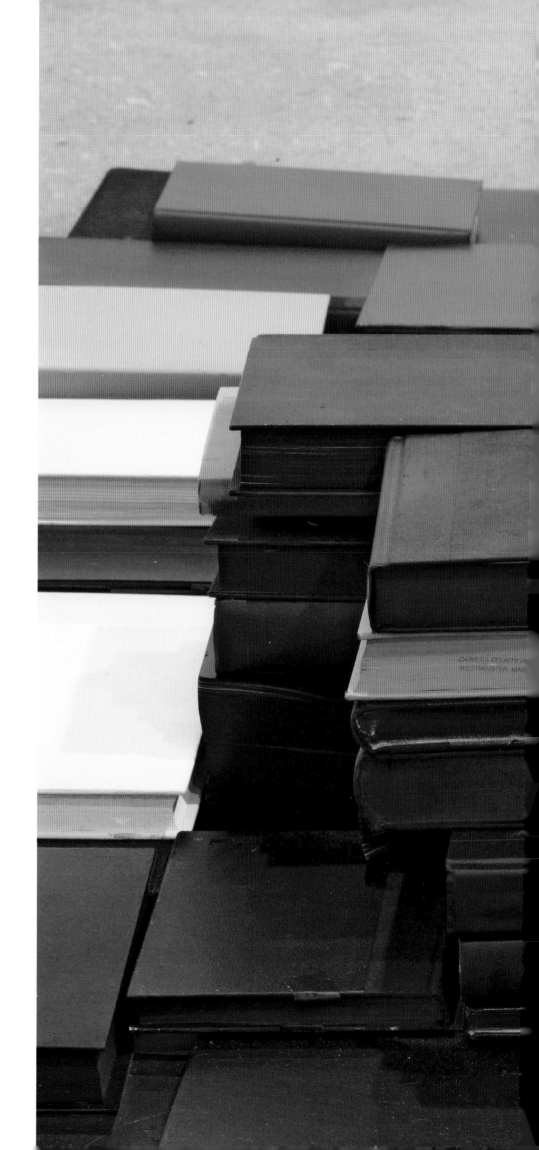

Bookcase (Pretty Vacant)
(detail), 2015.
Chairs, rags, wire, books, bucket,
straws, concrete, mirror, suitcase.
Dimensions variable

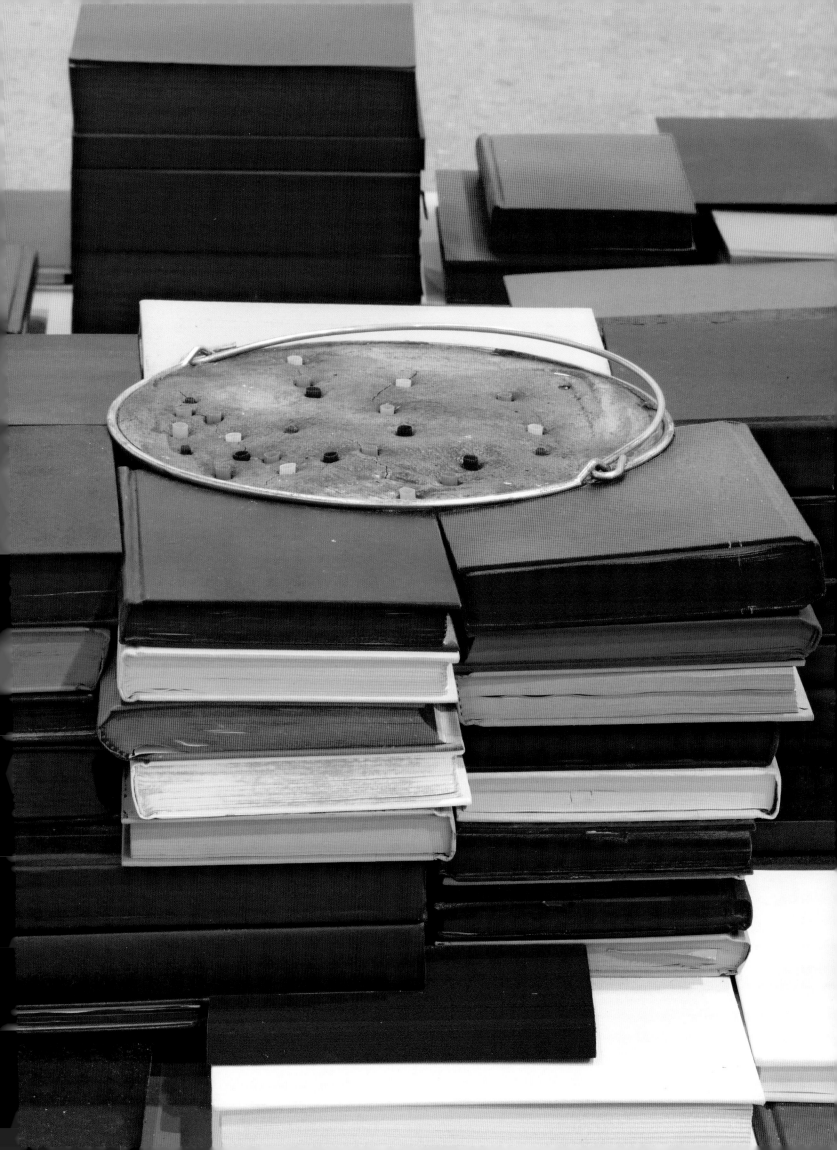

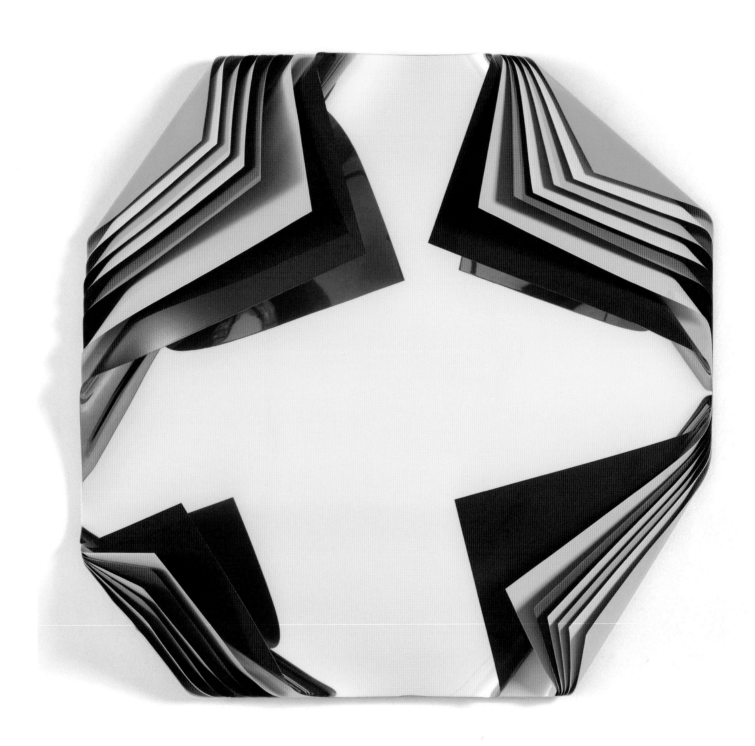

Metal Box (Karma Chameleon), 2015. Aluminium and polished steel sheets, household paint. 125 × 125 × 31 cm

Zobop Colour Stairs, 2003/2015. Colored vinyl tape. Dimensions variable

48

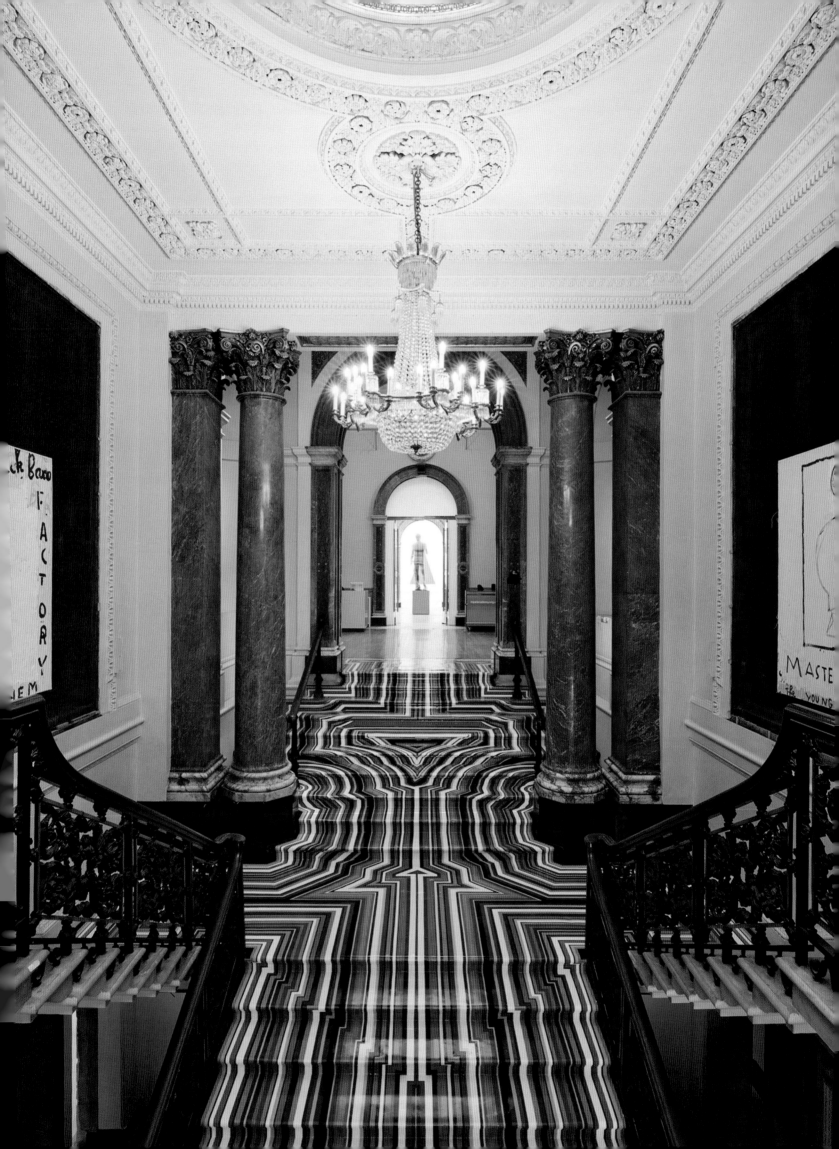

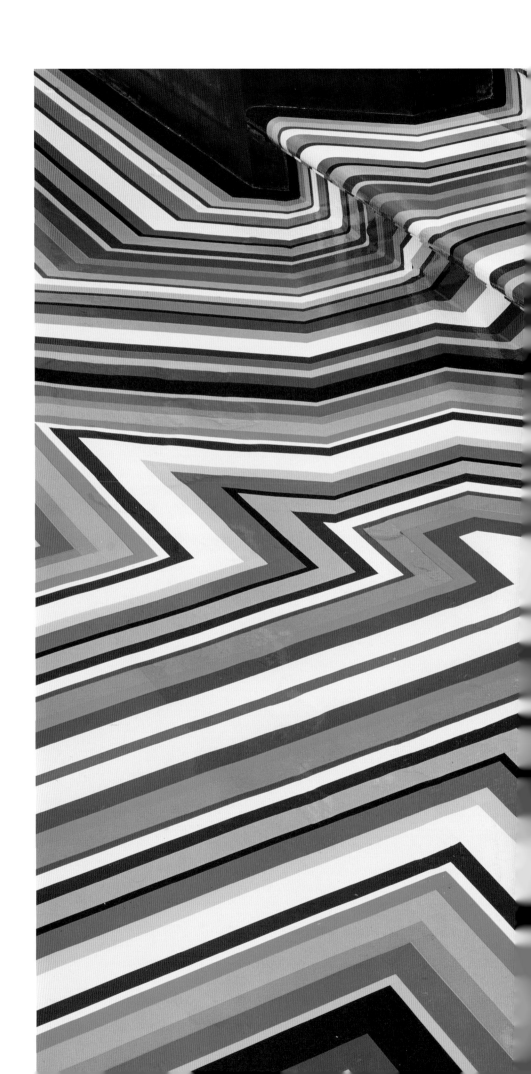

Zobop Colour Stairs (detail),
2003/2015.
Colored vinyl tape.
Dimensions variable

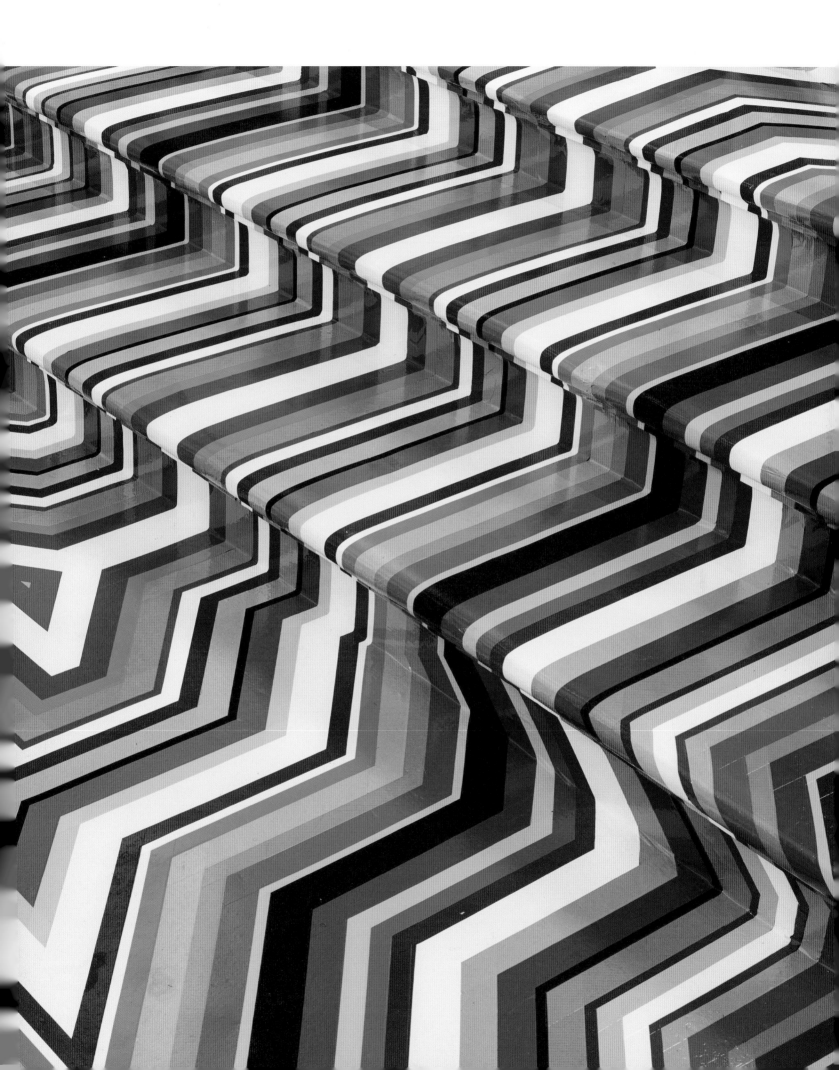

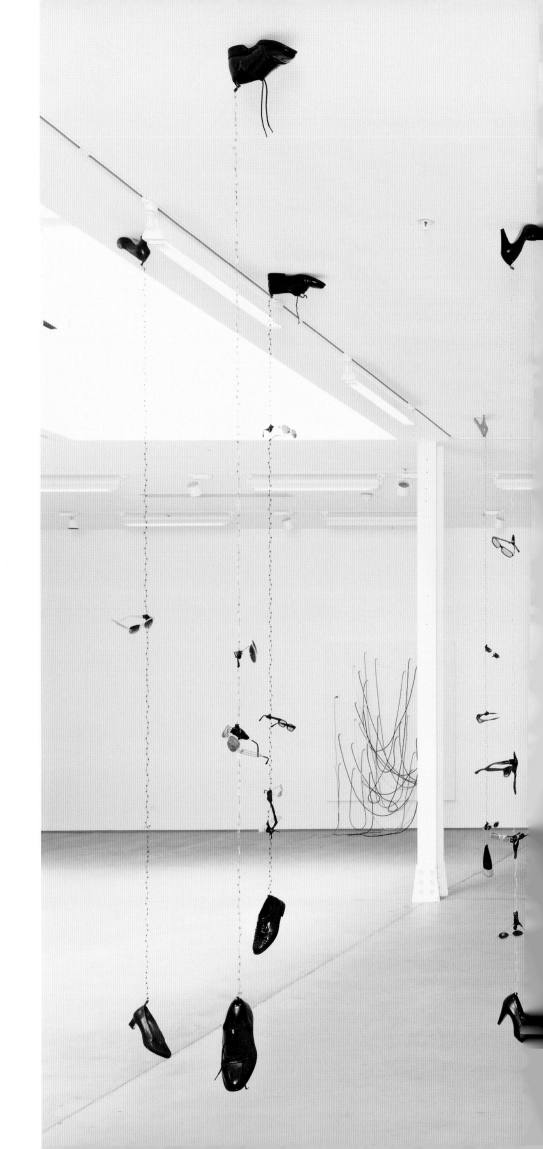

Ultratheque (Poppers Remix), 2014.
Shoes, sunglasses, acrylic paint,
gloss paint, fluorescent paint,
safety pins, tape.
358 × 513 × 622 cm

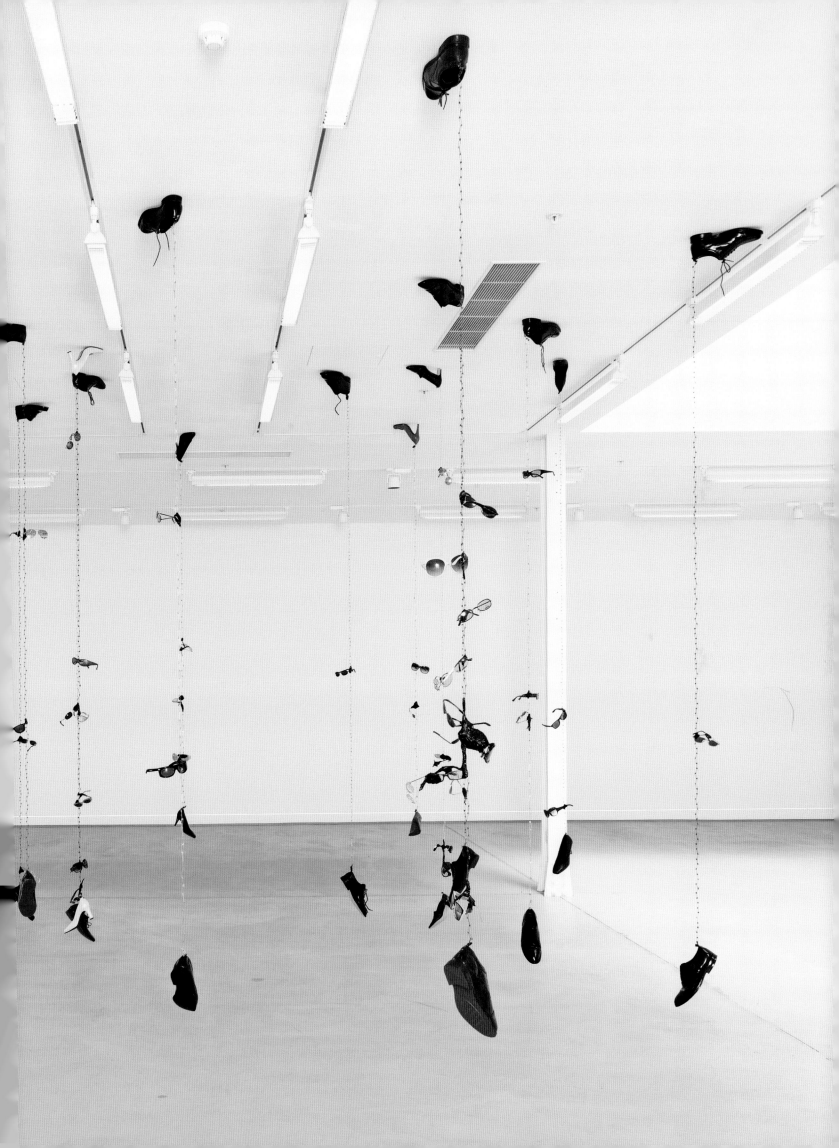

Totally Wired, 2014. Shirts, trousers, 1/4-inch guitar leads, mono plug sockets, household gloss paint on canvas. 190 × 160 × 62 cm

54

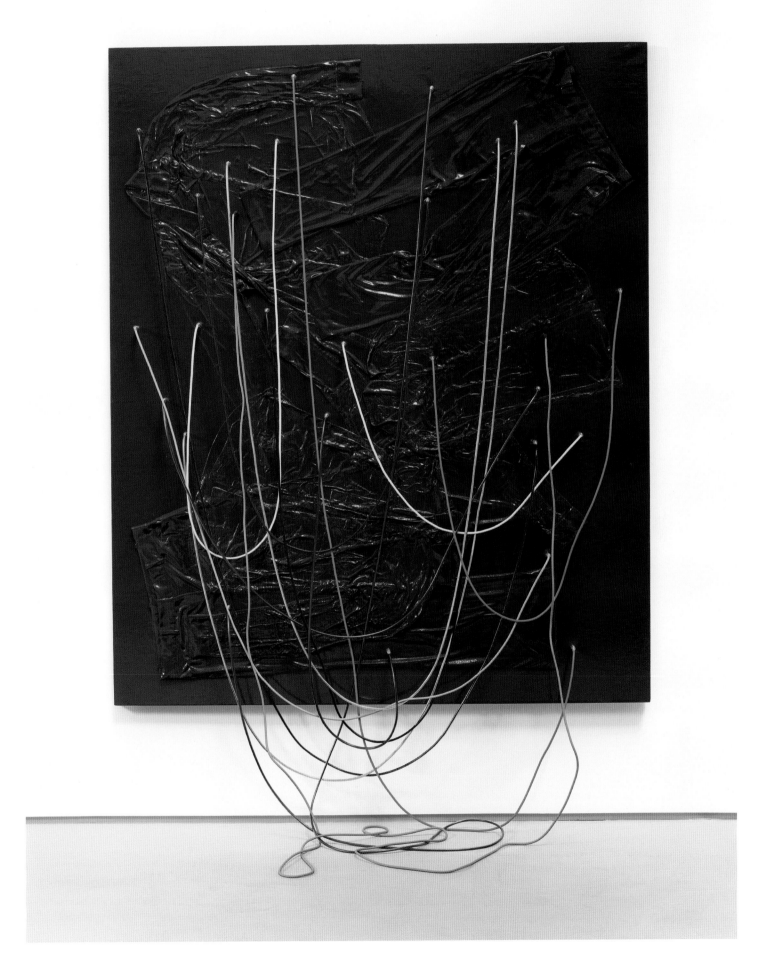

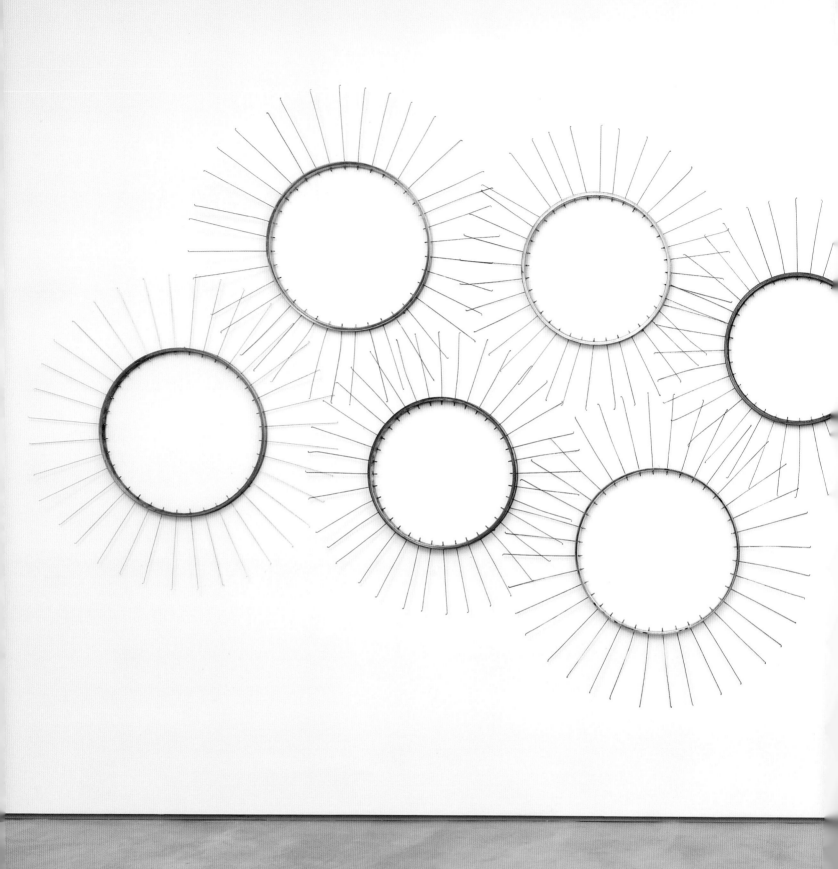

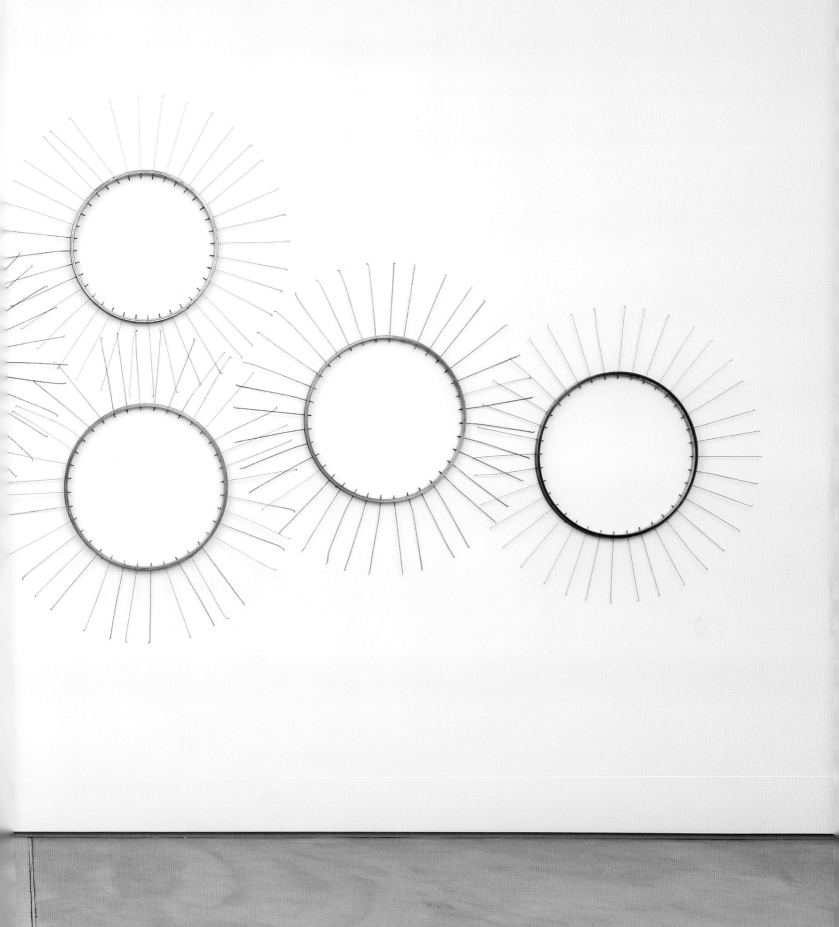

Many Suns, 2014. Aluminium bicycle wheels. Dimensions variable

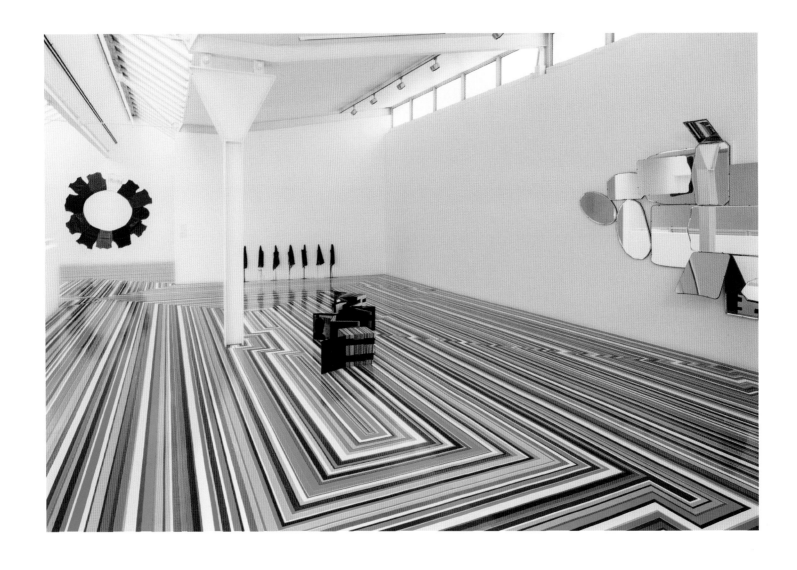

Installation view, The Fruitmarket Gallery, Edinburgh, 2014

opposite: Pyramid, 2014. Potato bags, acrylic paint, expanding foam, on canvas. 230 × 215 × 87 cm

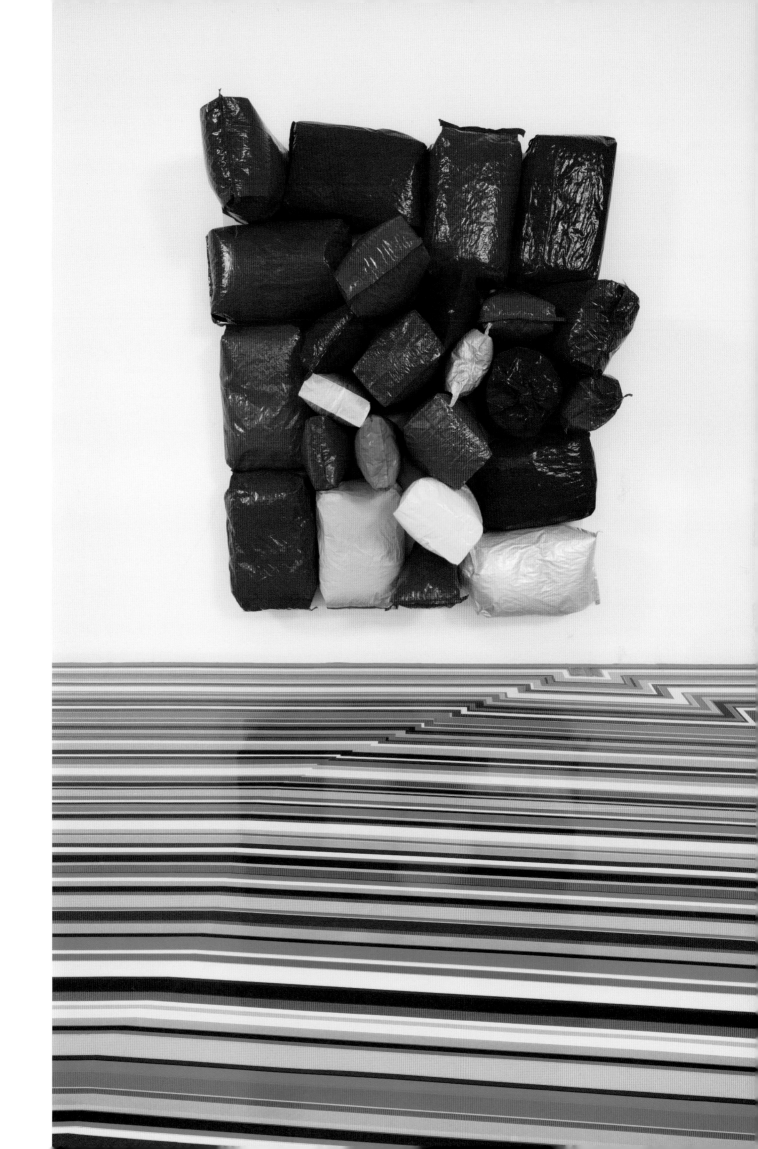

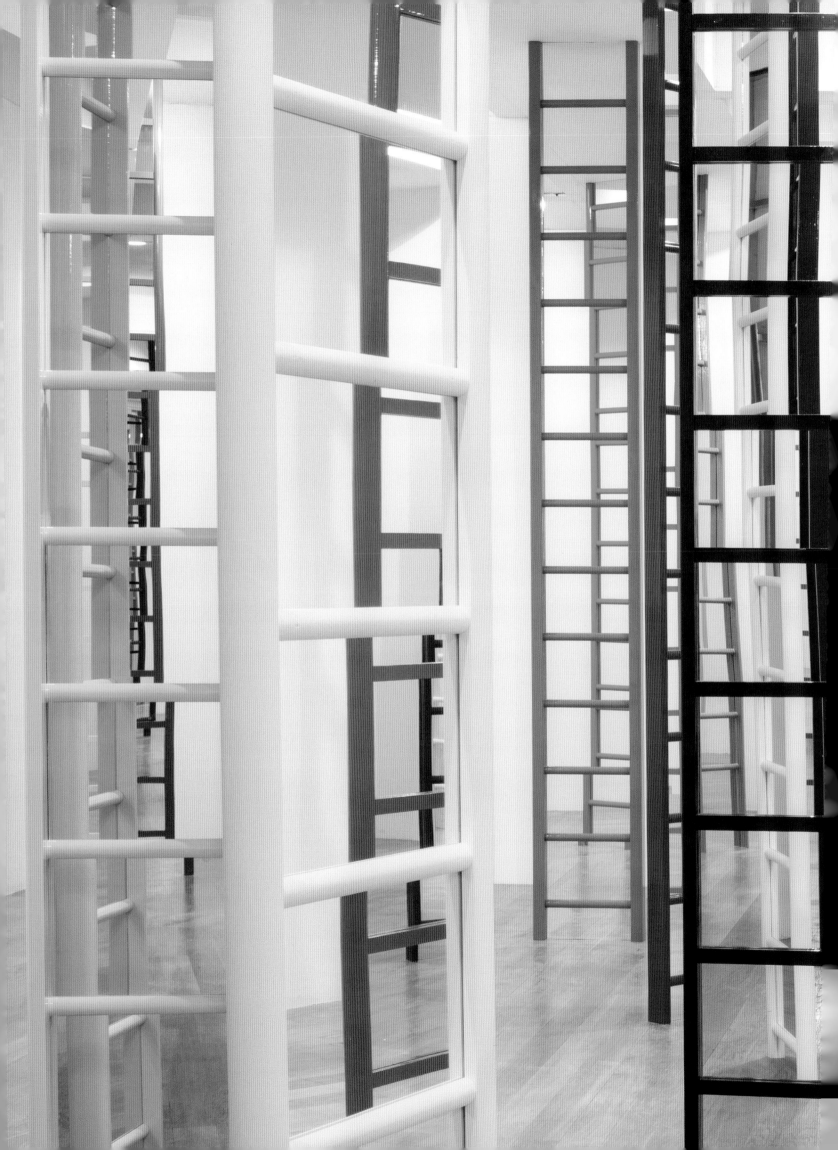

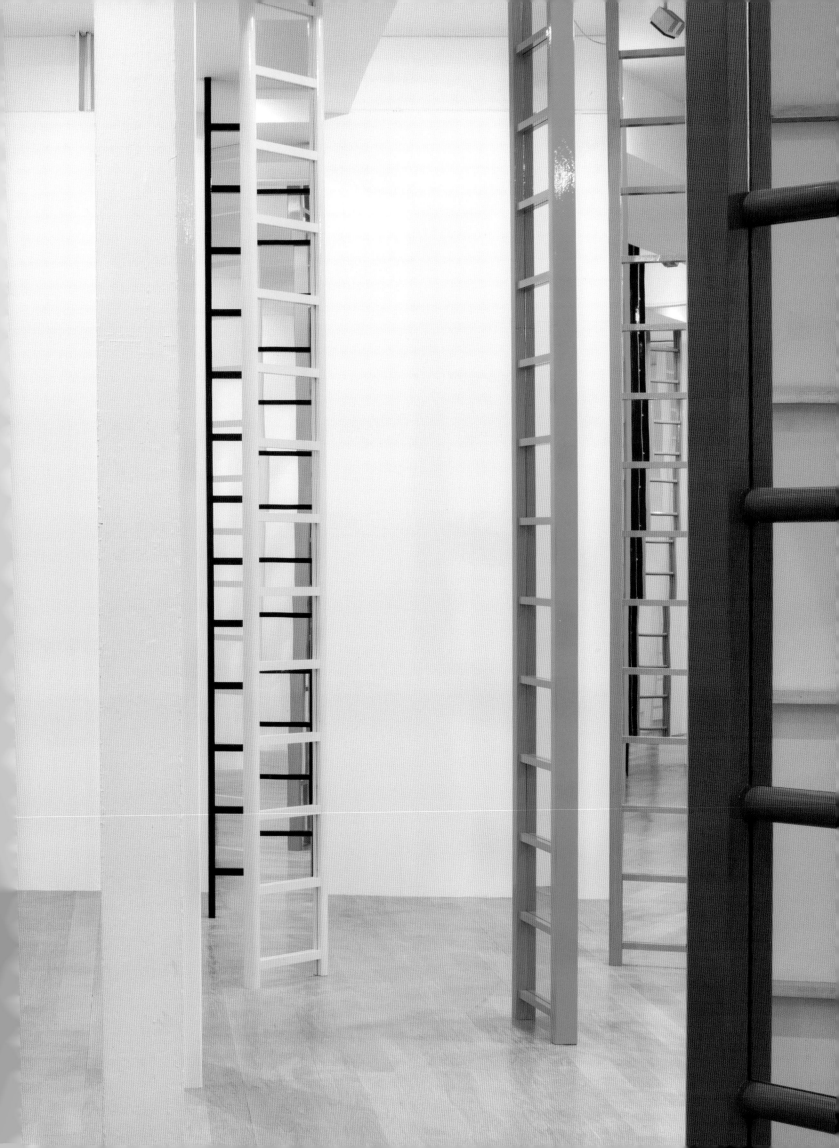

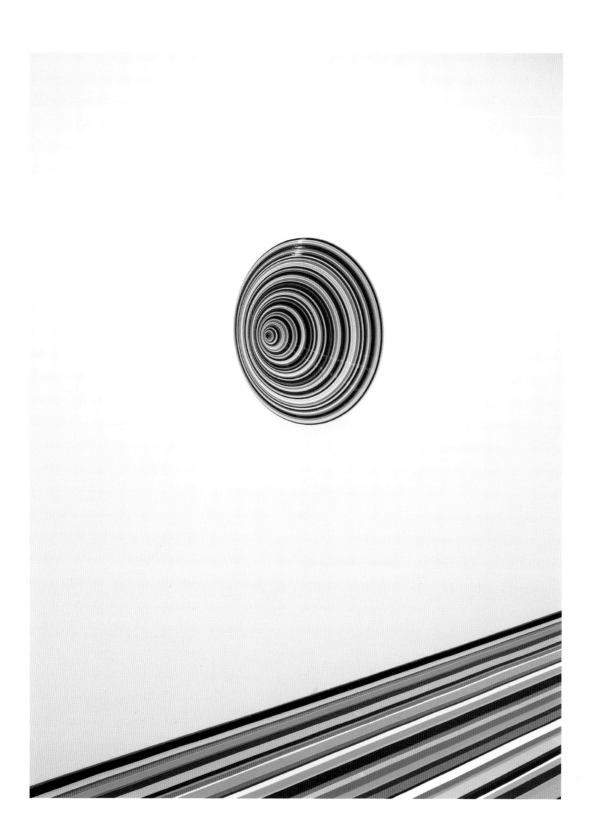

previous: Shaved Ice, 2012/2014. Wooden ladders, mirrors, household matt, gloss and fluorescent paint. 33 ladders, installed dimensions variable

Vortex (This Perfect Day), 2013. MDF, household paint. 85 cm diameter × 40 cm

opposite: Psychedelic Soul Stick 68, 2007. Shirt collar, safety pins, necklace, Marlboro Light packet, bamboo, colored thread. 102 × 9 × 7 cm

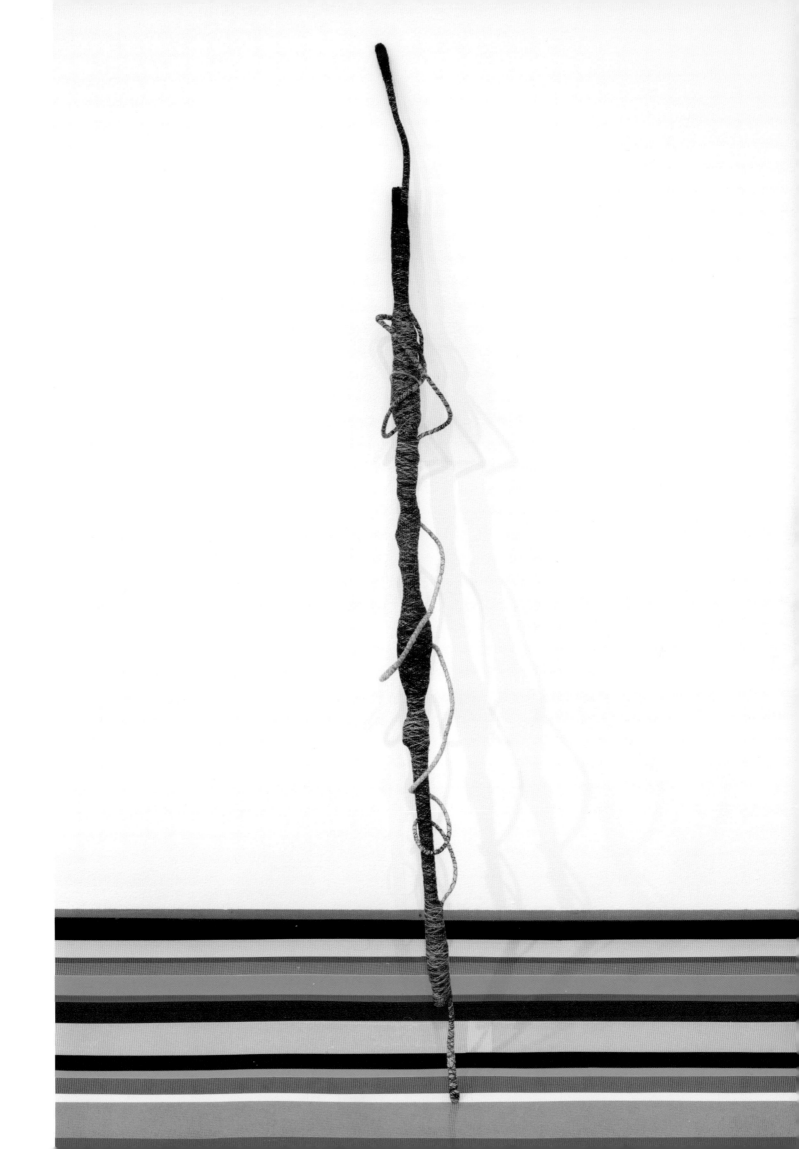

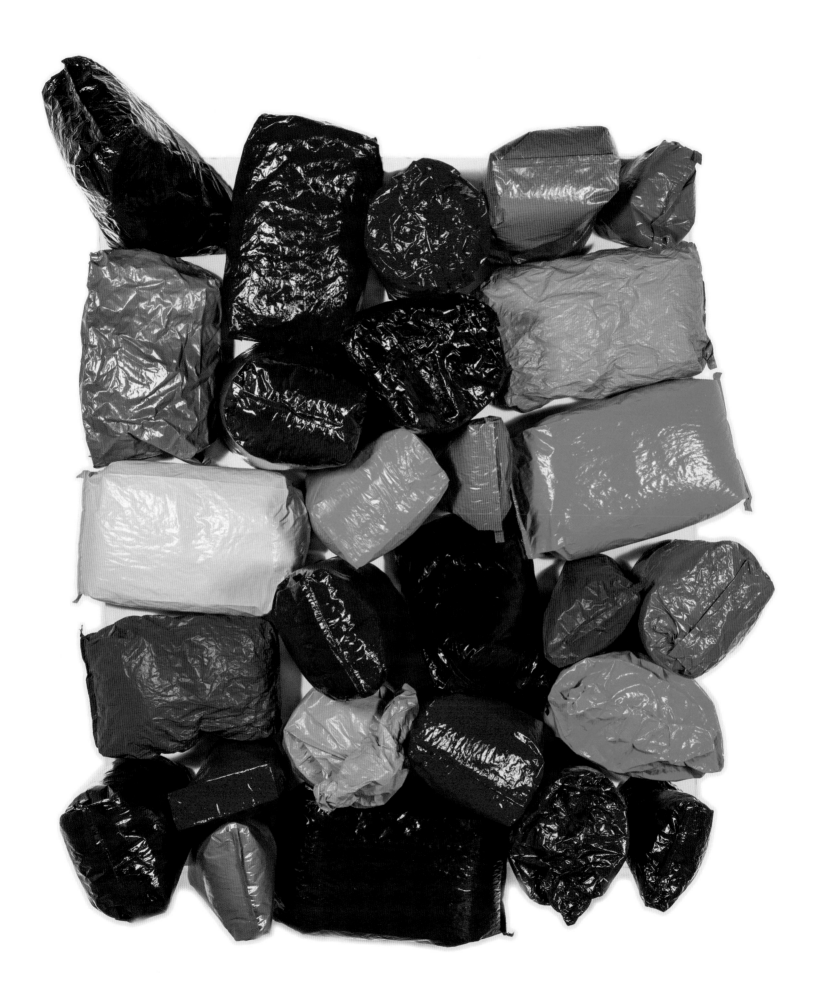

Sphinx, 2014. Potato bags, acrylic paint, expanding foam, on canvas. 235 × 193 × 60 cm

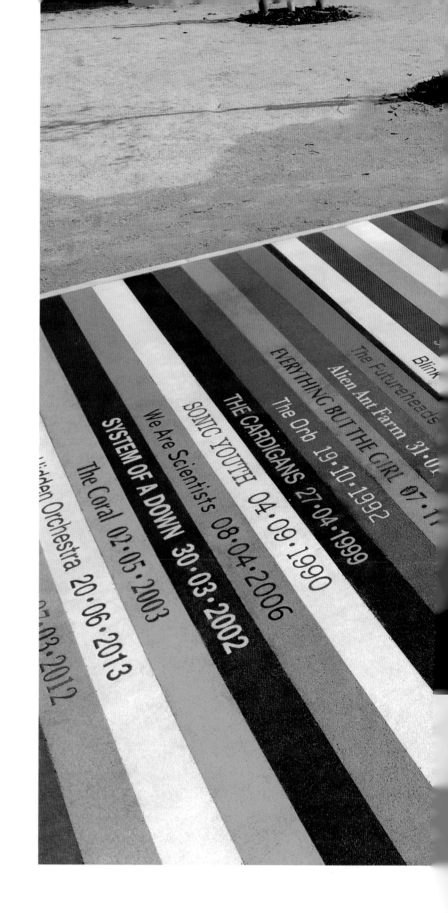

Blink

The Futureheads

Alien Ant Farm 31·0…

EVERYTHING BUT THE GIRL 07·11

The Orb 19·10·1992

THE CARDIGANS 27·04·1999

SONIC YOUTH 04·09·1990

We Are Scientists 08·04·2006

SYSTEM OF A DOWN 30·03·2002

…den Orchestra 20·06·2013

The Coral 02·05·2003

…·03·2012

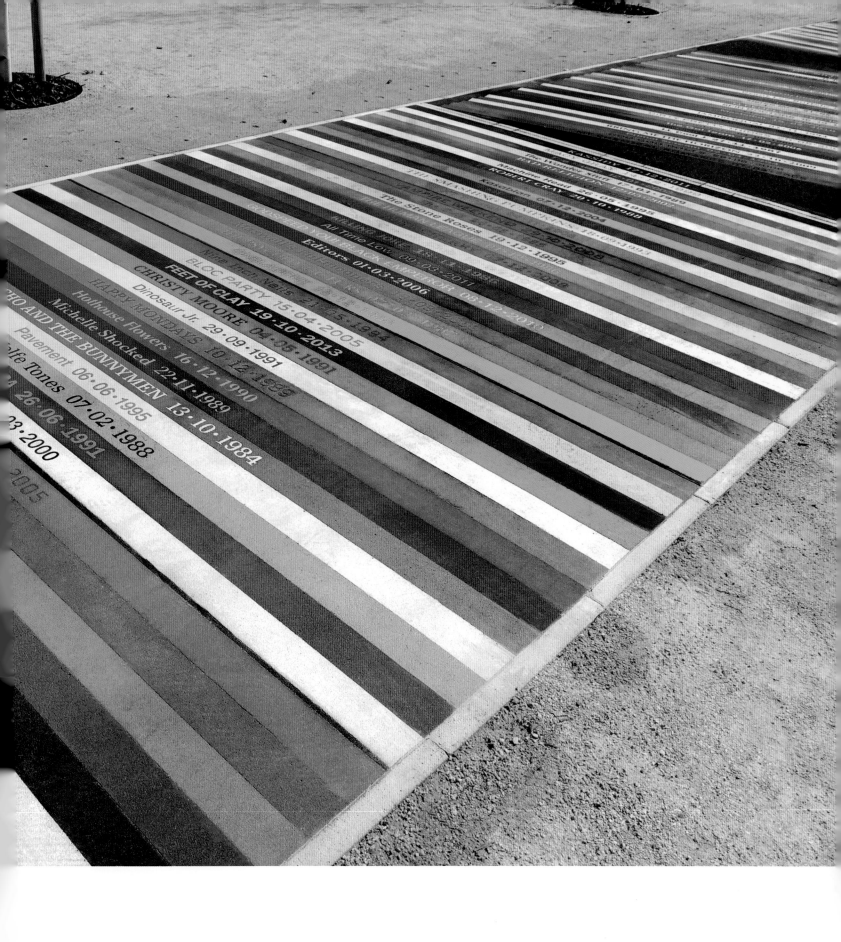

67 The Album Pathway, 2014. Colored concrete. 1030 × 300 cm

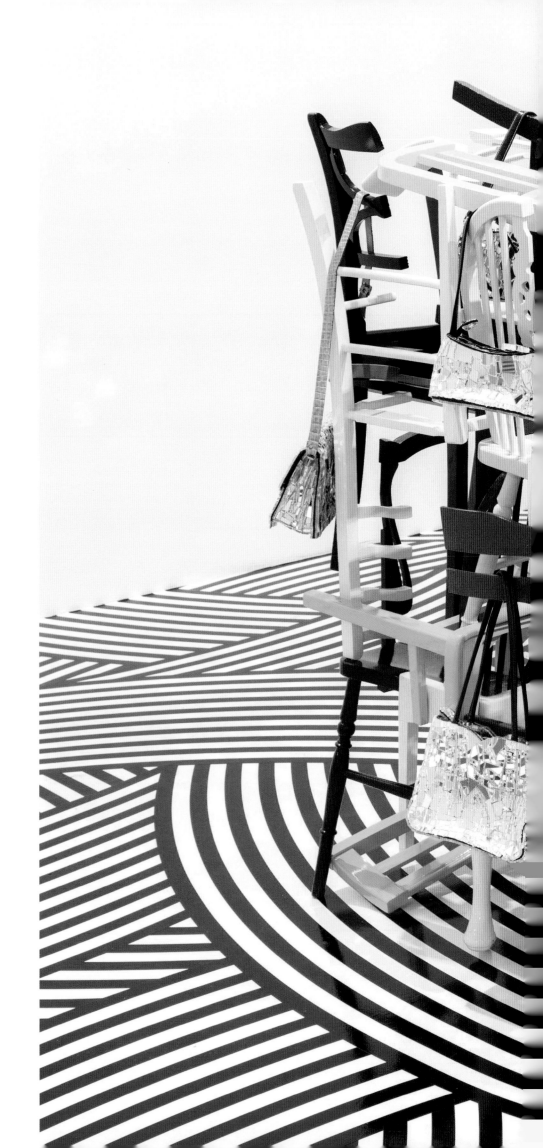

I Remember (Square Dance), 2009.
Chairs, gloss paint, mirrored handbags.
150 × 150 × 150 cm

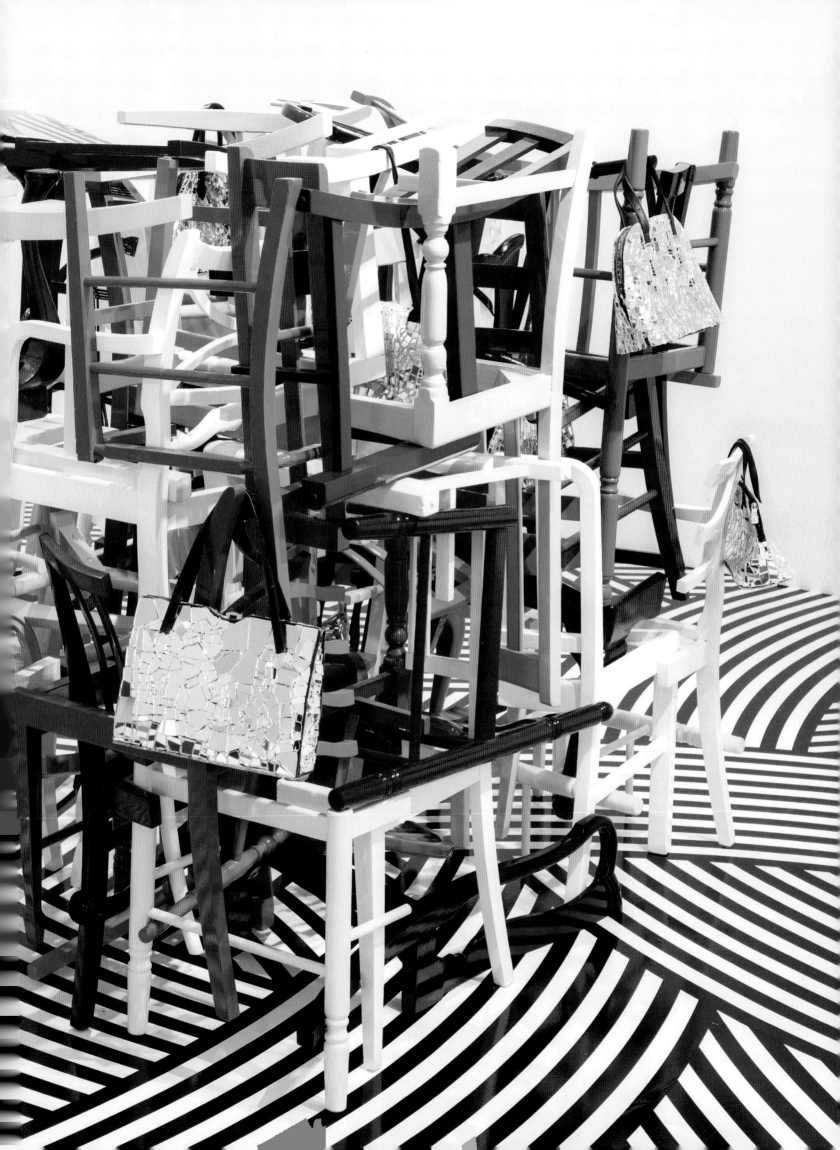

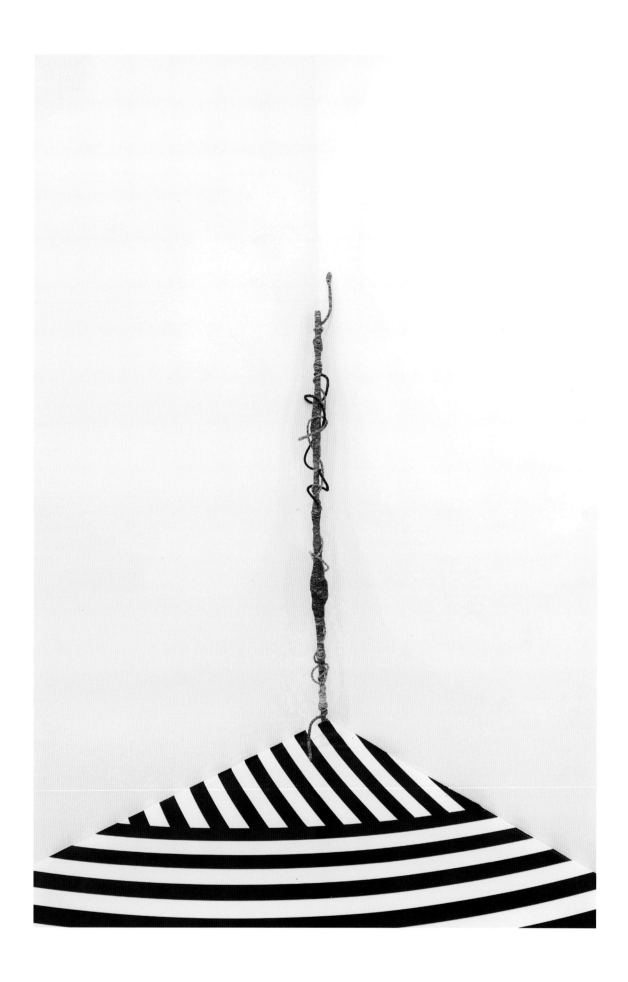

Psychedelic Soul Stick 75, 2011. Marlboro Light packet, 2 safety pins, belt, 1 bead, colored thread, bamboo, wire. 111 × 11 × 8 cm

73 Beautiful Future, 2012. Photo collage with metal teapots. 151 × 110 × 30 cm

Prick Up Your Ears, 2012. Photographic print, hooks, found cutlery. 150 × 110 × 7 cm

opposite: Diamond Guitar (Truman Capote) (detail), 2013. Photographic print on aluminium, polished steel scaffold poles. 179 × 184 × 9 cm

EMPTY AND *FULL*
Jim Lambie in conversation with Daniel Baumann

DANIEL BAUMANN: Can we begin by first discussing your background a bit?

JIM LAMBIE: I was brought up twelve miles outside Glasgow in a housing scheme, a northern British equivalent of sorts to the projects. It was the 1970s and Britain was in the grips of a battle between the government and the unions. I remember many public services being on strike—trash mountains in the streets, power cuts, and candles.

There is a fantastic photograph brought to my attention in a work by Jeremy Deller of a wrestler called Adrian Street whose wrestling image and costumes were very flamboyant—makeup, lamé suits, silver platform boots—very much influenced by glam rock, and it's him with his father, a coal miner, in the 1970s. It just about sums up the general feeling or mood in Britain at the time: one of hope, but at the same time, knowledge of impending industrial wipeout. No one was going down without a fight though, and where the distraction of glam inevitably failed, punk took over. It was more aggressive and high octane. A beautiful "fuck you" to those who thought they had things under control. It worked—for a while.

DB: You mention glam rock and punk in Britain in the 1970s— was this the initial trajectory with music for you?

JL: The glam rock element was my first contact with youth culture. It was framed within sound, fashion, and to some extent the film *A Clockwork Orange*. Most of the styling was taken from it. It was boot-boy style and it came with an aggression carried out on the streets. The styling and the makeup came with a hard-edged, violent streak. Gangs in makeup would have running pitched battles in the lots, like they were running the ultraviolent scenes straight from the film. The Rolling Stones sang about "Street Fighting Man," Elton John sang "Saturday Night's Alright for Fighting," and everybody was "Kung Fu Fighting," according to Carl Douglas [*laughs*]. So I suppose, yes, this was the initial trajectory, but of course this was all chart music influenced. What I began to understand was that there was a whole underground scene going on that would begin to reveal itself, away from mainstream popular culture.

DB: For years now, though, pop music has been one of the framing mechanisms used to talk about your work. What does pop signify for you?

JL: It always meant music and art. When I was in my early teens, around 1978 or '79, Warhol and the Velvet Underground had a massive impact on the Glasgow underground music scene. Postcard Records, this short-lived but influential record label run by Alan Horne, had bands like Orange Juice, Aztec Camera, and Josef K. Those bands were the major music and culture reference for those of us in Scotland who were looking outside chart music for something else.

Other bands on the fringes of the Postcard scene had a massive influence too: The Bluebells went for pop overdrive, putting the Glasgow "jangly" guitar sound on the charts. The Pastels were then and remain outsider music's most authentic influence.

Creation Records, run by Alan McGee, unleashed the perfect storm for me, though: The Jesus and Mary Chain, Primal Scream, and a club called Splash One. This club and the crowd it attracted had all the best bits of psychedelic, punk, and the underground outsider scene mixed together. It opened up a whole new world for me.

DB: So Splash One was key. Looking back on thirty years of work, what would you identify as some other big moments?

JL: The revelations have been gradual. Stopping being in a band and deciding to try and get into art school was probably one of my better decisions. I was twenty-six when I finally got in, on my second attempt.

Four years later, I went to Marseille to do this artist residency called Triangle France, in this former tobacco factory called La Friche Belle de Mai—it was around 1998. I was there for three months, in what turned out to be quite a monastic experience. My home life consisted of a mattress on the floor, a small kitchen, and toilet. I arrived in August, when most people were on vacation, and I worked pretty much in isolation.

I wasn't really making things for the first month or so; mainly wandering around, absorbing the place. I would also spend quite a lot of time at this great museum, Musée d'Arts Africains, Océaniens et Amérindiens, looking carefully at all the tribal artifacts.

Most days, when I would come out of my apartment in the morning, the street would be littered with ropes and colored plastic wrapping used to tie boxes together from the street market. I would be literally wading through it in some places. So I started picking up this stuff and taking it to the studio.

DB: And in some ways, this is where it began?

JL: Just finding things in the real world. Picking things up. The day-to-day essentials that are necessary in holding everything together. The wrappings and the bindings—string and tape. Elements that had a common language.

DB: A common language?

JL: You would have to go to a very remote place for somebody not to know what a chair is for example, or a mirror. So without really fully understanding what I was working with—and because financially I couldn't just go and make a ten-foot bronze sculpture—I began discovering the potential in what was around me. The discovery of an everyday object or event would trigger a run on my imagination. It's something I now share with students: if you've only got a tube of blue paint, just make a blue painting. If you can't be creative with that, you need to find a way. It's far more instrumental to discover what you can do with what you have in front of you.

DB: Would you refer this back to class, or to Glasgow?

JL: A class thing? I grew up in the UK, so I wouldn't rule it out [laughs]. Seriously though, I think it's more of a personal decision. It's an observation that art doesn't or shouldn't rely on the use of expensive or exotic materials. Art history has been teaching us this for a long time, but more than this, from within myself, it felt exciting to not know what was coming next, to allow the world to present itself, and if I was paying enough attention, to see what could be done with it.

In Marseille I couldn't get the wrapping material to do what I wanted conceptually when I first picked it up, so I stripped it down, and I found really cheap thread inside. That's when I made the first Soul Stick. I had started with wrapping tin cans and things like this, but it didn't work. Then I thought I'd make something that felt much more religious, like a shaman stick. Something which referenced or felt more like some of the objects I had been studying in the museum.

There is a meditative experience involved in wrapping the Psychedelic Soul Sticks. They can take up to fifteen hours to make, sitting there an hour at a time, wrapping the threads round and round. It all just came together in that one piece.

DB: You build a structure, you try to wrap the world.

JL: You kind of make your own religion in a way. I guess everybody makes their own religion, even if you're an atheist. I was playing with the idea of a quasi-religious object, and it had all of that shamanistic feeling. Getting to the Soul Stick was a big moment that I didn't realize at the time, but it was really tapping into what that structure, of what a work of art, could be.

DB: And at the same time, you introduced something psychedelic?

JL: Yeah, really psychedelic. I mean, within psychedelia there is so much of tapping into shamanism and the subconscious.

DB: And is this the point where color comes in?

JL: It was a discovery—the colored threads binding together to create the overall silhouette of a larger image. The resurfacing of the object. There were so many threads, tightly wrapping themselves around the smaller objects—old cigarette packets, buttons, beads wire, etc.—which I had taped and stuck to a central bamboo core with tape. Hundreds and thousands of individual lines wrapping themselves into one, unified object.

DB: And that you could make this work "overdosed" by color and layers?

JL: I remember thinking, the art around me wasn't so colorful at that time [laughs]. Everything was highly conceptualized, too much even. Lots of text pieces—with dull or drab palettes. Everybody seemed to want to be Lawrence Weiner [laughs], which is great, if you're Lawrence Weiner.

But something came though. With the colors, and with the new work—when I came back from Marseille, I got offered my first solo show at Transmission Gallery, in Glasgow.

DB: And that solo show at Transmission was the first time you used tape on the floor, right? I can see the path from the Soul Stick—it's the same process, covering up, but flattened out.

JL: It is the same process. So I have the show, and I'm thinking, What will I do? Do I fill it full of work? Or do I keep the show very minimal and empty? Those were the two big edges. And in asking how do I fill a space and empty it at the same time, I started thinking of the floor.

DB: You walk on the taped floor, which is lined out—time in meters. The thread wrapping the Soul Stick is the same—time in meters. And the visitor adds his own time layer by walking through it.

JL: You can actually see the time, the industry, and the work. You can understand how I get from point to point in the room.

The architectural system of the room is controlling the shape of the piece—the premise is apparent and clear. It was crucial for me that the work was conceptually anchored. This creates an opening and a freedom to emotionally engage—to play by introducing color—without the fear of theatrics.

DB: We've talked about universal languages, quasi-religious experiences or objects, color, but what about rhythm and movement? The crunched doors, the scattered mirrors, the way your work breaks, parcels, scatters, and recomposes—do you see a through line in this?

JL: Yeah, there's rhythm. The floor works with their rhythm and beat punctuated through color, or the Strokes work for my solo at the Gallery of Modern Art in Glasgow, which rocks and rolls and undulates like the top of an ocean. There is a stack of painted chair halves rising up in the form of a single wave, scattered around the room is the flotsam and jetsam of the sunken concrete record collection.

There's a rhythm to the way we experience space, and there are surprises in that. The work Plaza came about through a simple street observation while standing at a bus stop. Across the road was a woman walking and carrying some shopping bags. One of the bags, a red polyethylene bag, knocked against a concrete bin in the street. She didn't notice for a few moments, which allowed me just enough time to observe white milk start to pour through the tomato red of the bag and onto the street as she casually continued along.

DB: Your works seem to combine movement and sculpture, or, to be a bit pathetic, time and space. You've never thought of yourself as a painter?

JL: Not really. I don't know where I lie in terms of those banner headlines for things. I love painting, I love looking at painting—but I need a reason for the painting to exist. I was trying to find a way for me, and thinking how paintings are always described as windows to another world, a view out to a new space for yourself. But if you change the word window to portal, you have a two-way entry to another space, and, well, if it's a portal, it becomes a door. If there is a way in, there must also be a way out.

There's this fruit and veg shop near where I lived with bags of potatoes sitting outside. I thought maybe it'd be interesting to use the potato sacks—fill them with expanding foam—and attach them to canvas. Then the paintings are spilling into the room, placing you back inside instead of giving you a window out.

DB: It is like dancing, right? Where you make space for yourself yet constantly place yourself back inside the room. What about the installation with colored ladders with mirrors between the rungs?

JL: Back to a common language—everybody knows what a ladder is and how it is supposed to work. And the openings where you would normally stick your feet between the rungs. When the piece is installed in a room, your automatic perception leads you to assume it's a normal ladder because it's not immediately clear that there are mirrors slotted where there should be open space.

There are very few objects this could work with, but the ladder is perfect because of those innate assumptions. Even when I was installing it, I knew what the work was. You assume you're going to see somebody continuously through the rungs, but instead they disappear and reappear behind these objects you think you know the rules of. And the more ladders you put in, the more this happens. The space expands and contracts, while time remains constant. And as an aside, it's quite good for disappearing at an opening [laughs].

DB: It creates a space that's simultaneously empty and full. Which brings us back to that first Transmission show, or forward to your jars stuffed with colored fabrics: they play with the option to be emptied out.

78

JL: Very much so. Individually, they are in this vacuum of the space inside the jar. Overall, there is a rhythm going through the work with the pattern of colors in each glass. The jars are always installed up in a corner or on a ceiling. The poetics of a corner are that it's this very intimate, personal, introverted area. And all those colors are coming in from T-shirts from thrift shops.

DB: And with that intimate corner space, and with the used clothing, we are getting into a sort of hidden thread in your work—the body. It's unexpected at first, but you can see it already present in the very early pieces—the cigarettes and the boob tubes. Then the ladders where you hide and disappear, or the bodies of the potato bags. So in the end, it's all so . . .

JL: It's all so figurative [*laughs*]? We can't get away from the body. No matter how much we try. There are the everyday materials which we bring into our lives, fill our homes and work spaces with. These are the systems which prop us up, which hold us together, which seem to make things easier to cope with. And yet, our bodies are very much a part of everything.

DB: So let's say that the everyday objects come with a general and well-established language. They are generic, which makes them accessible. You reshape them, annoy them with the language of art, make them useless. Yet they don't disappear, but, if they succeed, create an alternative space, just like music. Sometimes it works, sometimes it doesn't. It is a tightrope on which you balance.

JL: Or to possibly lead people across that. And maybe they fall and it's a big drop. Or maybe, somehow, they get to the other side.

DB: This is the melancholy lingering underneath the cheerful surface.

JL: I think there is a sense of isolation. Feeling filled and then feeling emptied at the same time is kind of the same. I always have this feeling. I don't think I'm much different from anyone really.

DB: There is something . . .

JL: Hidden?

DB: Yes.

JL: I think we can leave it at that.

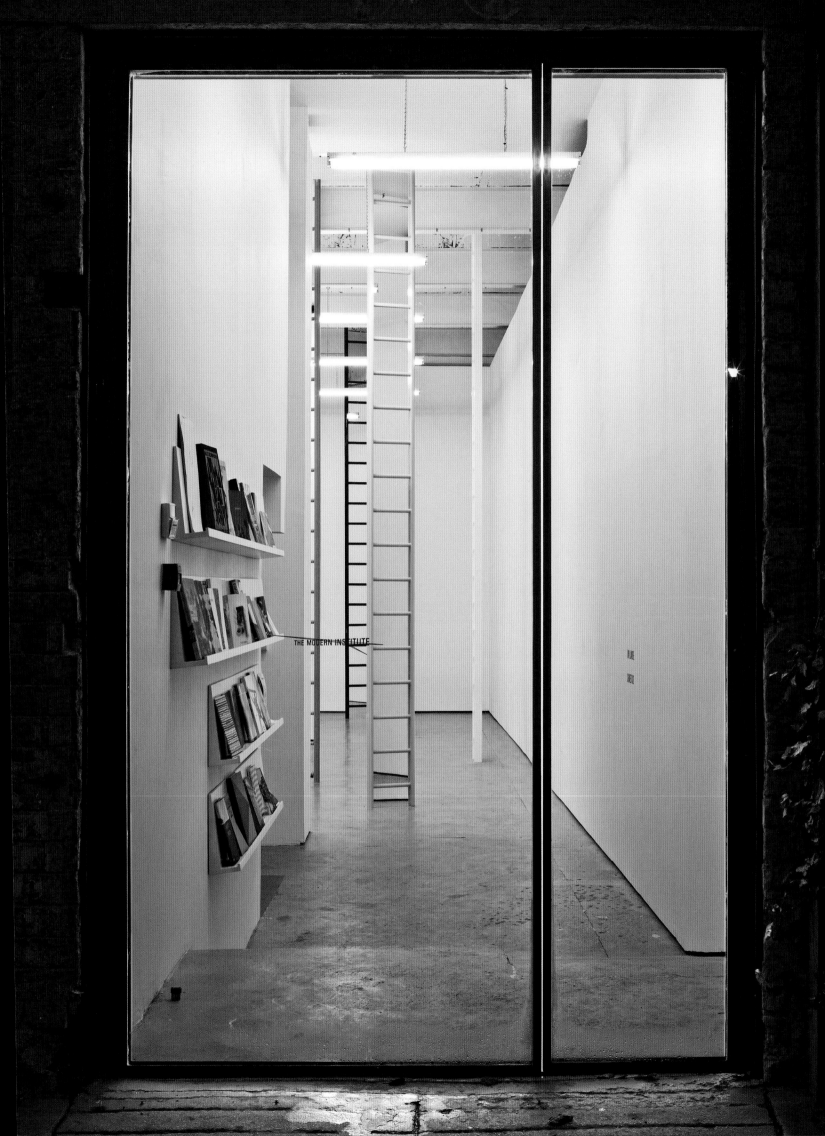

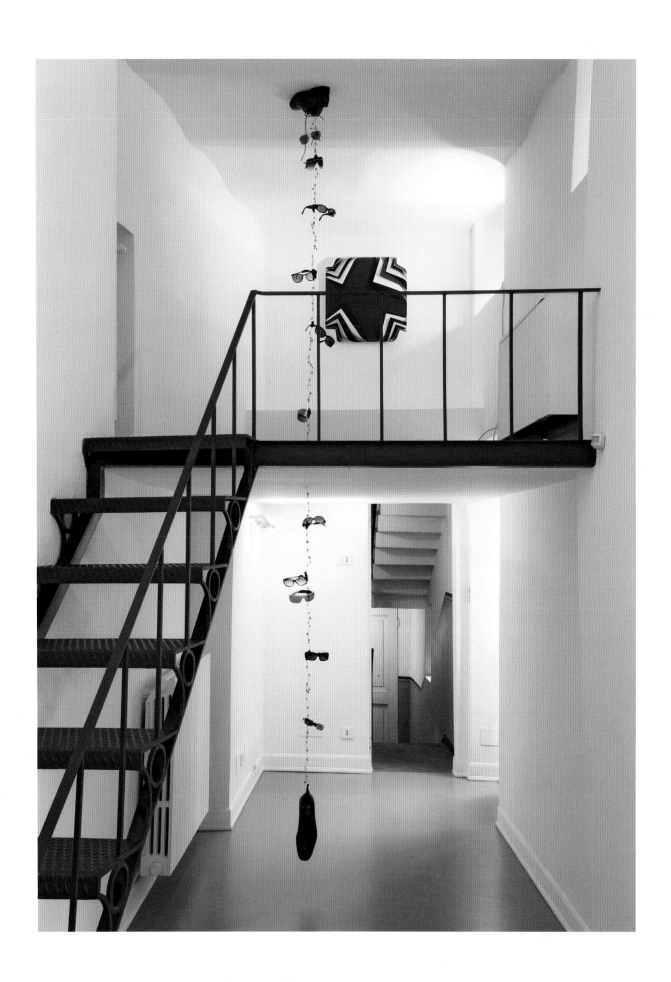

previous: Installation view *Shaved Ice*, The Modern Institute, 3 Aird's Lane, Glasgow, 2012

Installation view, *Everything Louder Than Everything Else*, Franco Noero, Turin, 2012

opposite: Medicine Man (detail), 2012. Metal, leather, plastic. 370 × 30 cm

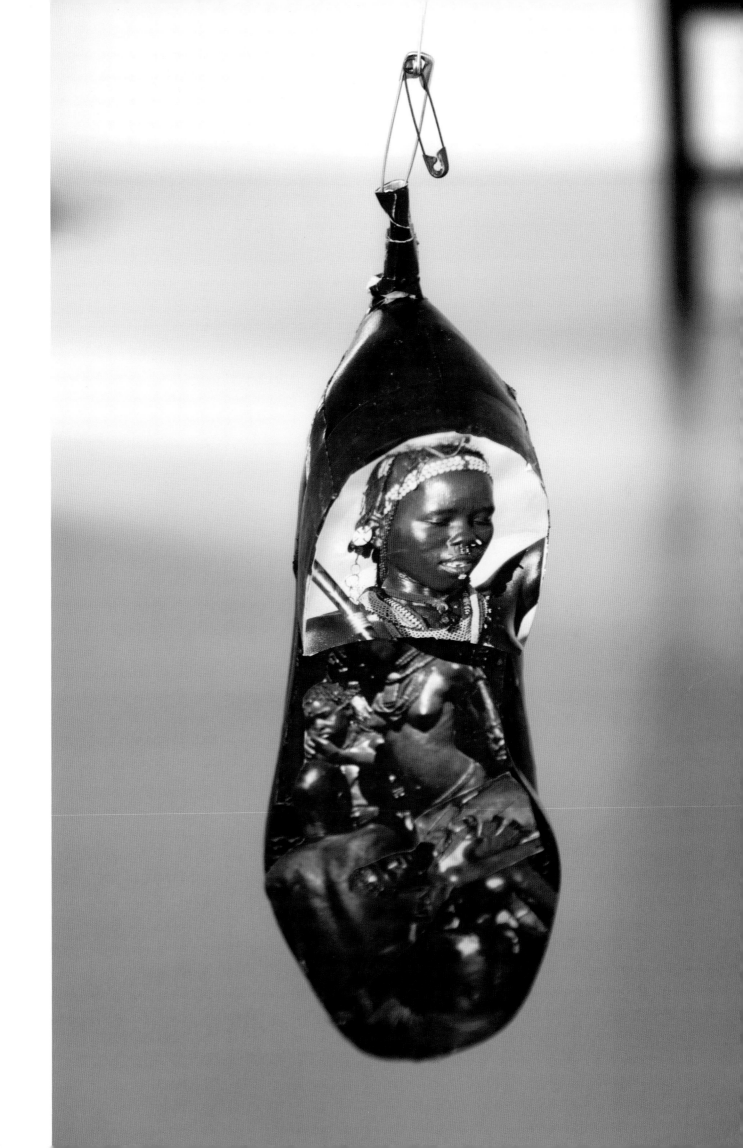

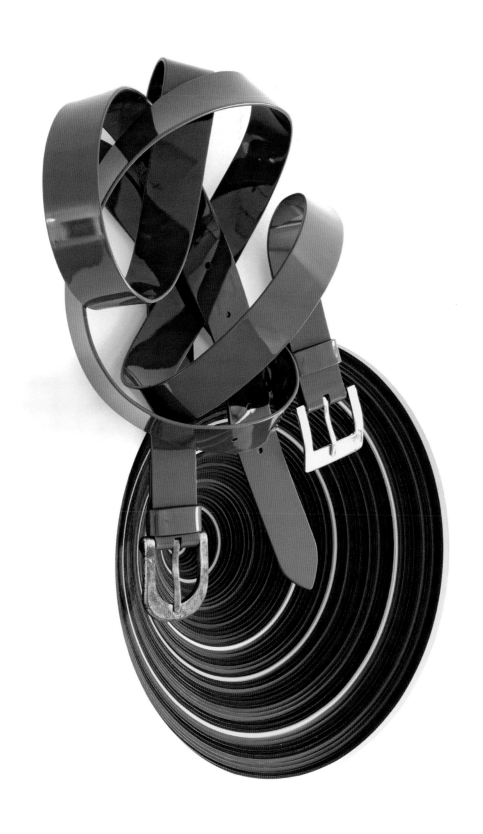

Vortex (Afrika Bambaataa), 2012. MDF, steel, paint. 110 × 100 × 30 cm

opposite: Pump Up The Jams (Ursa Major Remix), 2012. Glass, cotton, steel. 31 jars, dimensions variable

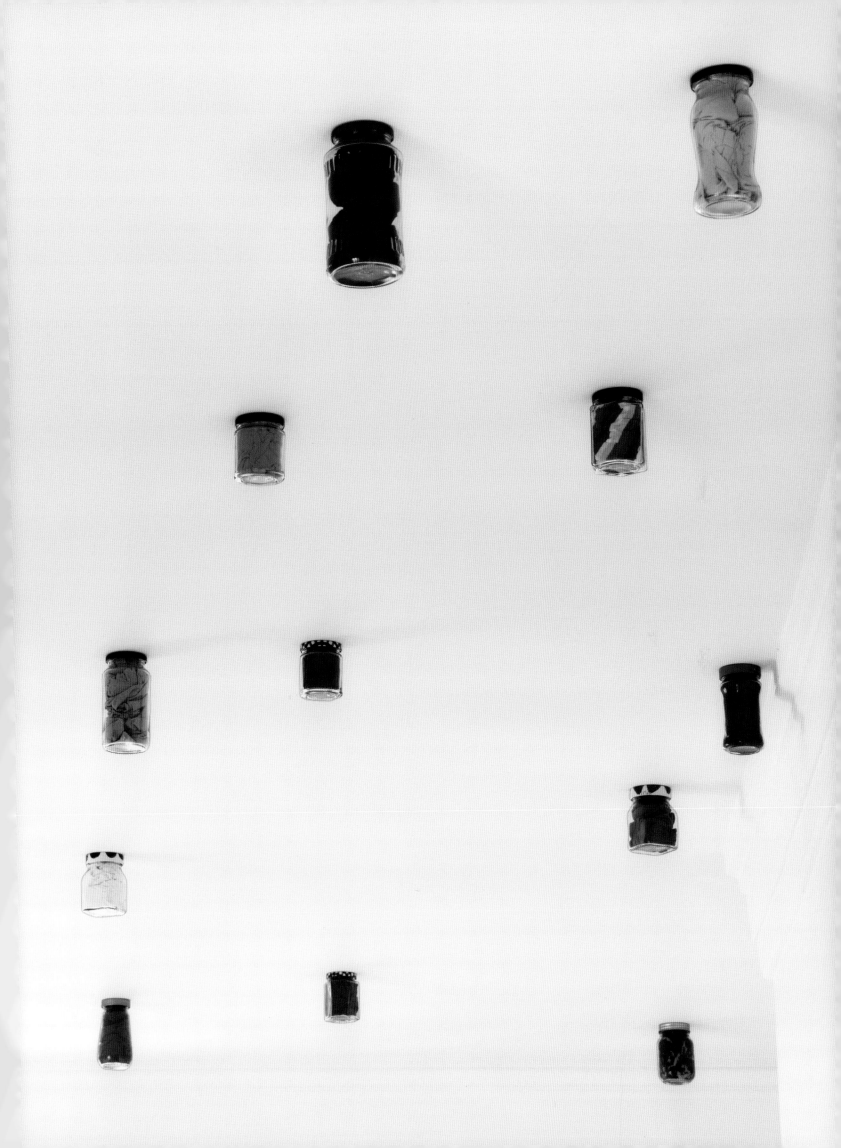

Pin Number 3379, 2016. Safety pins, acrylic paint on canvas. 190 × 160 × 5 cm

opposite: Pin Number 1858 (detail), 2012. White acrylic paint on canvas, safety pins. 190 × 160 × 5.5 cm

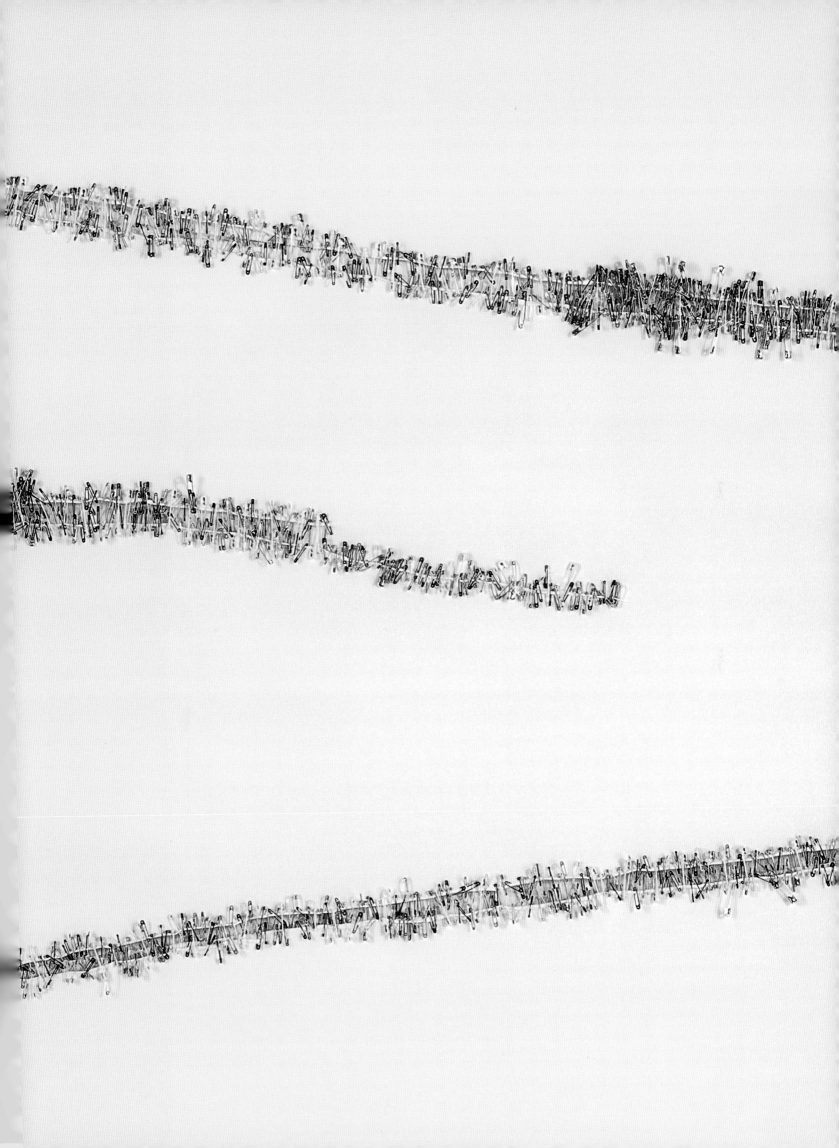

Metal Box (Dream Baby Dream), 2011. Aluminium sheets, gloss paint and fluorescent paint. 62.5 × 62.5 × 16 cm

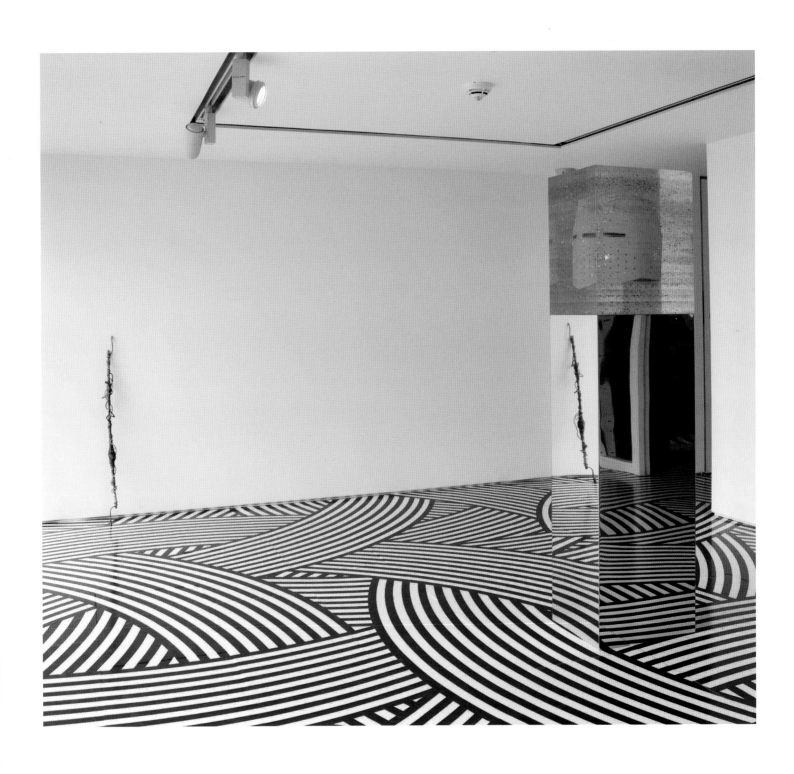

Knightclubber (Rave On), 2011. Painted armor helmet in resin block with glitter, polished steel plinth. 169.5 × 42.5 × 36 cm

Installation view *Beach Boy*, Pier Arts Centre, Orkney, 2011

Digitized, 2011. Glass, metal and cotton. 317.5 × 139.7 × 17.8 cm

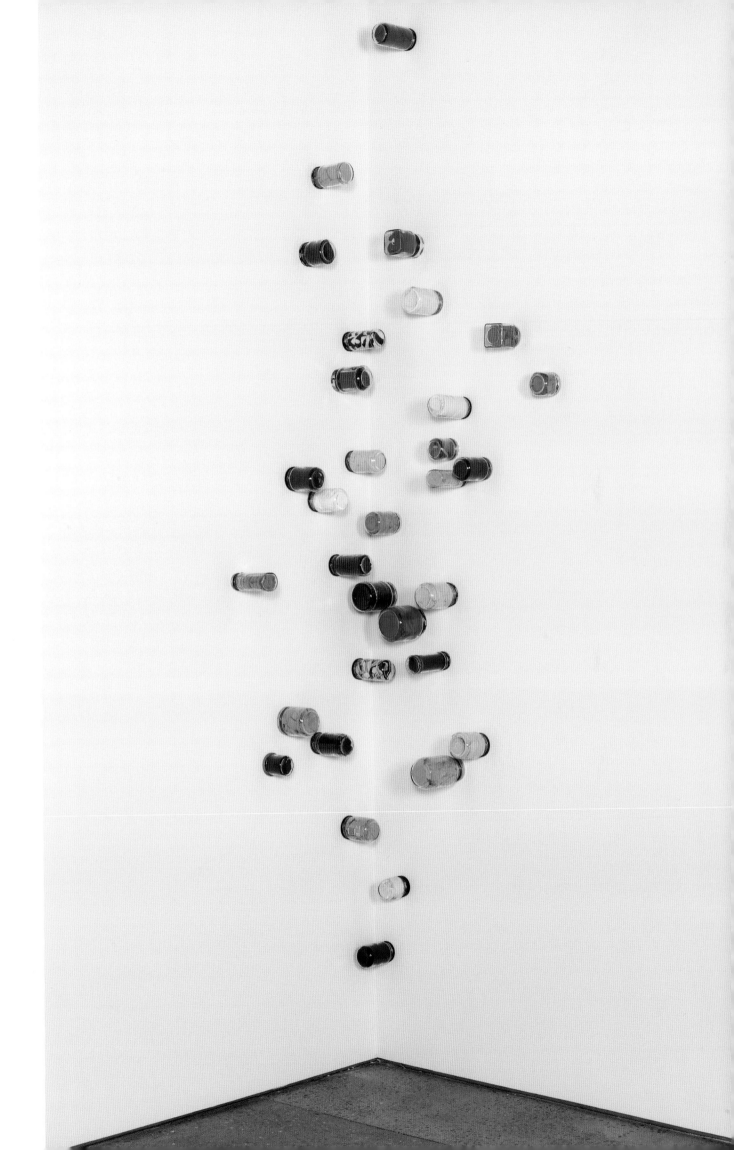

Zip Code (n°1), 2011. Zippers and gesso on canvas. 243.8 × 182.9 cm

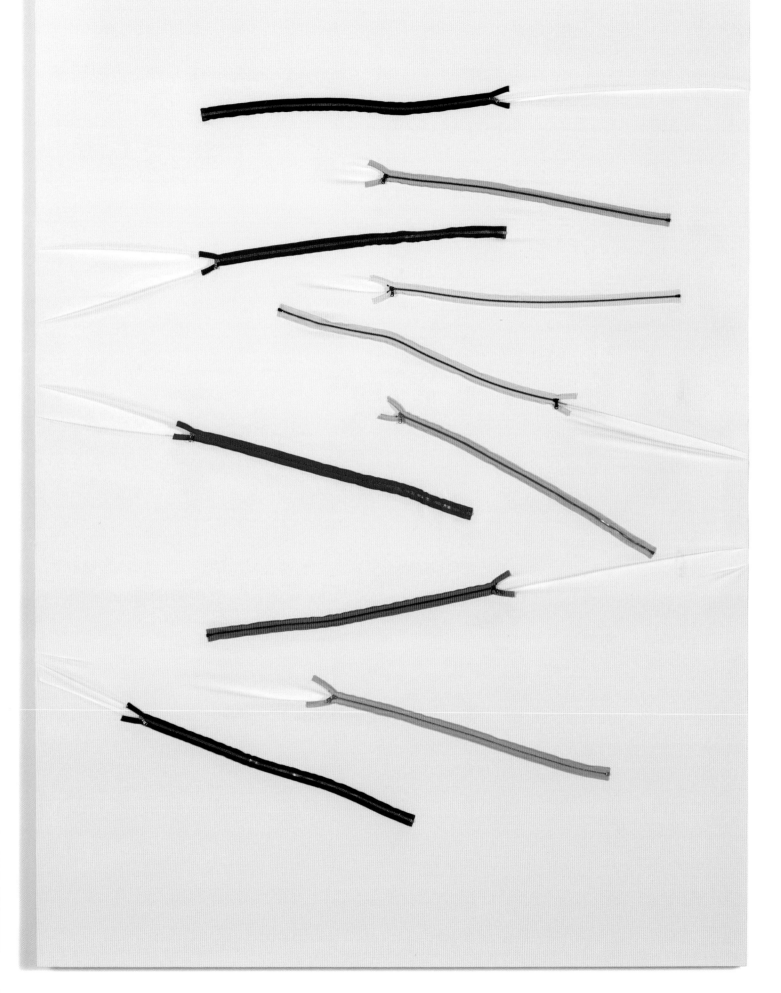

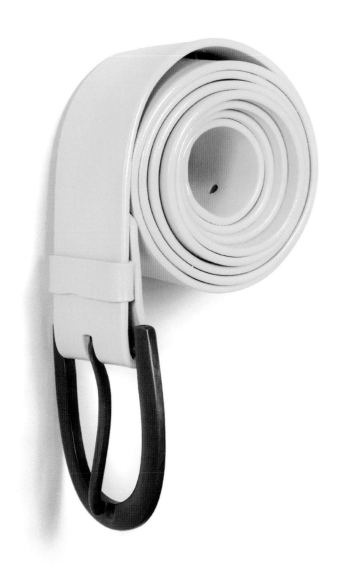

Belt Buckle (Voodoo Ray), 2011. Steel and spray paint. 33 × 19.1 × 13.7 cm

Installation view *Spiritualized*, Anton Kern Gallery, New York, 2011

Metal Box (Bird Orchid (Autumn)), 2012. Polished steel sheets and gloss paint. 187.5 × 187.5 × 32 cm

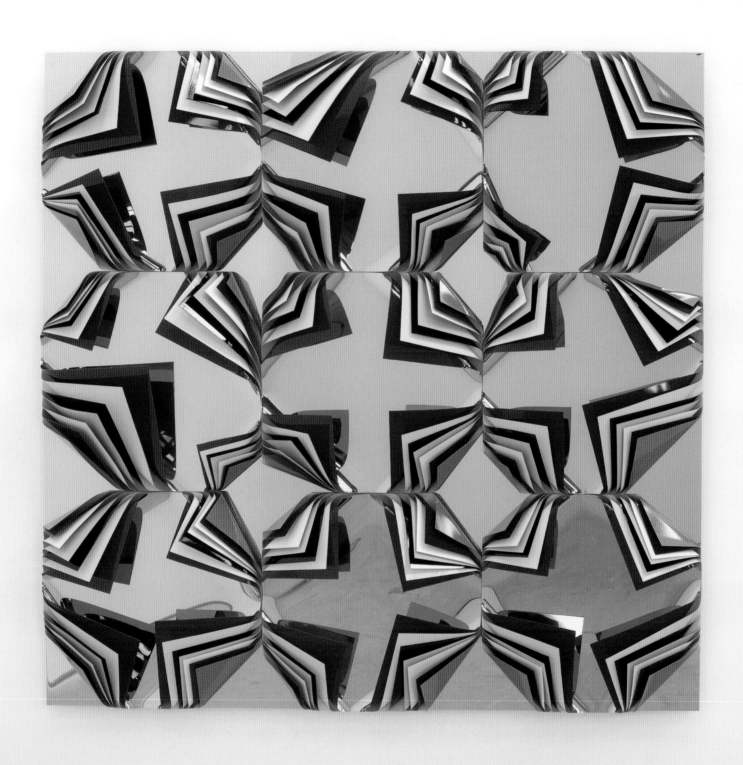

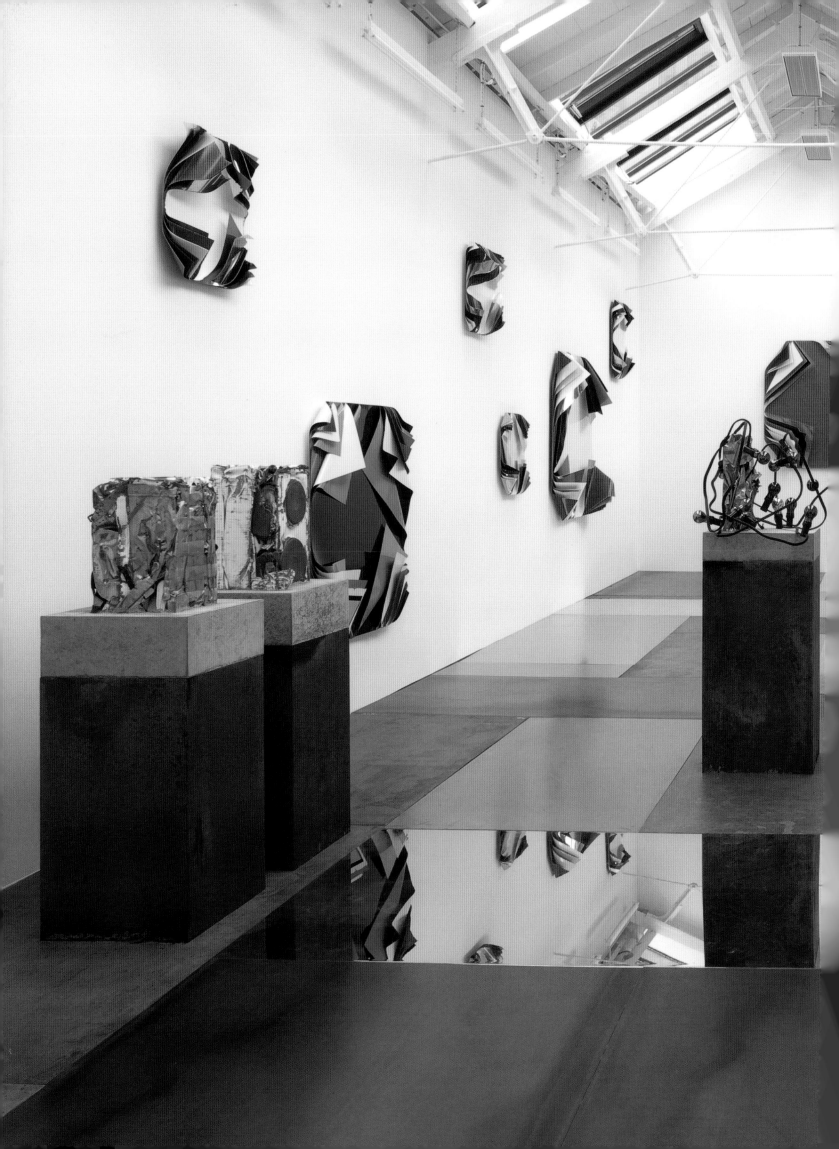

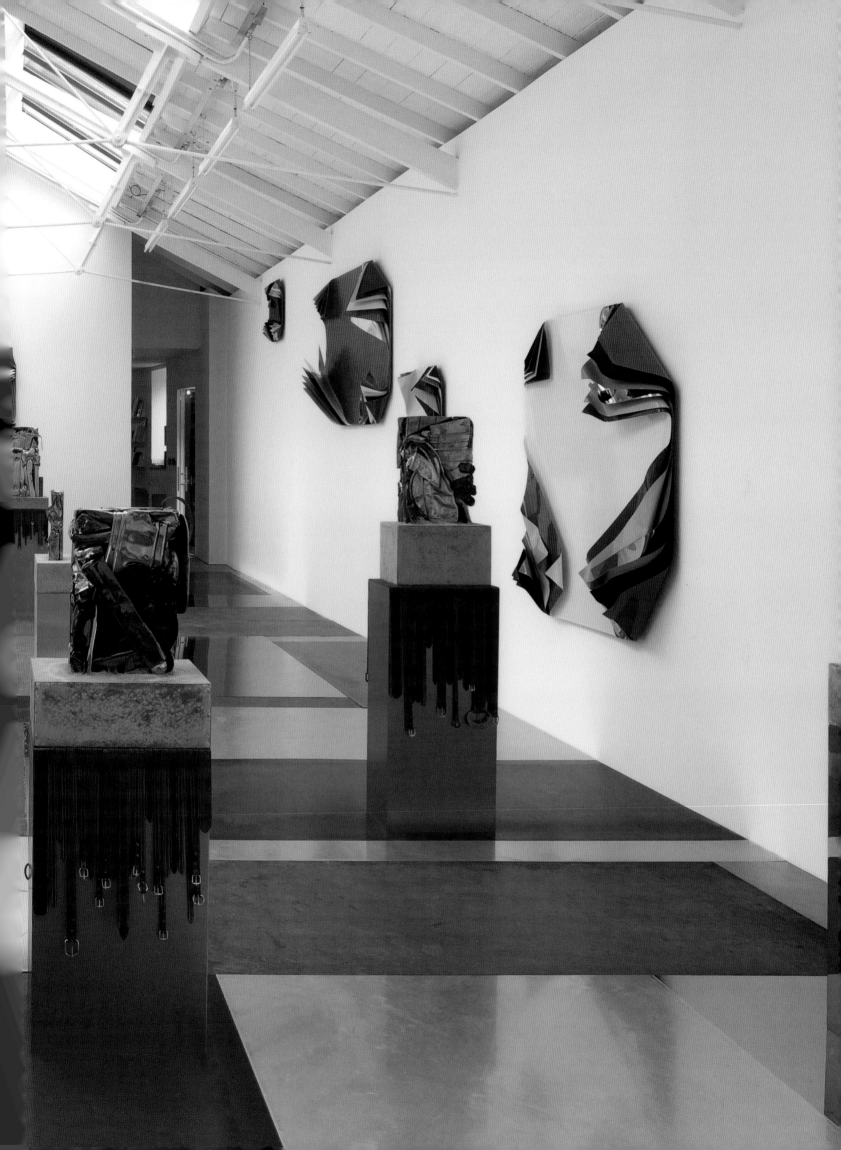

previous: Installation view *Metal Urbain*, The Modern Institute, Osborne Street, Glasgow, 2010

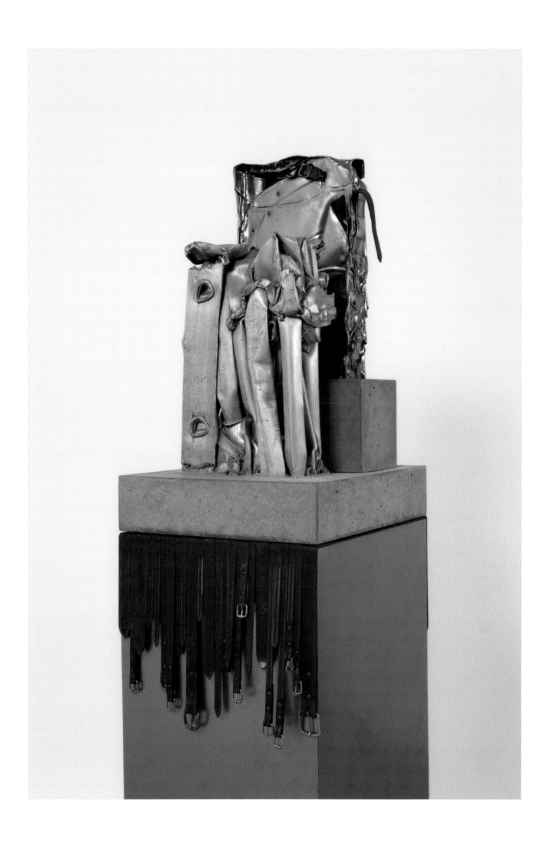

Into the Knight, 2010. Crushed suit of armor and crushed ladders set in concrete blocks, steel belts, steel plinth. 166 × 43 × 51 cm

opposite: Sunset (detail), 2010.
Crushed washing machine, stainless steel light bulbs, steel fabricated festoon lighting set in concrete block, steel plinth. 152 × 186 × 81 cm

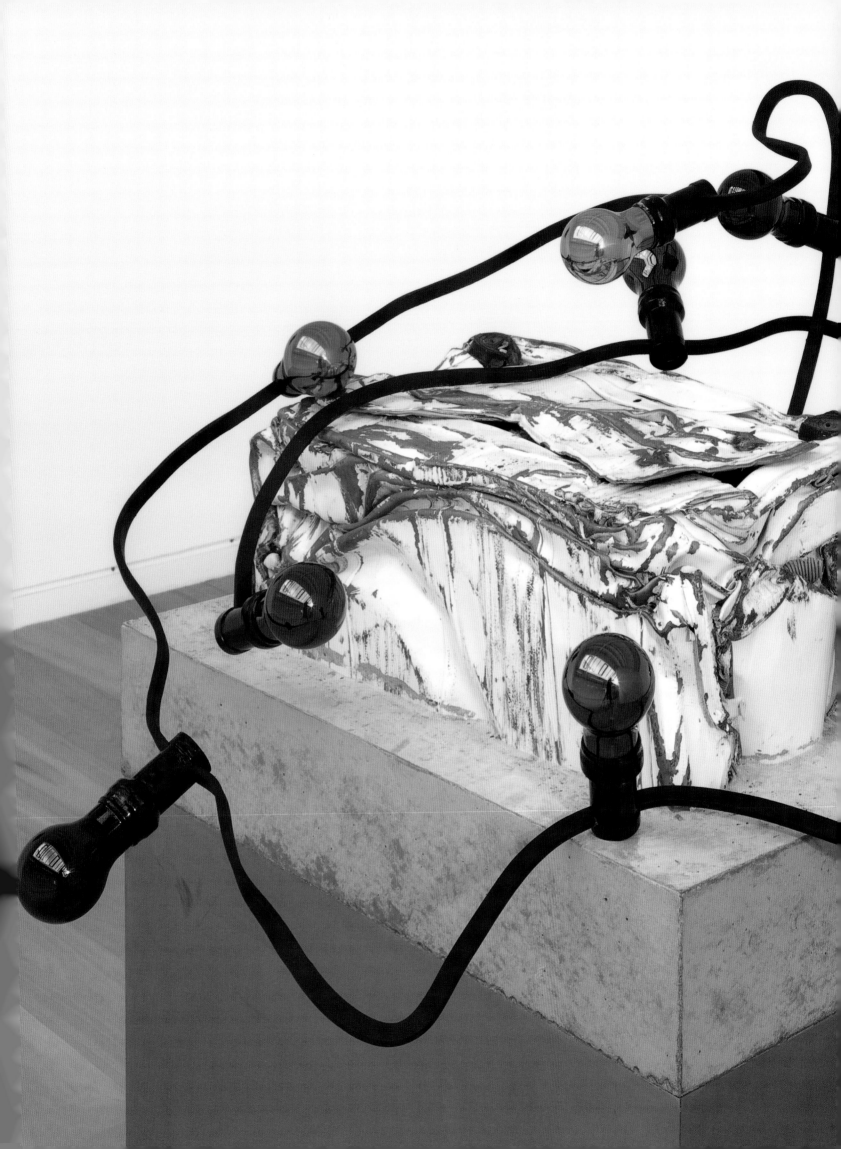

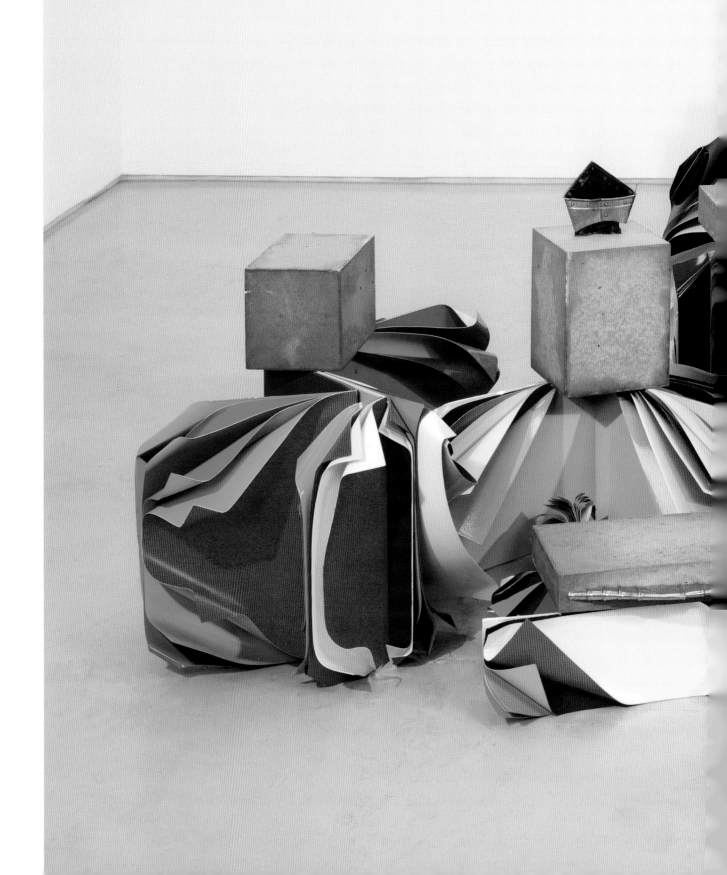

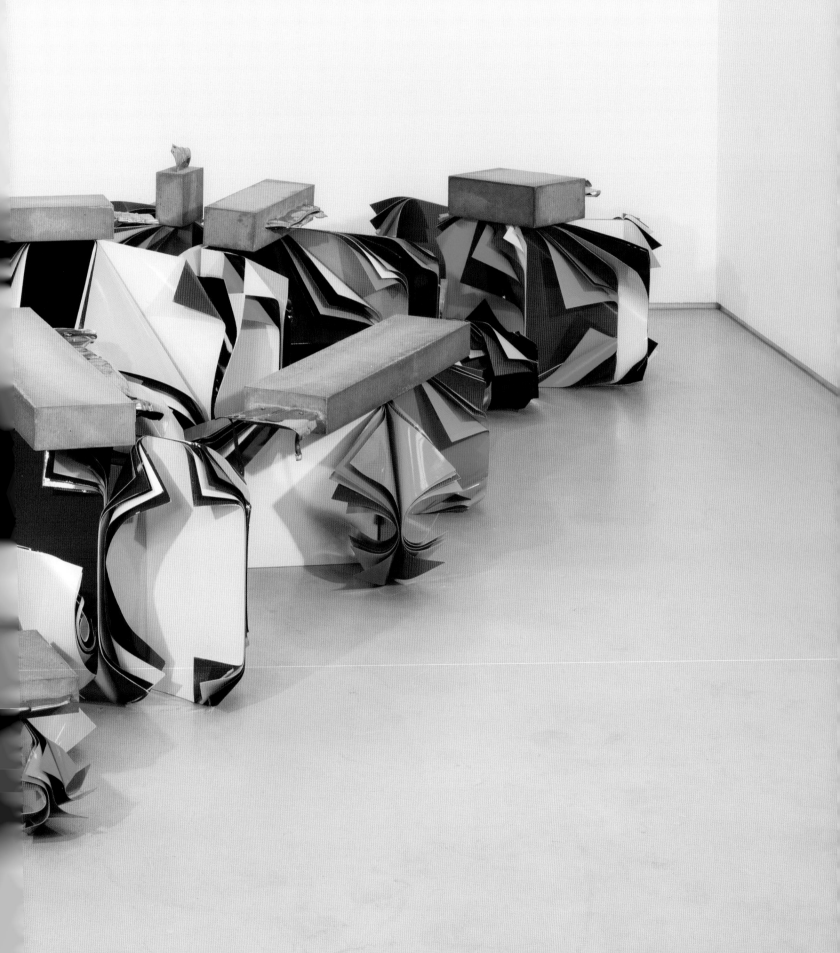

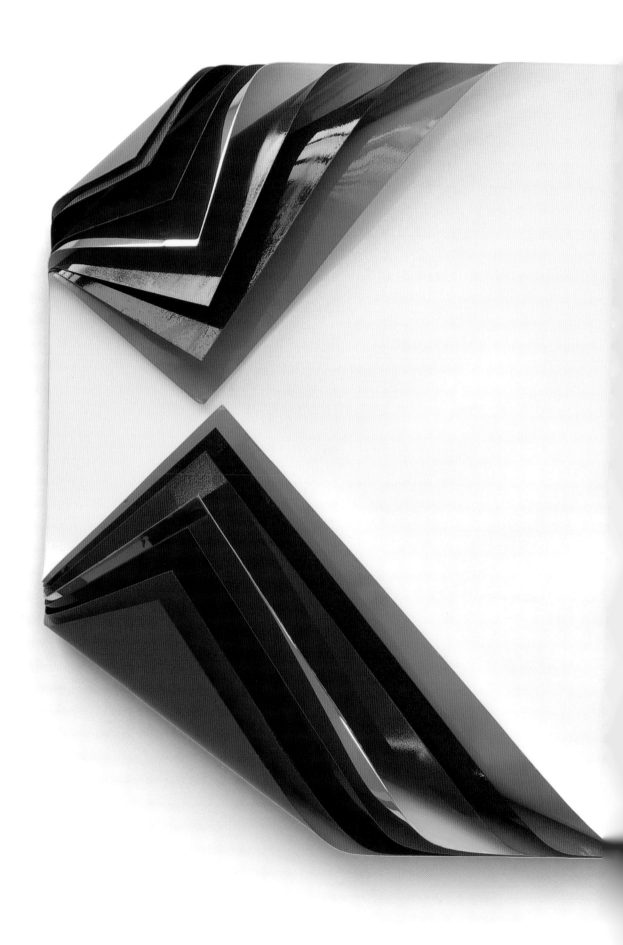

previous: Metal Urbain, 2010. Aluminium sheets, gloss paint, fluorescent paint, flattened suit of armor set in concrete blocks. 360 × 160 × 90 cm

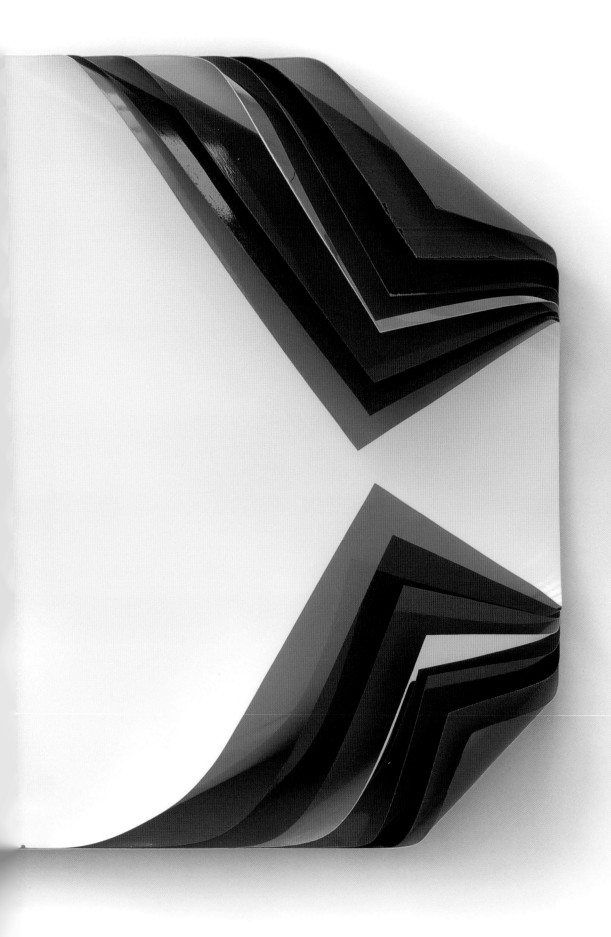

Metal Box, 2010. Aluminium and polished steel sheets, gloss paint and fluorescent paint. 125 × 187.5 × 27 cm

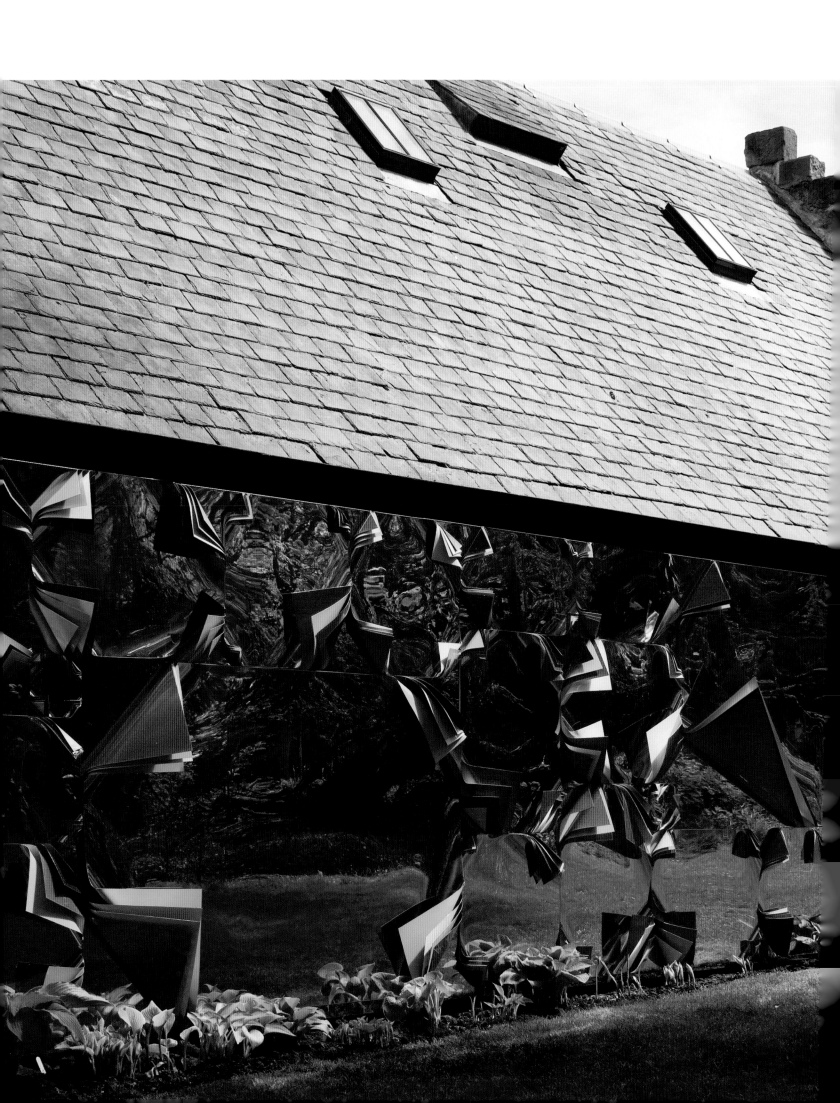

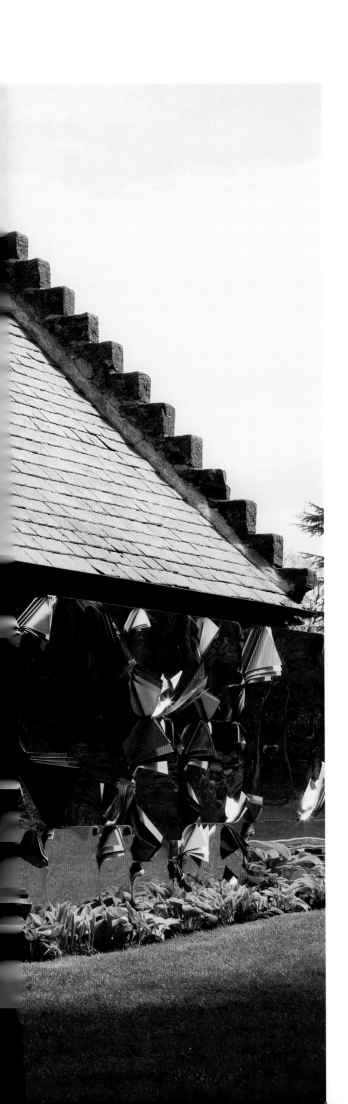

A Forest, 2010.
Polished steel sheets, gloss paint, and fluorescent paint. Dimensions variable

Metal Box (I Wish), 2009. Aluminium sheets and gloss paint. 83.3 × 62.5 × 18 cm

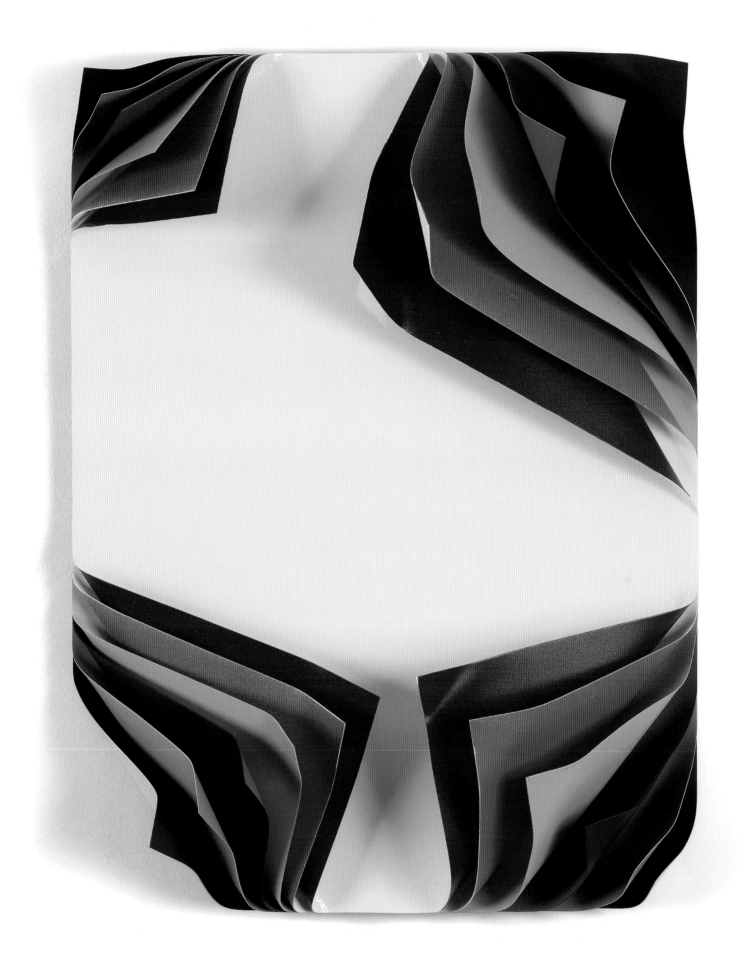

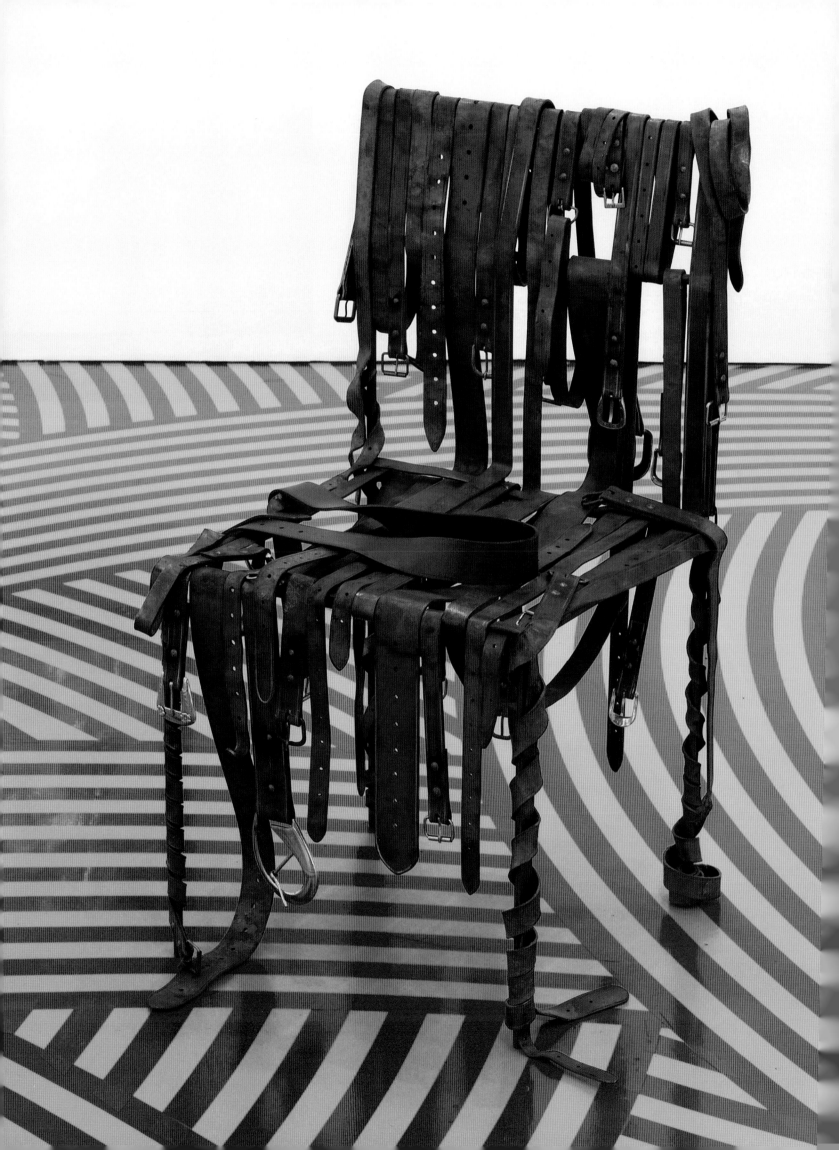

Seat Belt (Ned Kelly) 2009. Mild steel, acrylic paint. 83 × 54 × 58 cm

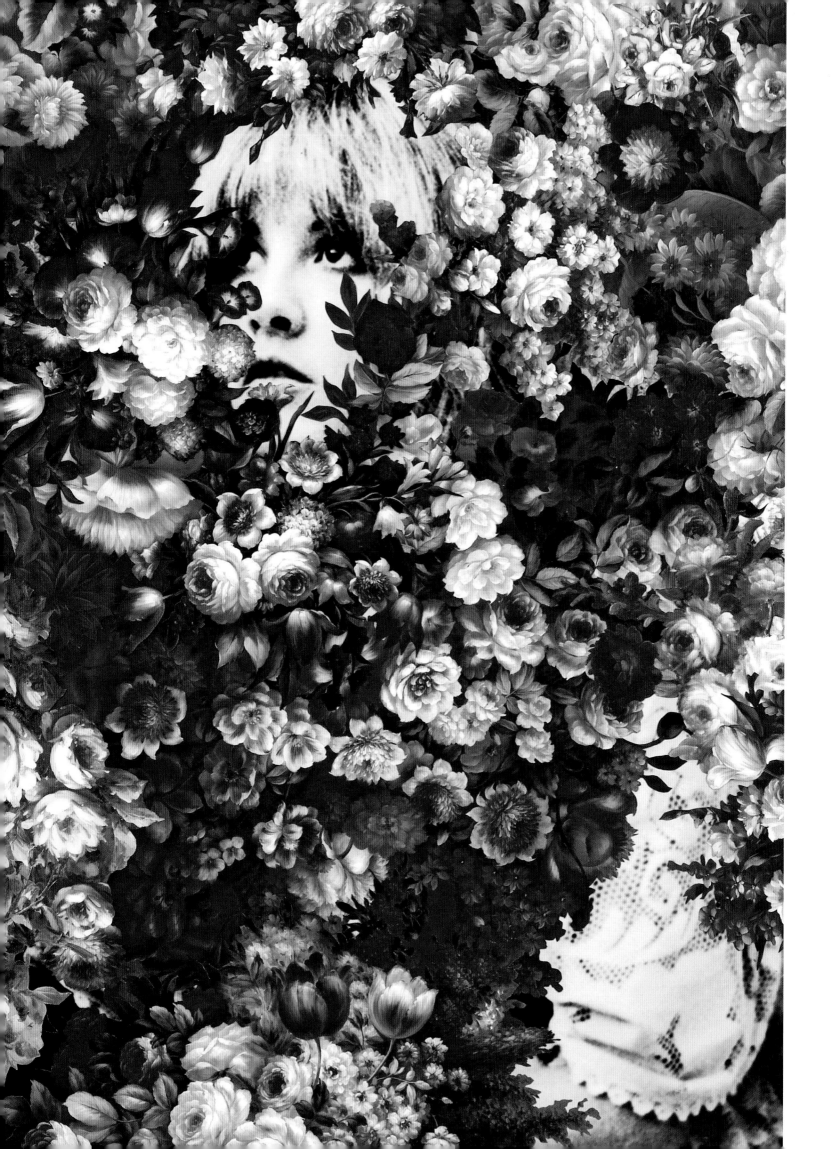

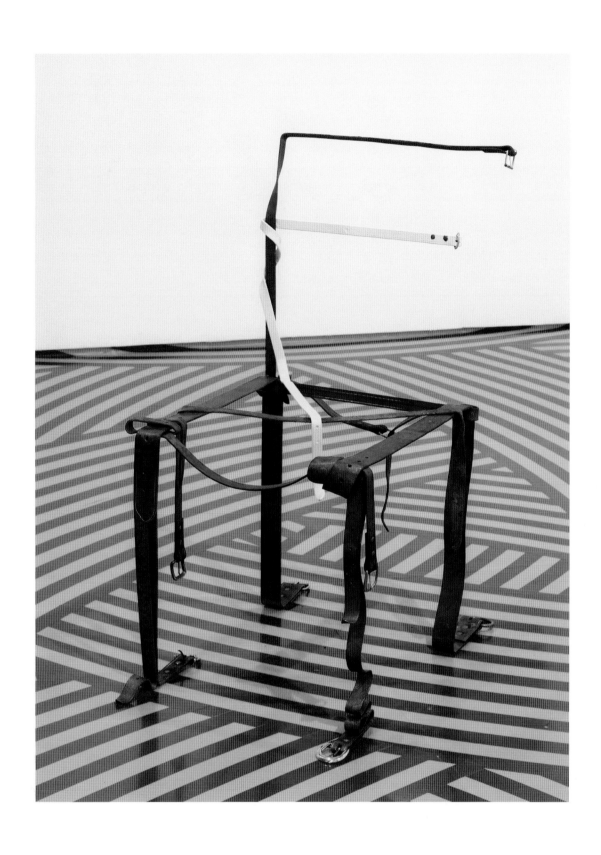

Seat Belt (Spellbound), 2009. Mild steel, acrylic paint. 83 × 42 × 63 cm

opposite: Gypsy (Stevie Nicks), 2009. Collage with oil painting and printed paper. 152.5 × 108 × 3.5 cm

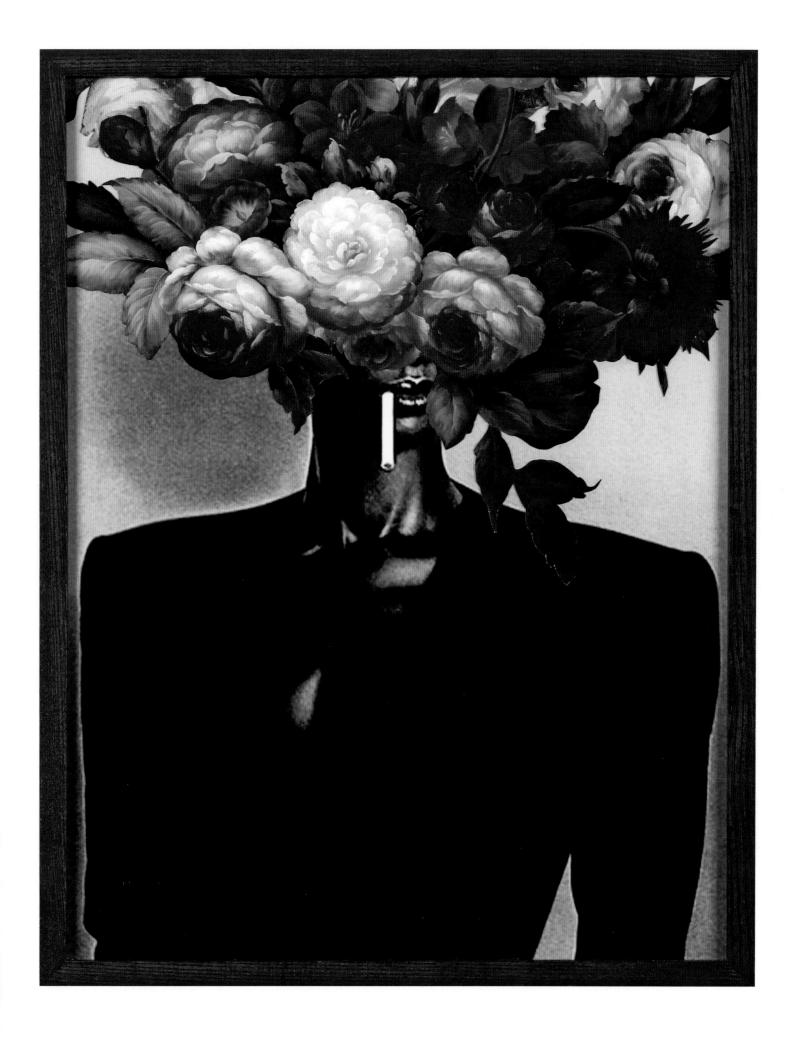

West End Girls, 2010. Glitter record deck. 10 × 40 × 30 cm

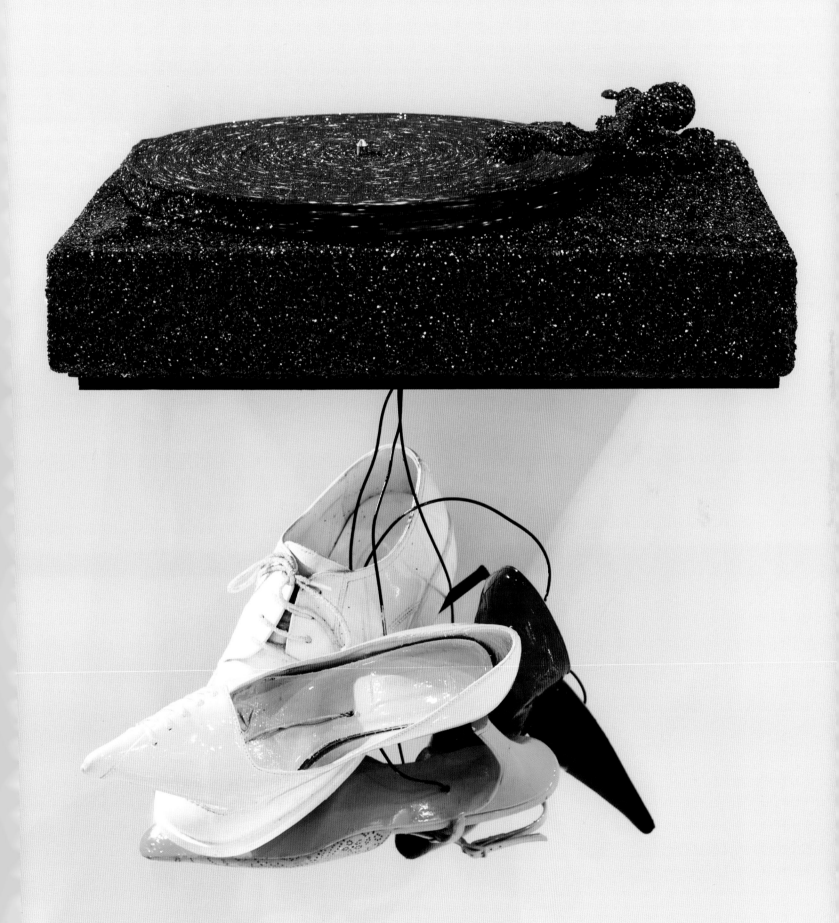

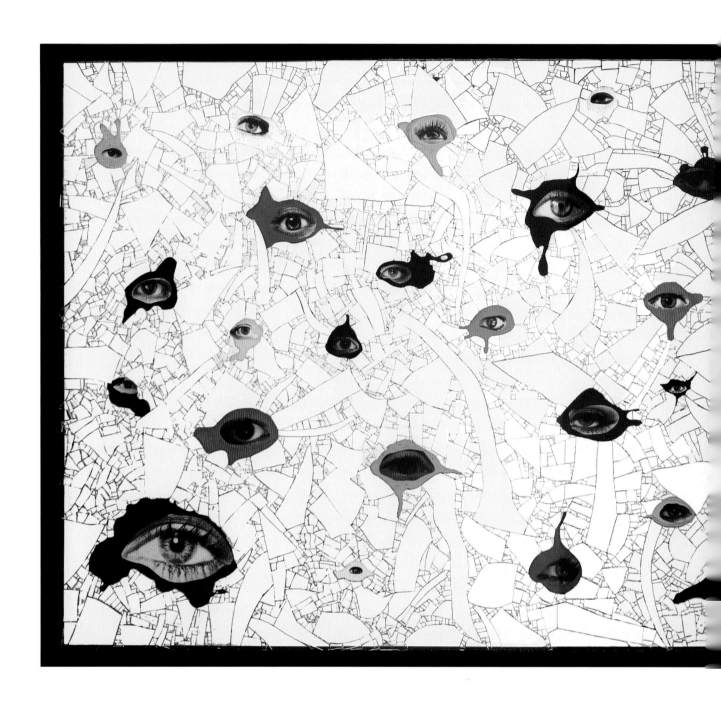

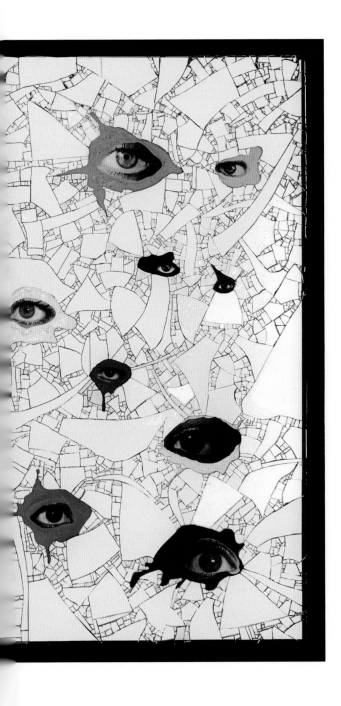

The Citadel, 2010. Mirror, enamel paint photographic print collage. 121 × 213 cm

Hot Corner, 2009. Chairs, paint, mirrored handbags. 102 × 141 × 70 cm

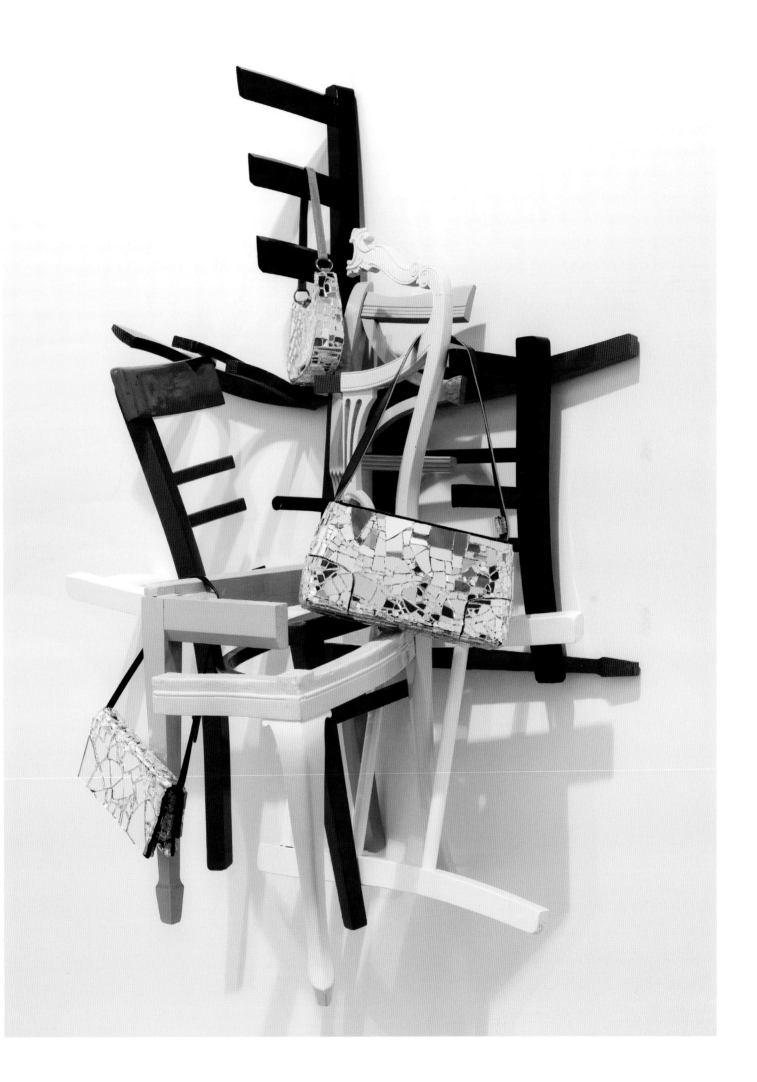

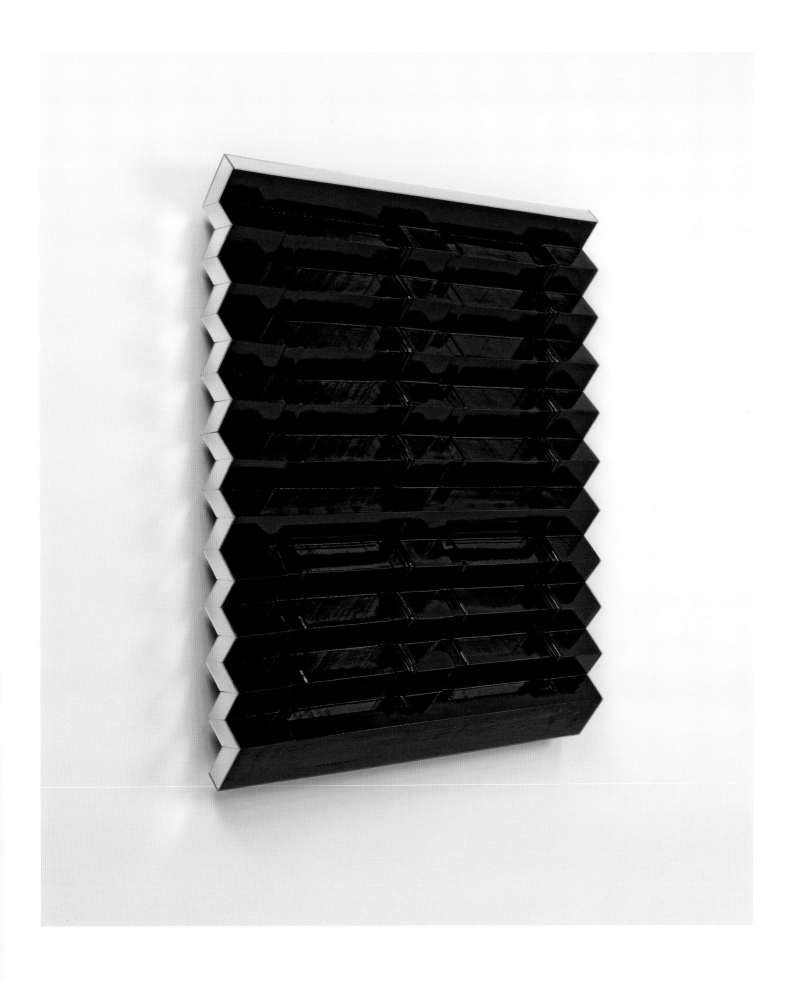

Radiator (Black), 2009. Doors, mirror, gloss paint. 97 × 77 × 10 cm

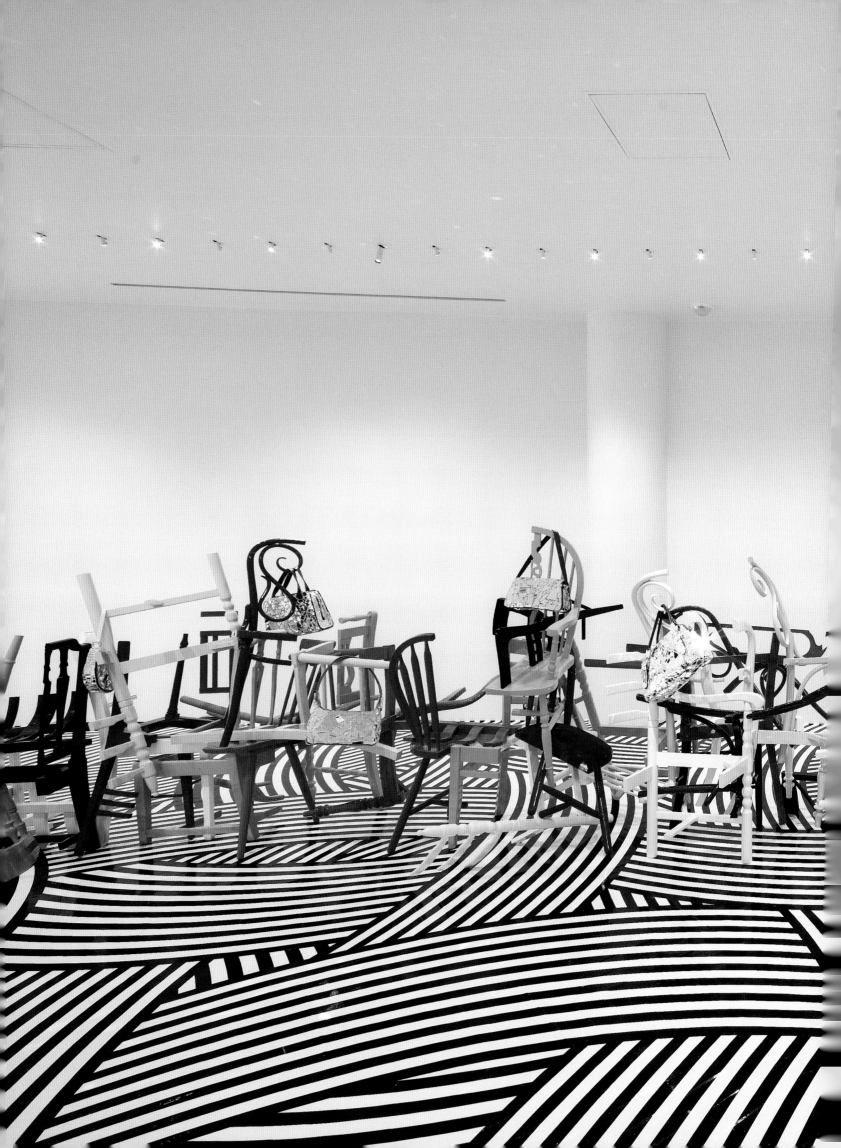

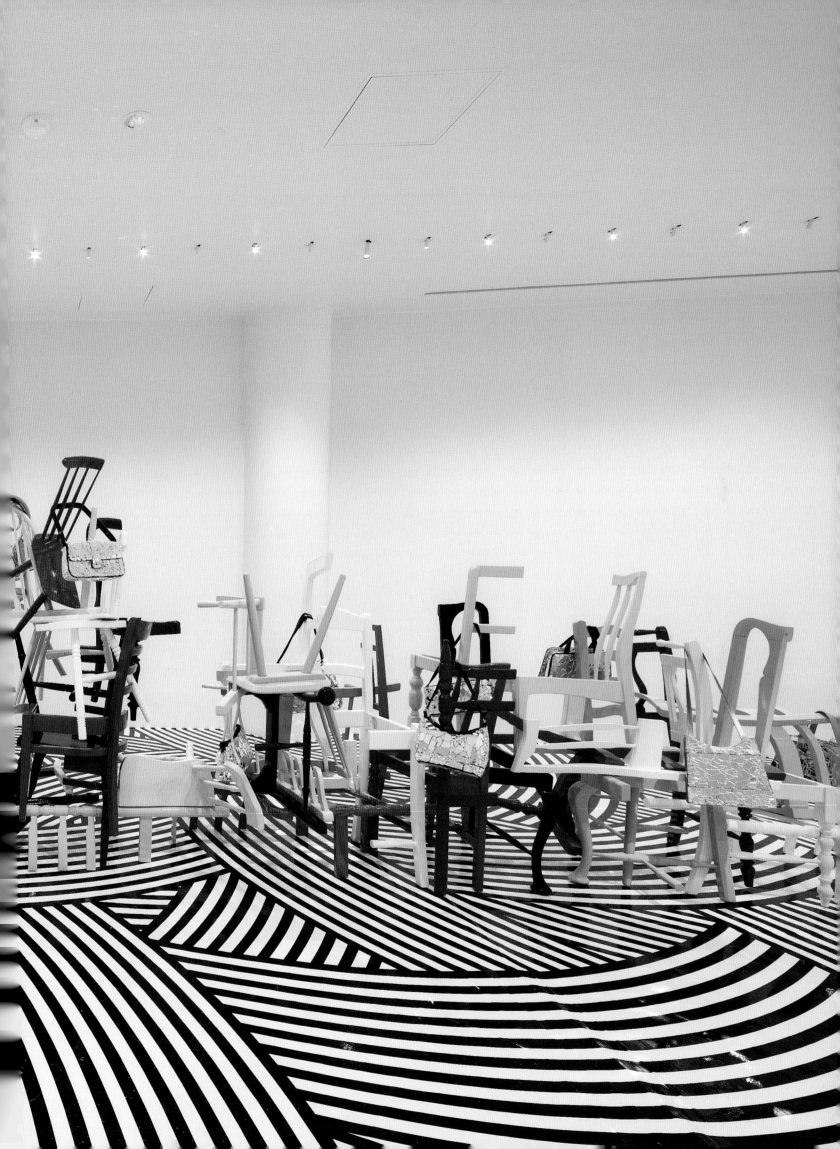

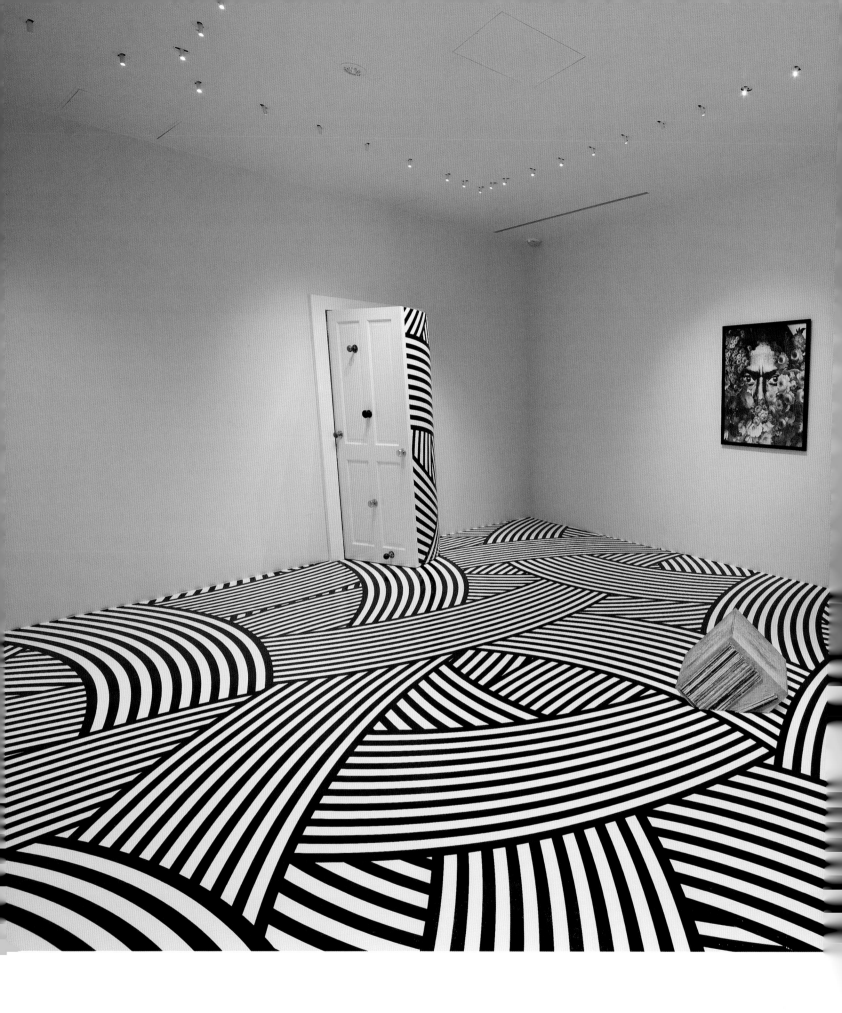

previous: Train in Vain, 2008. Wooden chairs, handbags, mirrors, gloss paint. Dimensions variable

Installation view *Unknown Pleasures*, Hara Museum of Contemporary Art, Tokyo, 2008

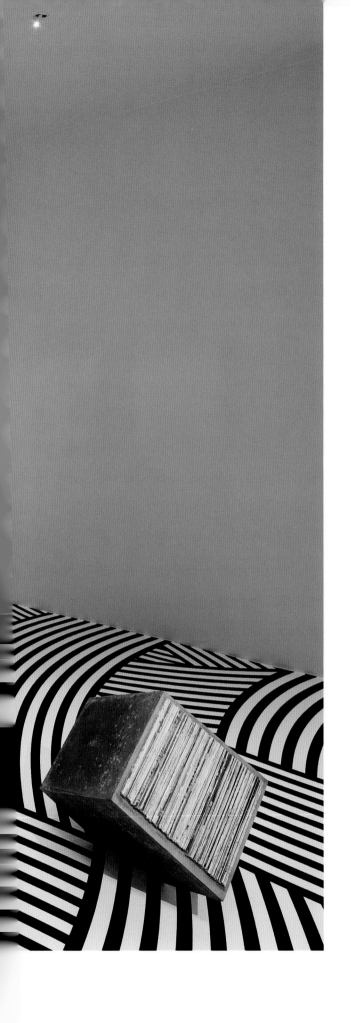

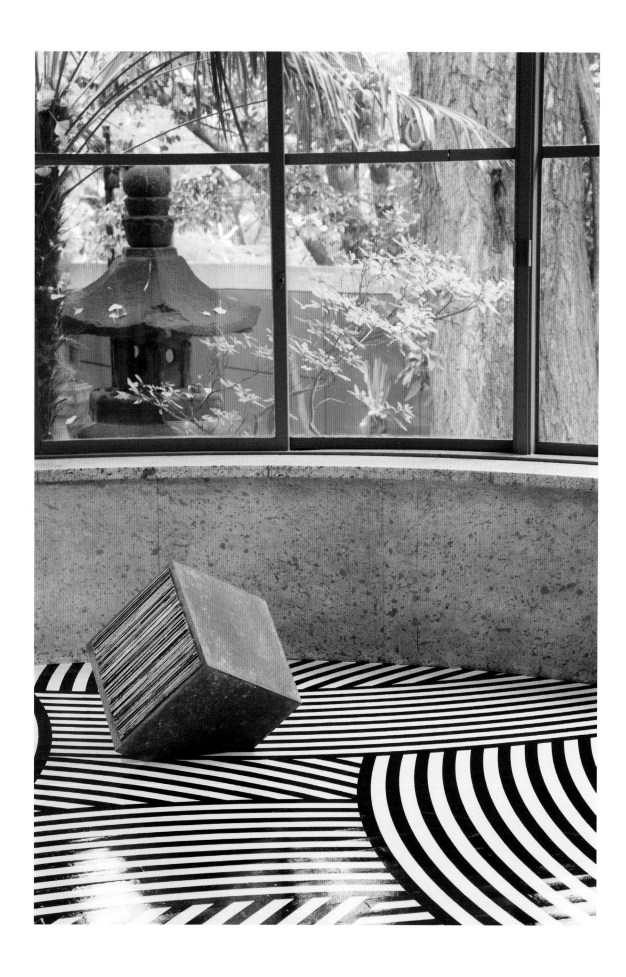

Installation view *Unknown Pleasures*, Hara Museum of Contemporary Art, Tokyo, 2008

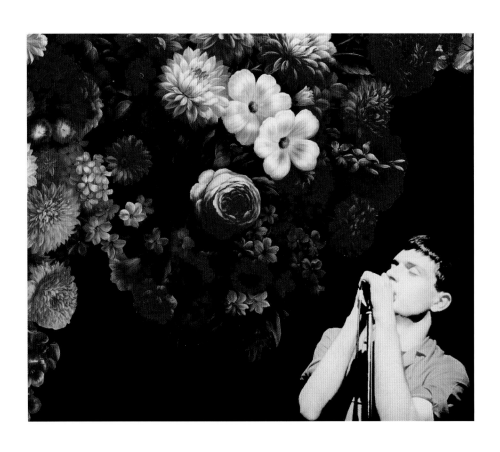

Found Flower Painting (Ian Curtis), 2008. Collage with oil painting and printed paper. 91 × 77 cm

opposite: Maybelline, 2008. Wooden door, gloss paint, door knobs. 210 × 95 × 30 cm

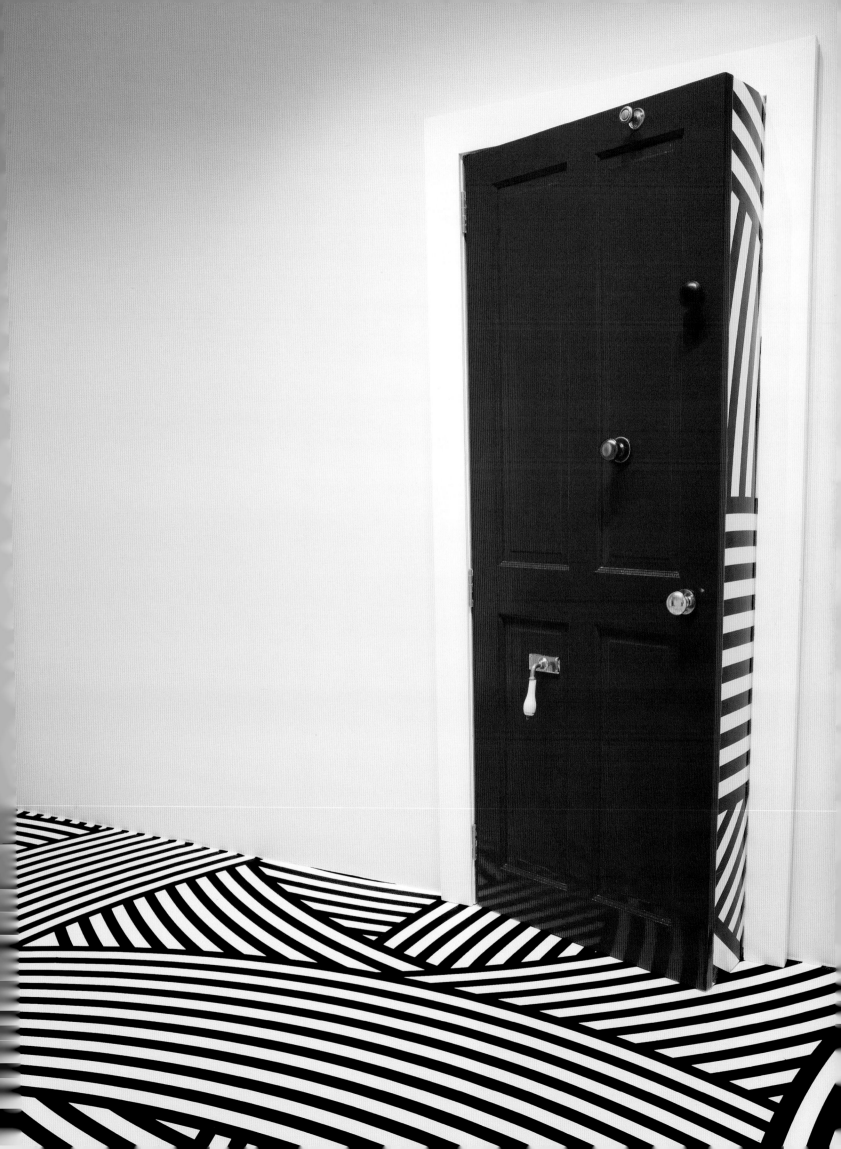

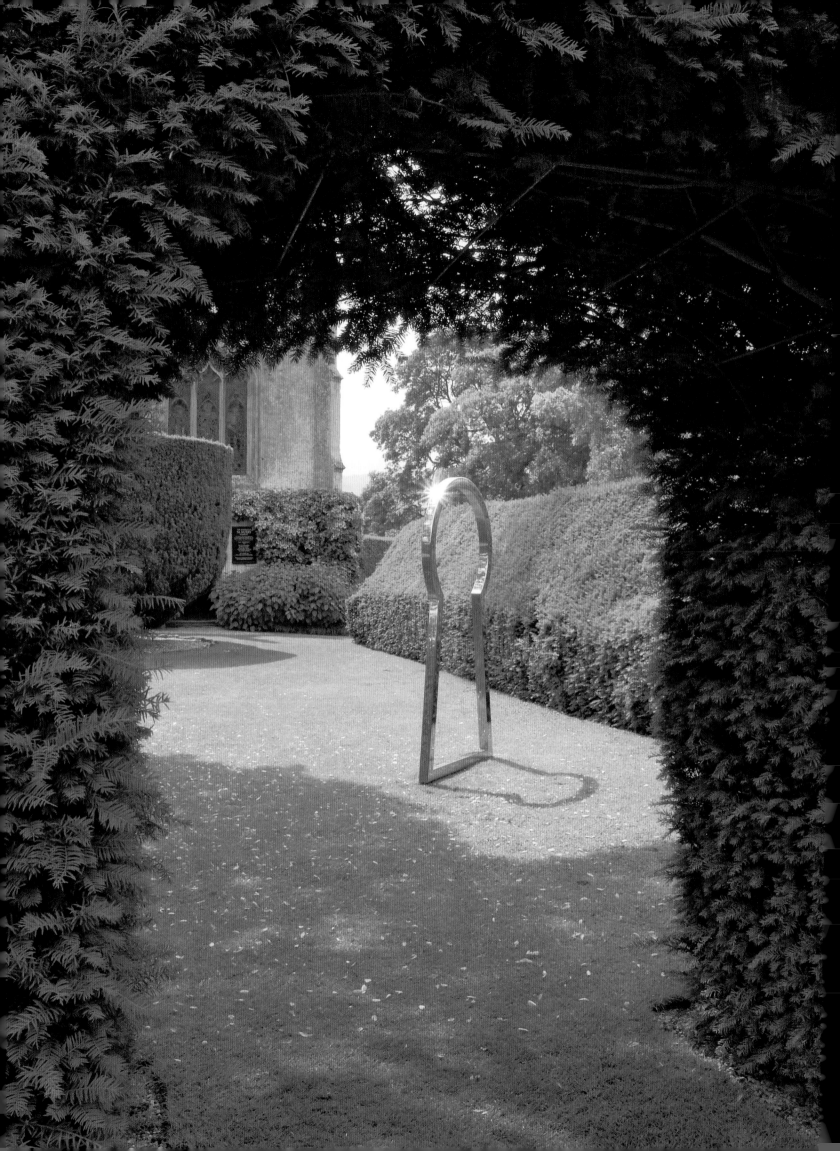

Secret Affair (Silver), 2007. Stainless steel. 215 × 113.4 × 8 cm

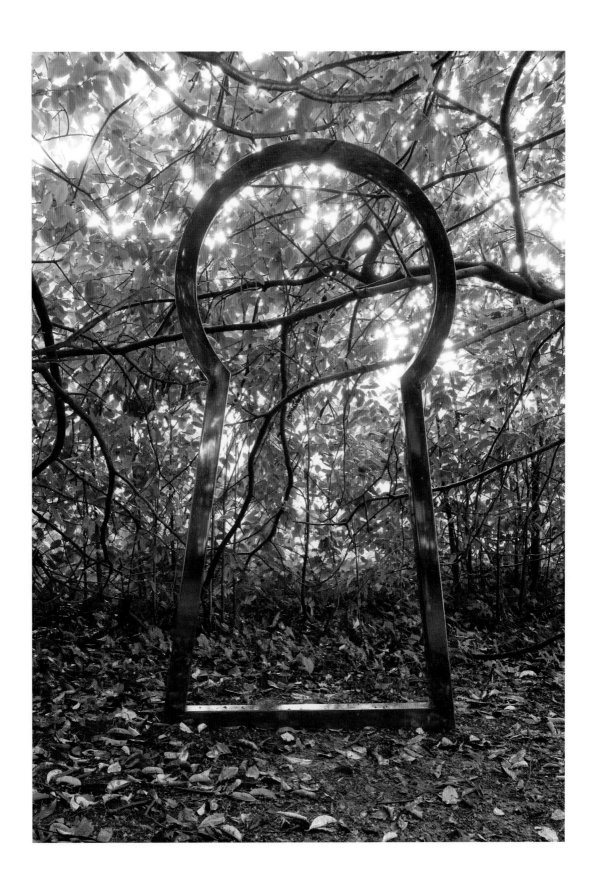

Secret Affair (Blue), 2007. Stainless steel. 215 × 113.4 × 8 cm

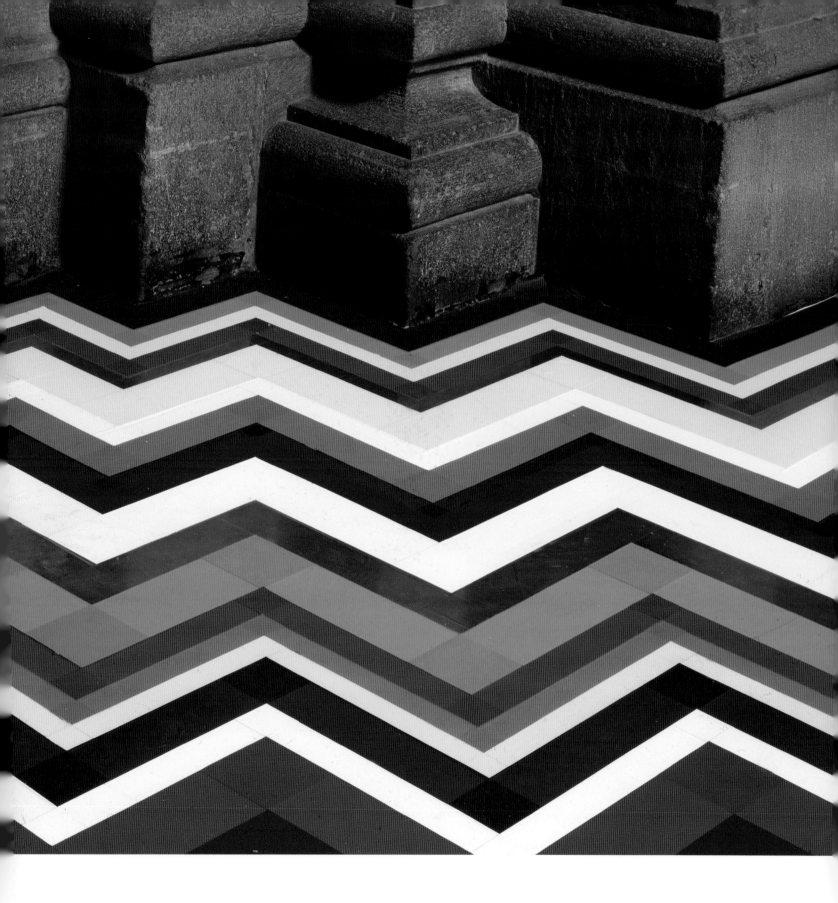

137 Zobop (Fluorescent), 2006. Vinyl tape. Dimensions variable

Zobop (Fluorescent), 2006. Vinyl tape. Dimensions variable

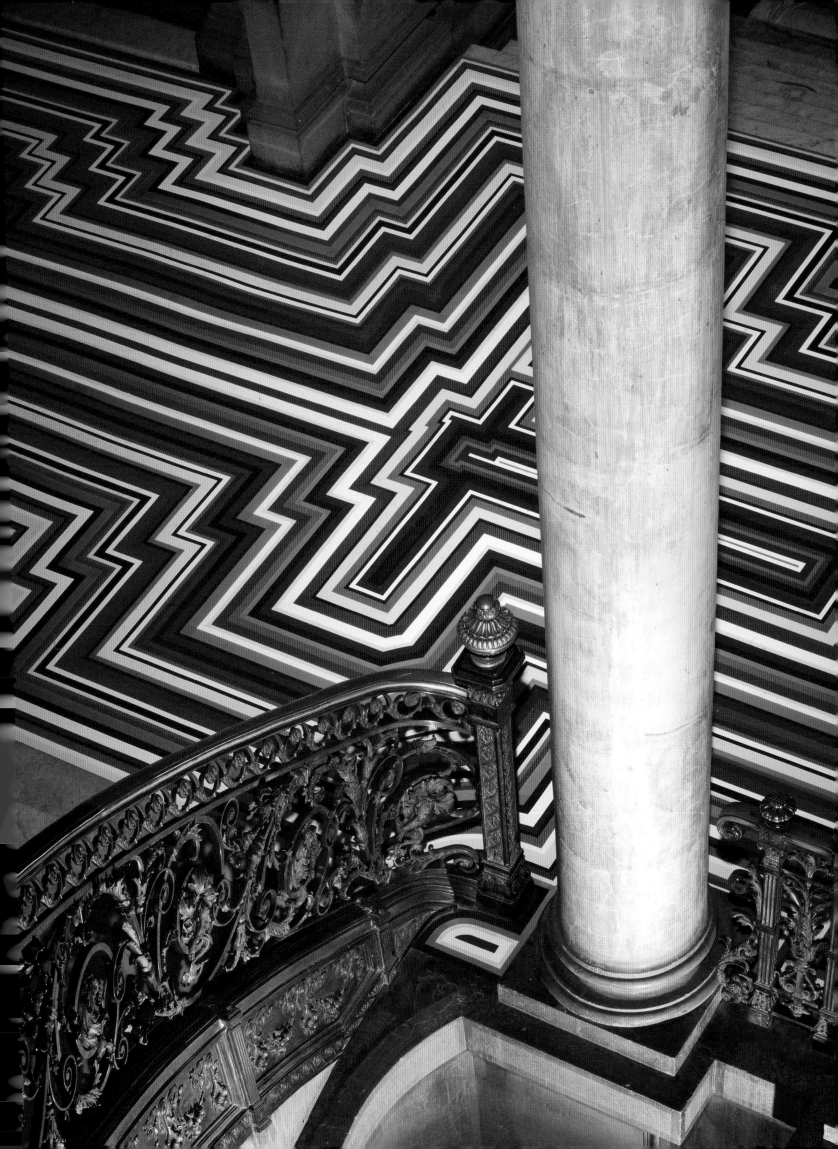

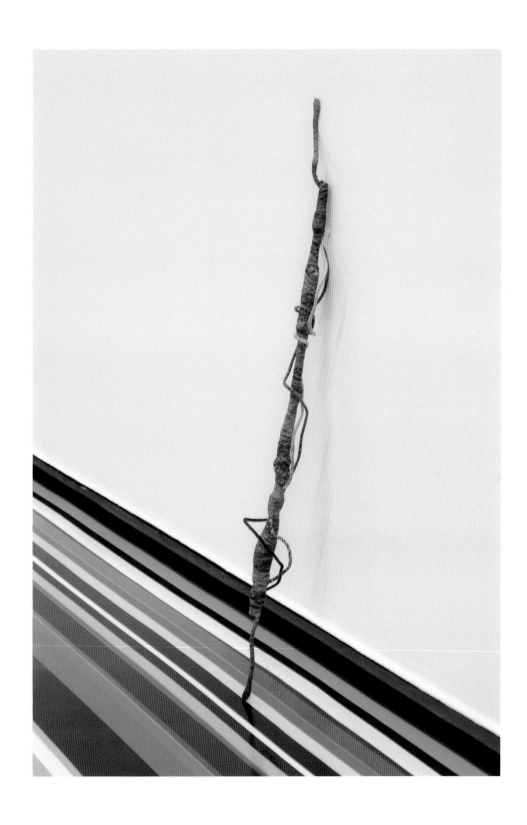

Psychedelic Soul Stick 69, 2008. T-shirt sleeve, bead necklace, safety pins, Marlboro Light packet, bamboo, colored thread. 10 × 110 × 10 cm

opposite: Untitled, 2008. Metal tubing, mirrors, vinyl. 450 × 200 × 30 cm

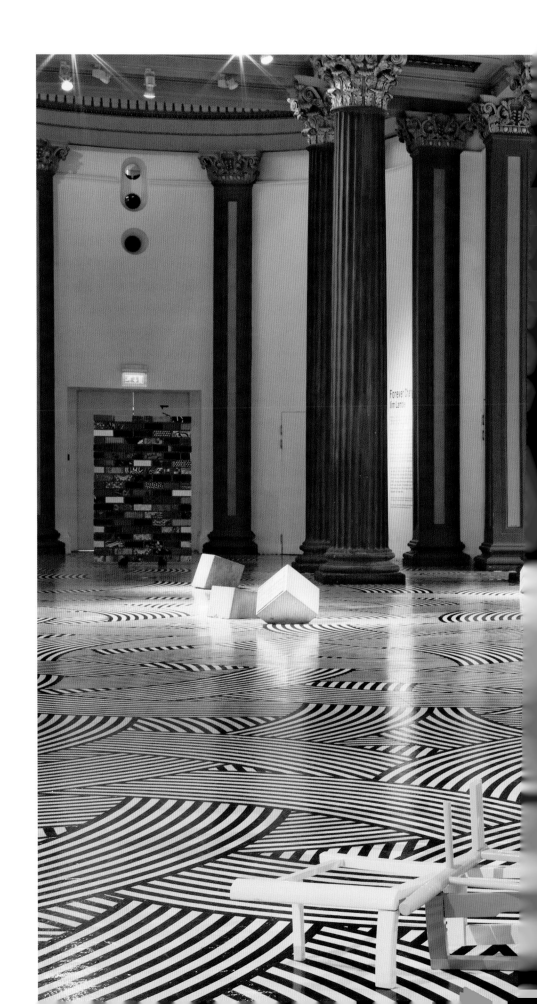

Seven and Seven Is or Sunshine
Bathed the Golden Glow, 2008.
Wooden chairs, handbags,
mirror, gloss paint.
216 × 350 × 270 cm

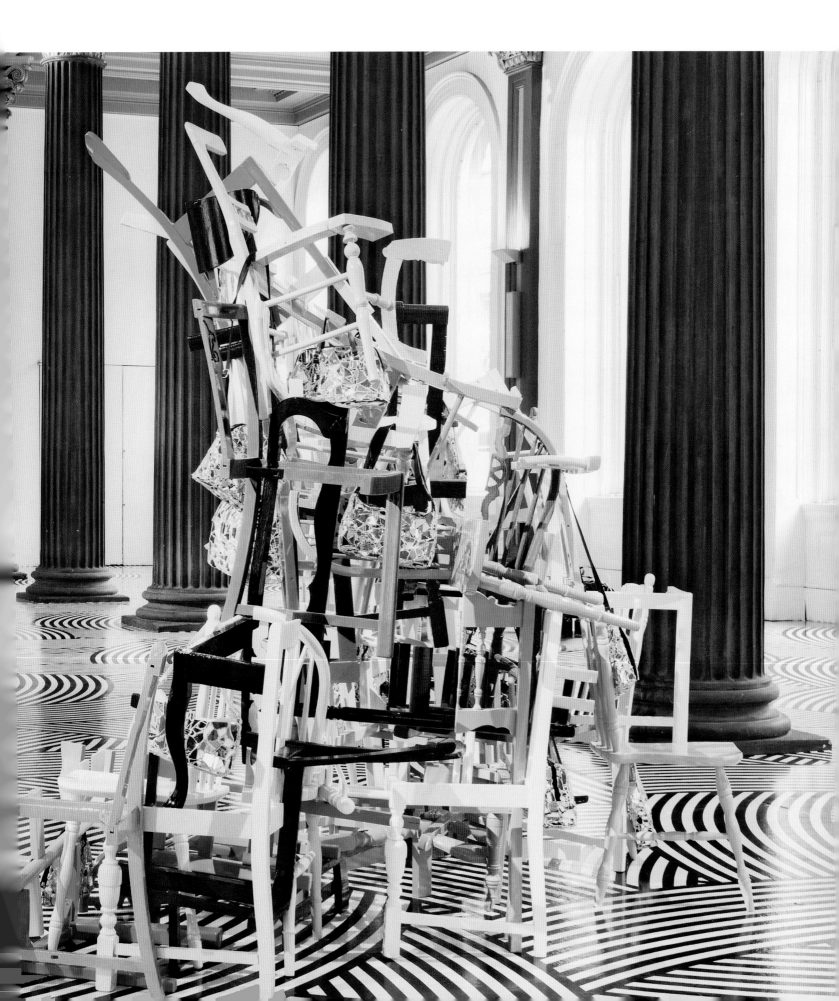

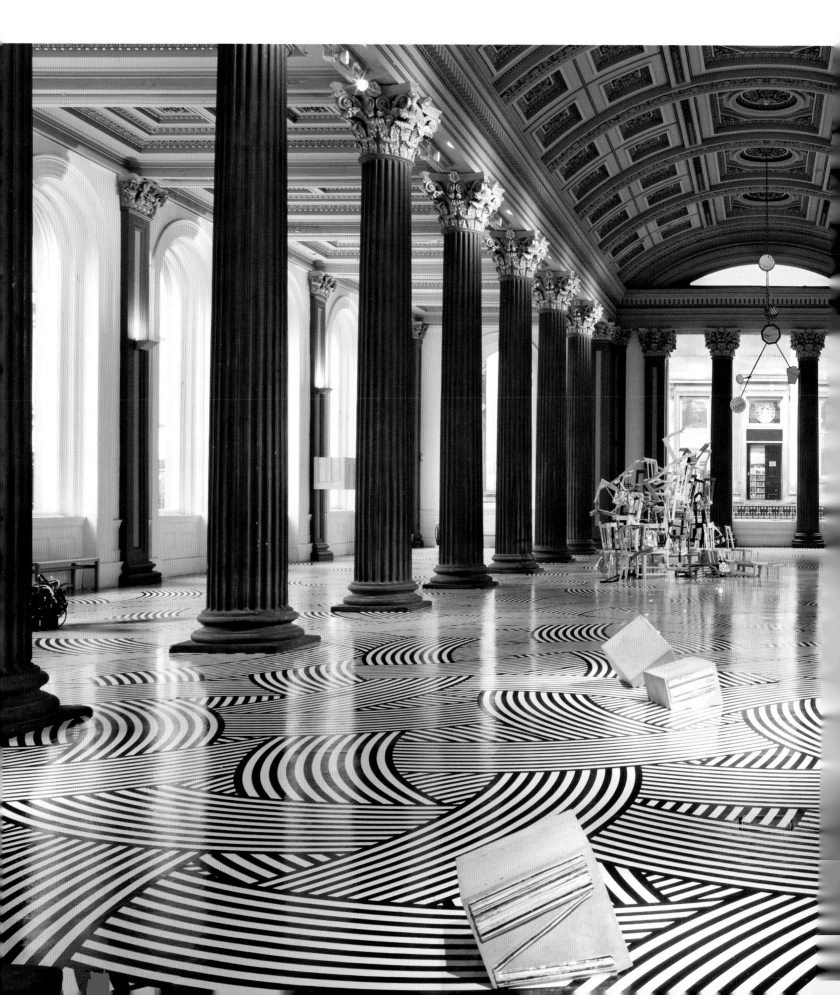

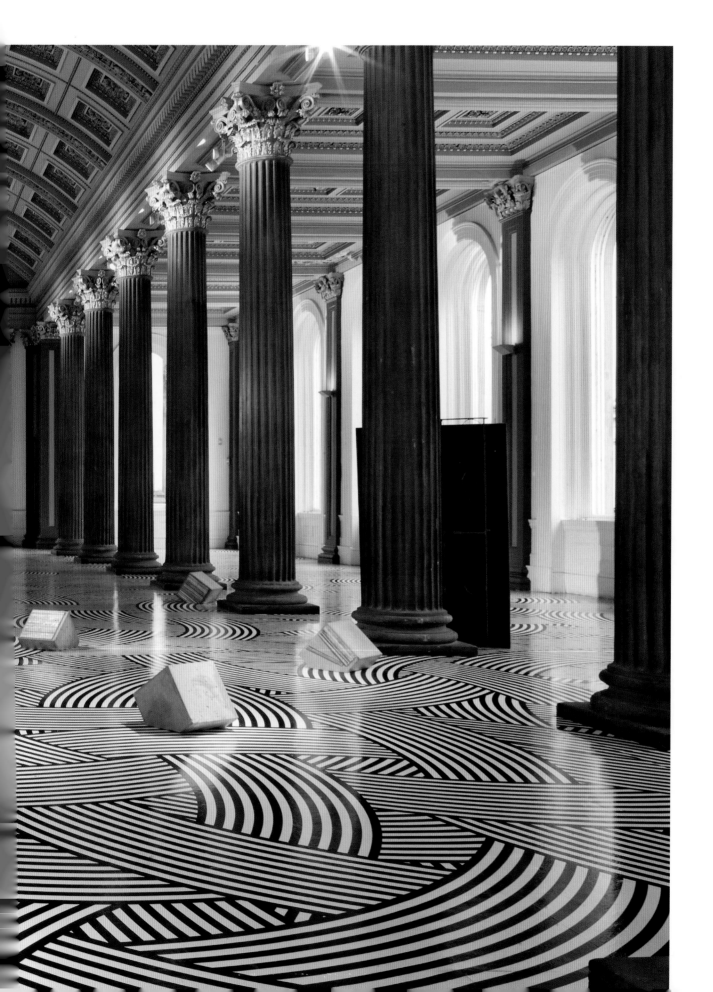

Installation view *Forever Changes*, Gallery of Modern Art, Glasgow, 2008

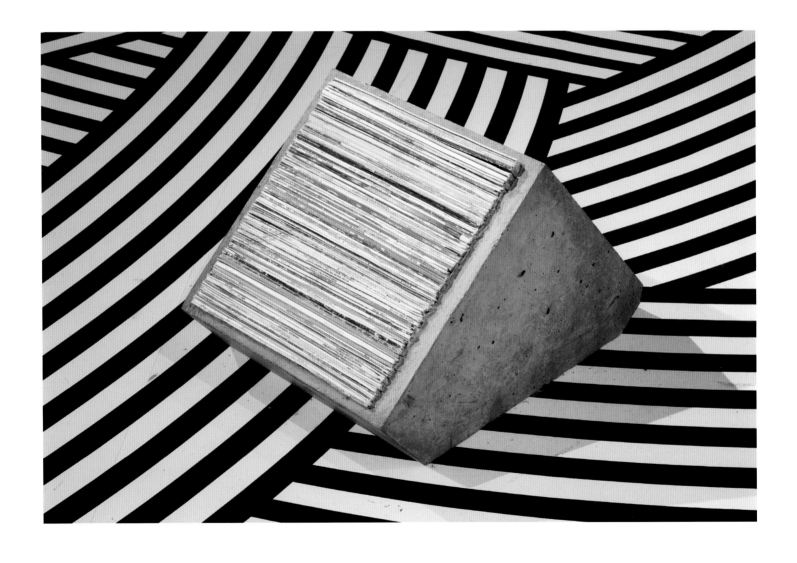

Sonic Reducer 7, 2008. Concrete block, album covers. 20 × 35.5 × 35.5 cm

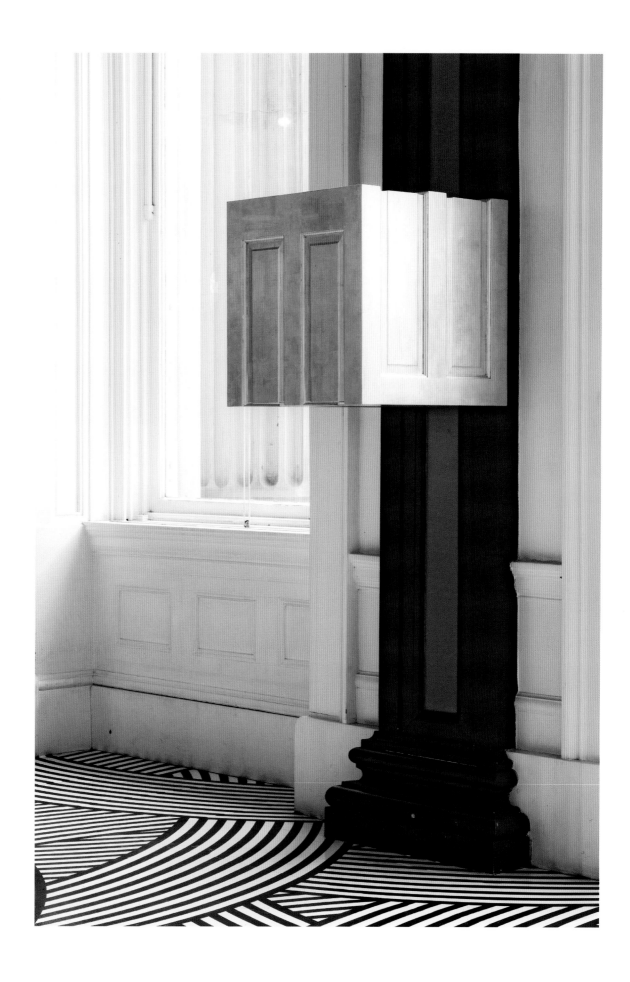

The Spell, 2008. Wooden doors, gold leaf. 66 × 66 × 66 cm

Psychedelic Soul Stick 65, 2007. Bamboo, colored thread, wire, beads, Malboro Light packets, T-shirt sleeve. 110 × 10 × 10 cm

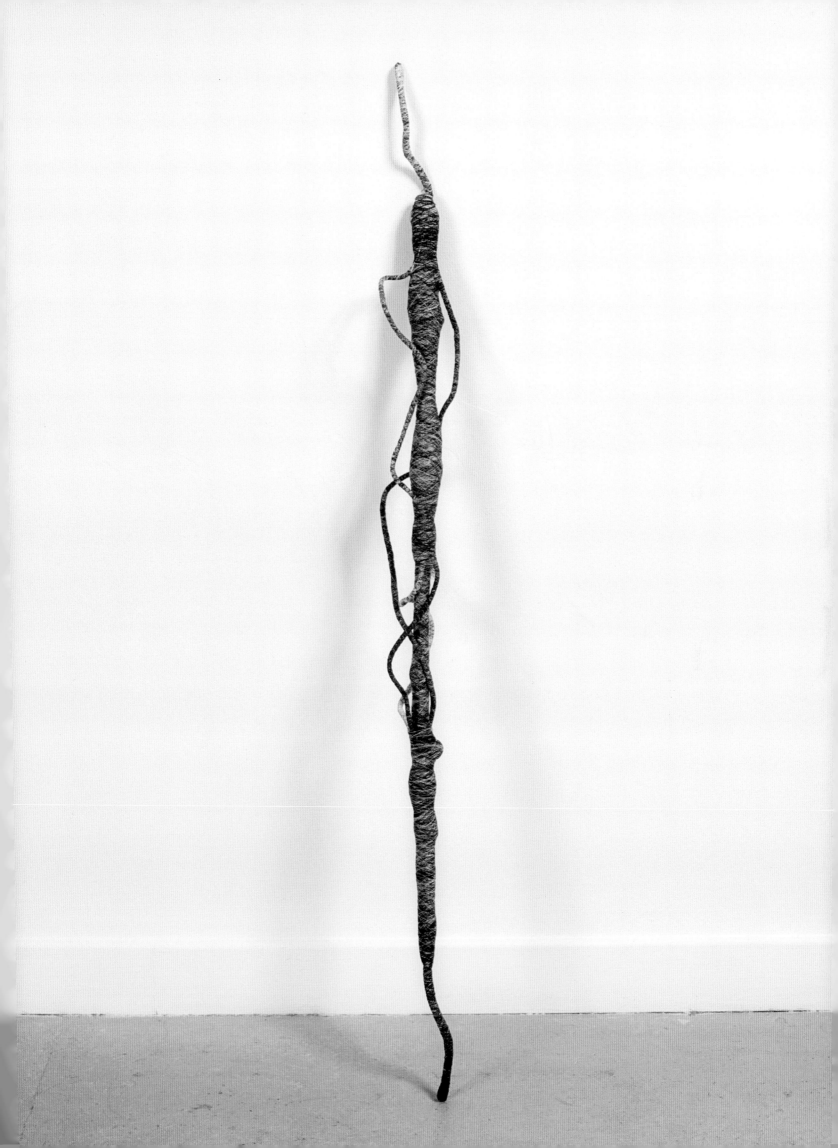

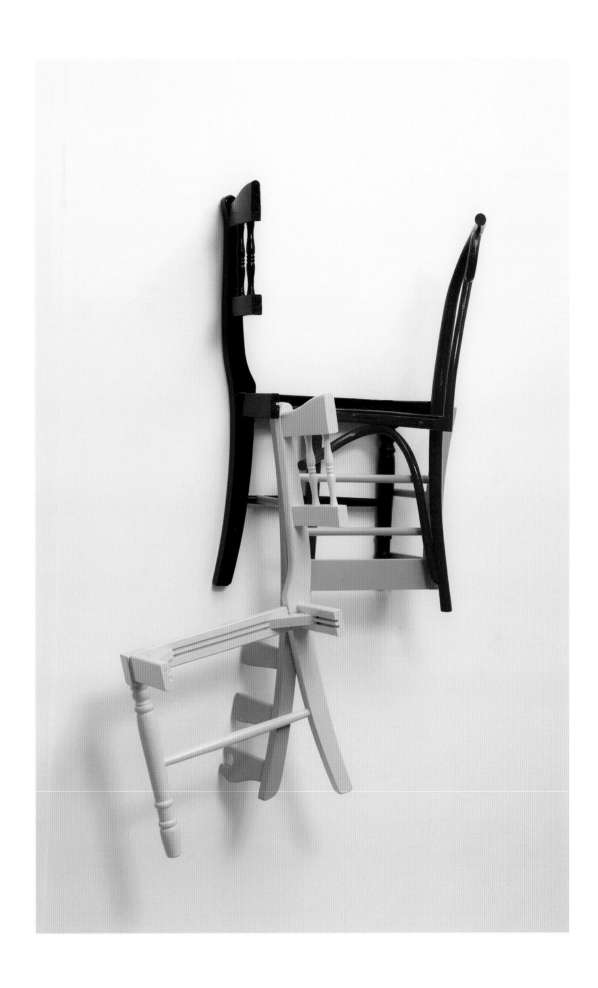

Durutti Column, 2007. Wooden chairs, gloss paint. 144 × 80 × 41 cm

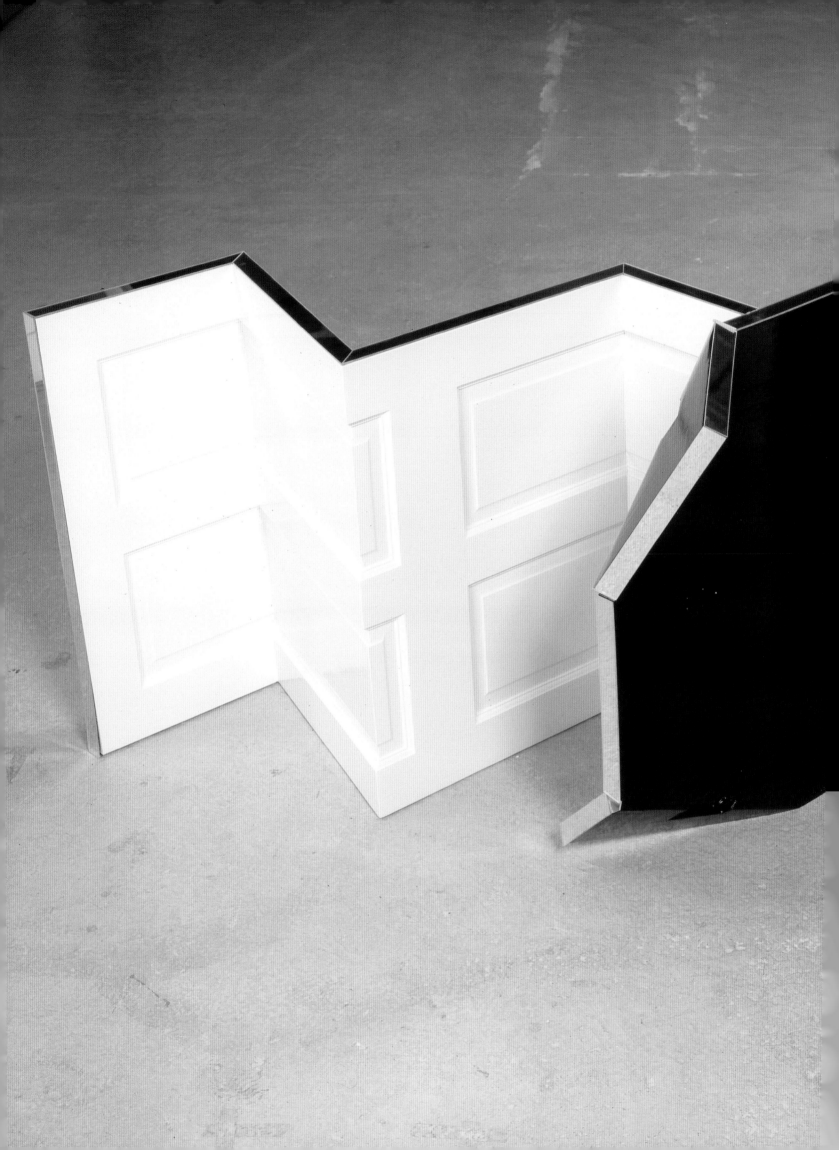

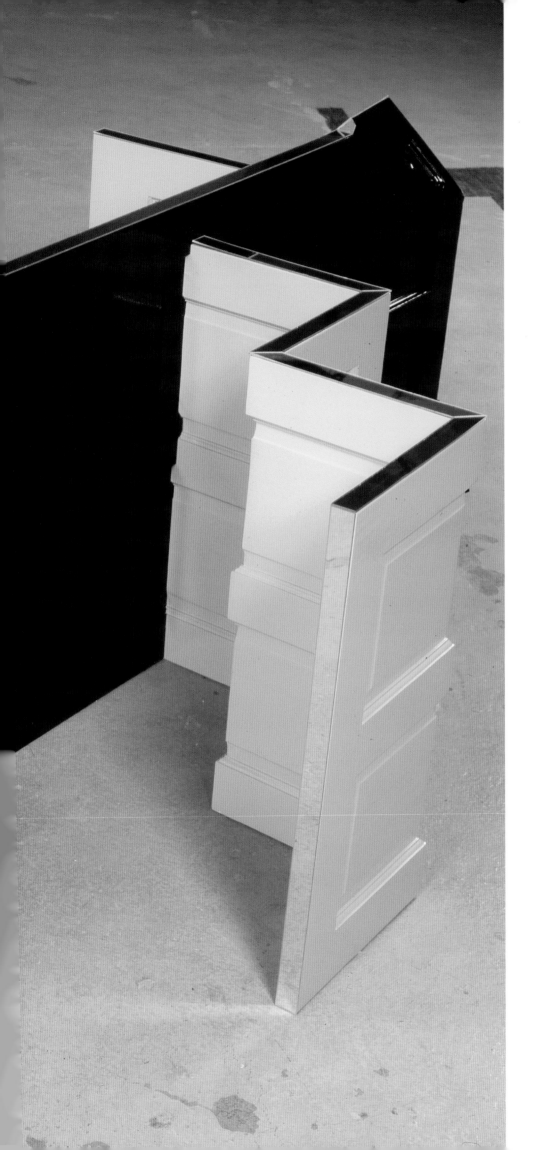

Phuture Days, 2006.
Wooden door, gloss paint, mirrors.
84 × 250 × 180 cm

155 Rainbow Room, 2002. Five mirrors, prismatic vinyl. Dimensions variable

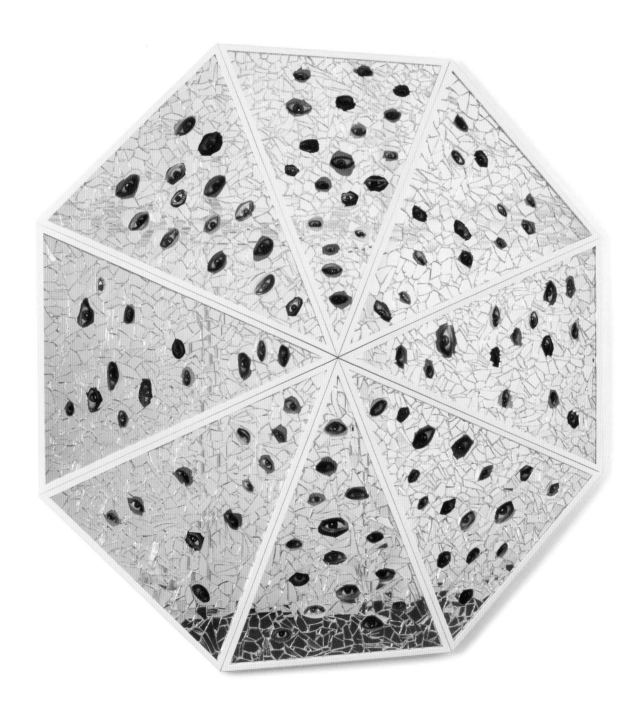

Oven Ready, 2006. Broken mirror, collage, gloss paint. 8 parts; 83.5 × 69 × 2.7 cm each

opposite: Psychedelic Soul Stick 58 (detail), 2006. Glove, T-shirt sleeve, Marlboro Light packet, bead from necklace, necklace with pendent, bamboo, cotton, wire. 106.8 × 7.6 × 7.4 cm

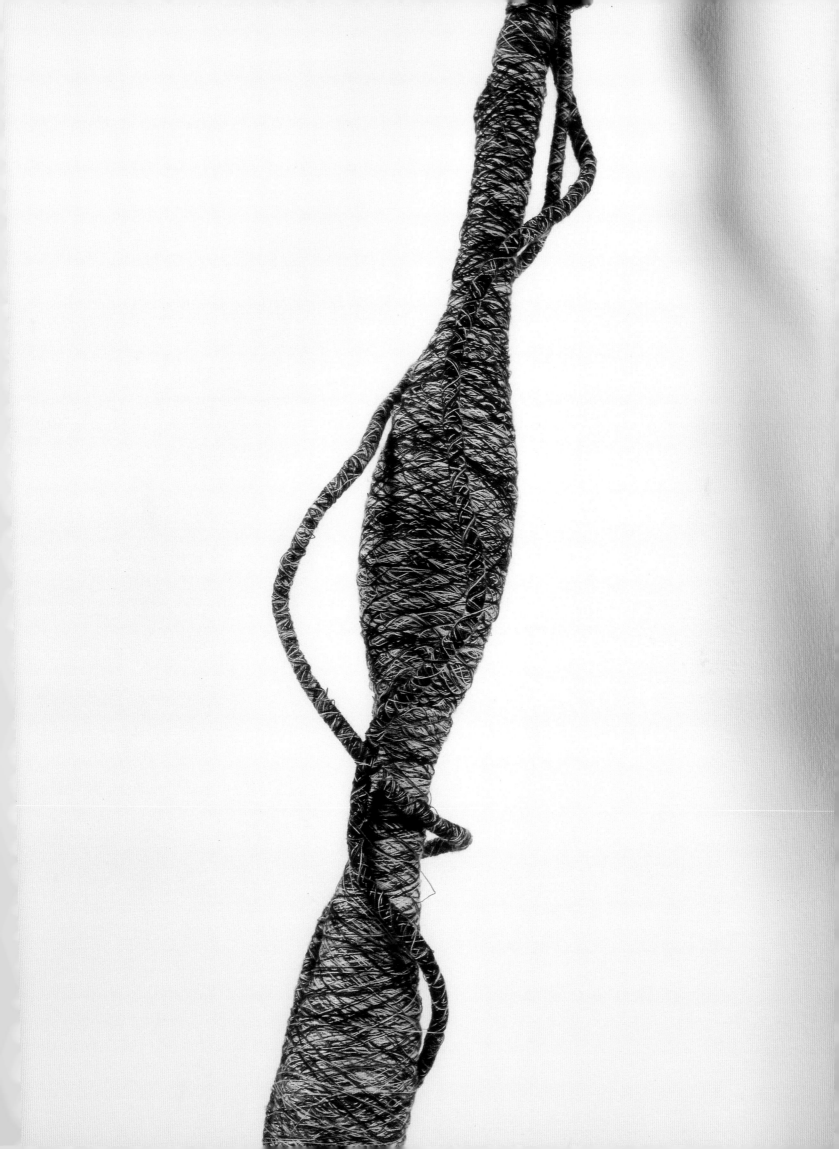

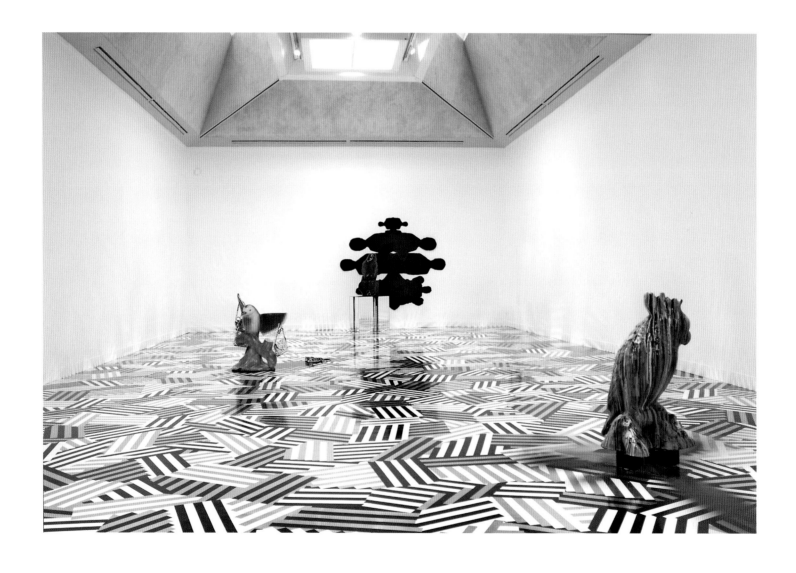

Installation view *Turner Prize*, Tate Britain, London, 2005

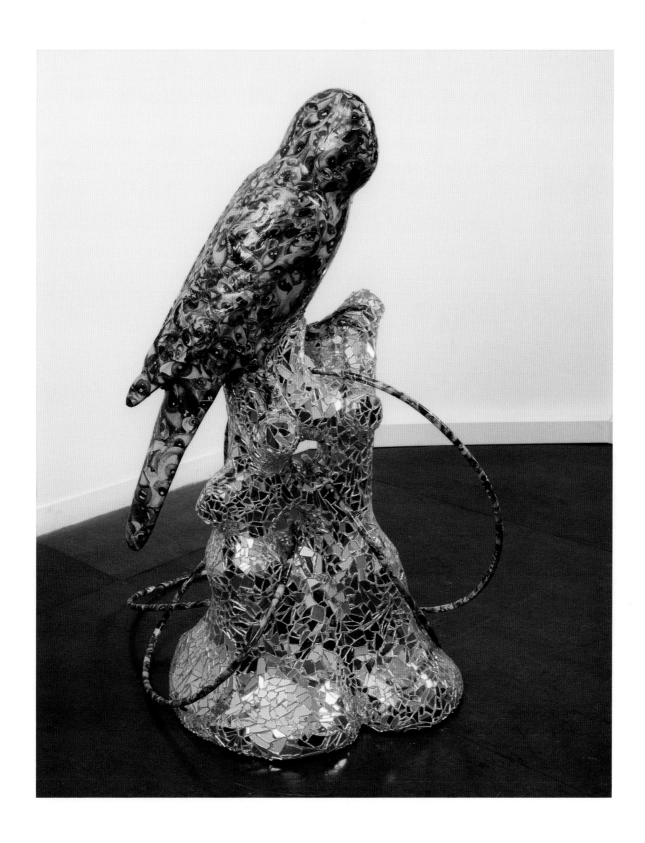

The Byrds (Four Hoops), 2005. Hula-Hoops, ceramic budgie. 139 × 77 × 74 cm

Blacktronic, 2005. Jeans, duct tape, aluminium tape, wood, belt, acrylic paint. 130 × 45 × 30 cm

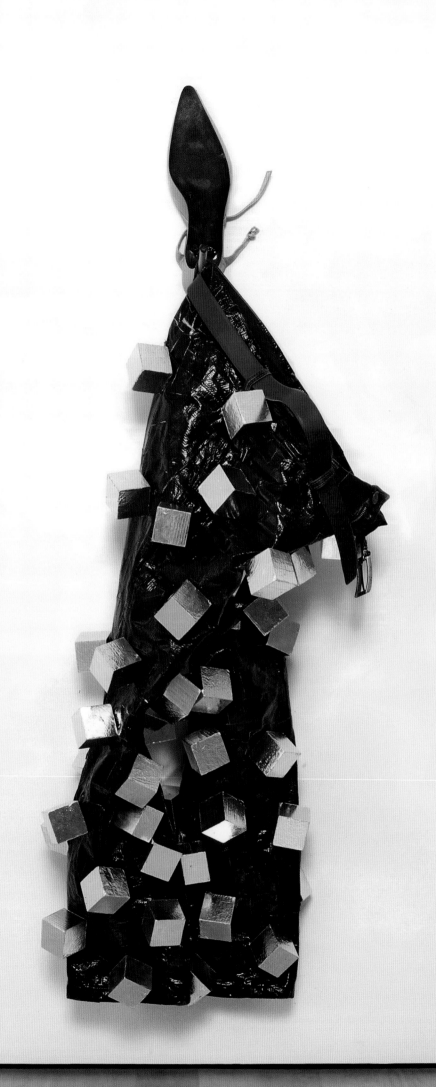

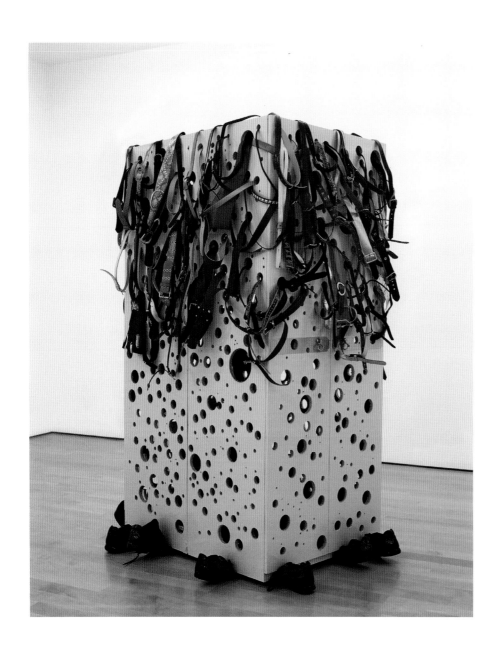

Split Endz (Wig Mix), 2005. Wardrobes, mirror, belts, training shoes, gloss paint. 184 × 137 × 120 cm

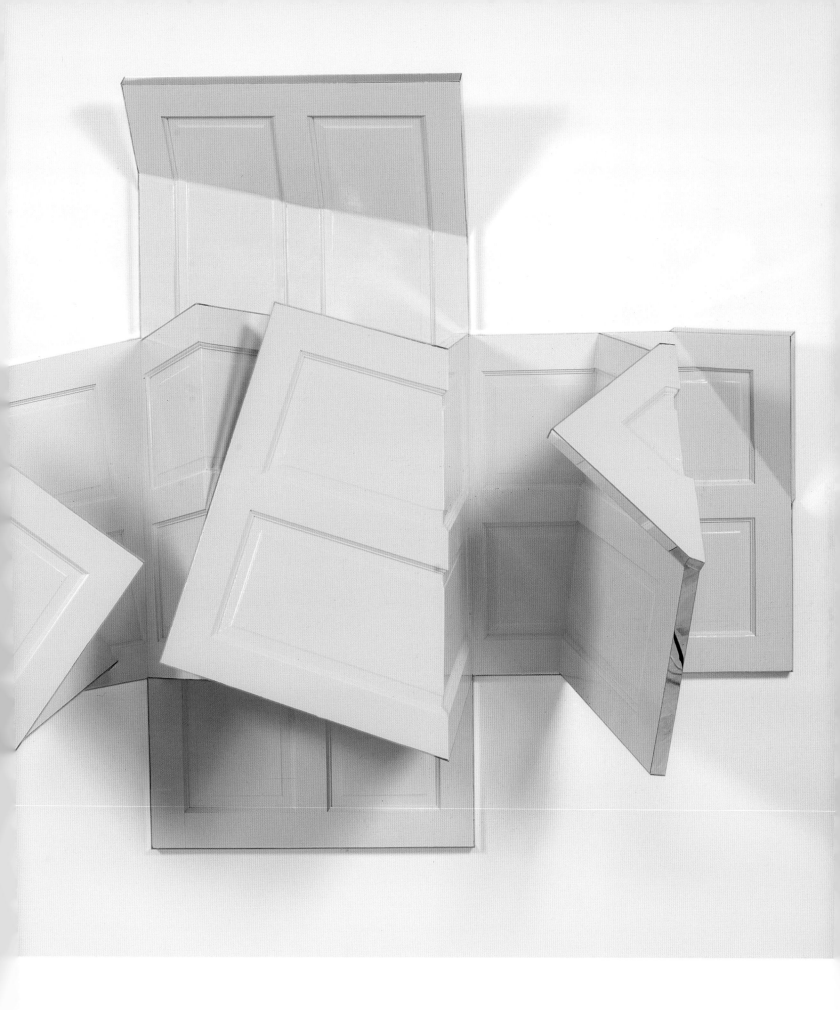

The Doors (Gloria G.L.O.R.I.A), 2005. Doors, gloss paint, acrylic mirror. 193 × 252 × 80 cm

Blueboy, 2006. Safety pins, LP covers, duct tape, acrylic paint. 37 × 38 × 35 cm

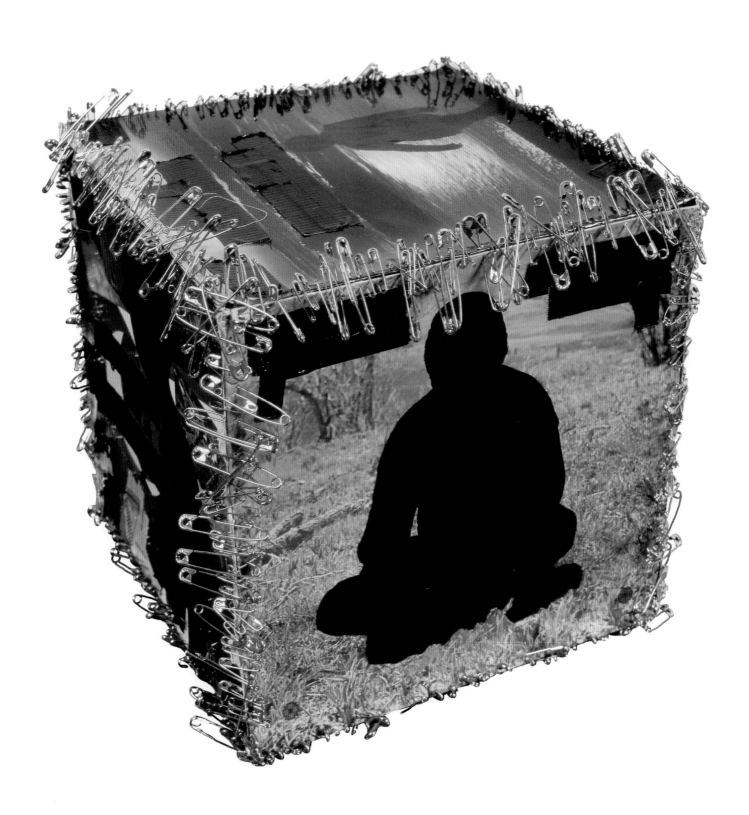

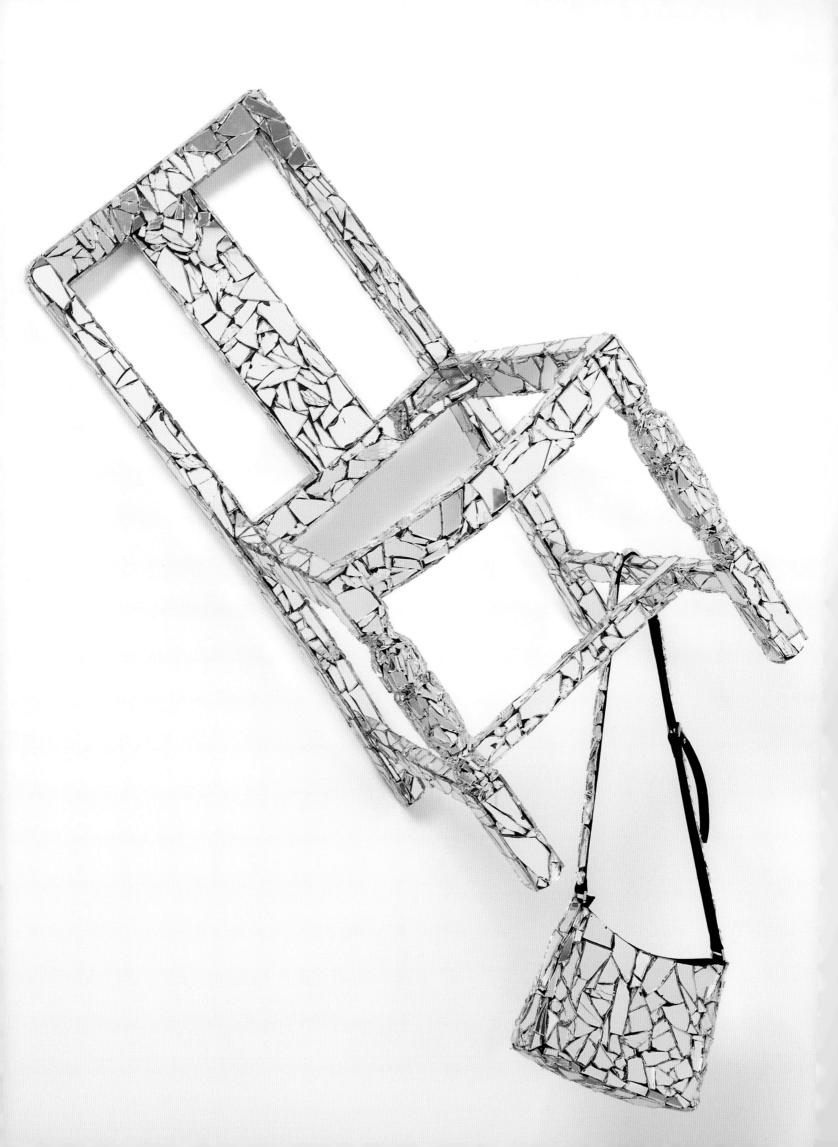

Danceteria IV, 2006. Broken mirror pieces, chair, handbag, glue. 122 × 99 × 48 cm

The Doors (Love Me Two Times), 2005. Wooden door, mirrors, gloss paint. 199 × 142 × 42.5 cm

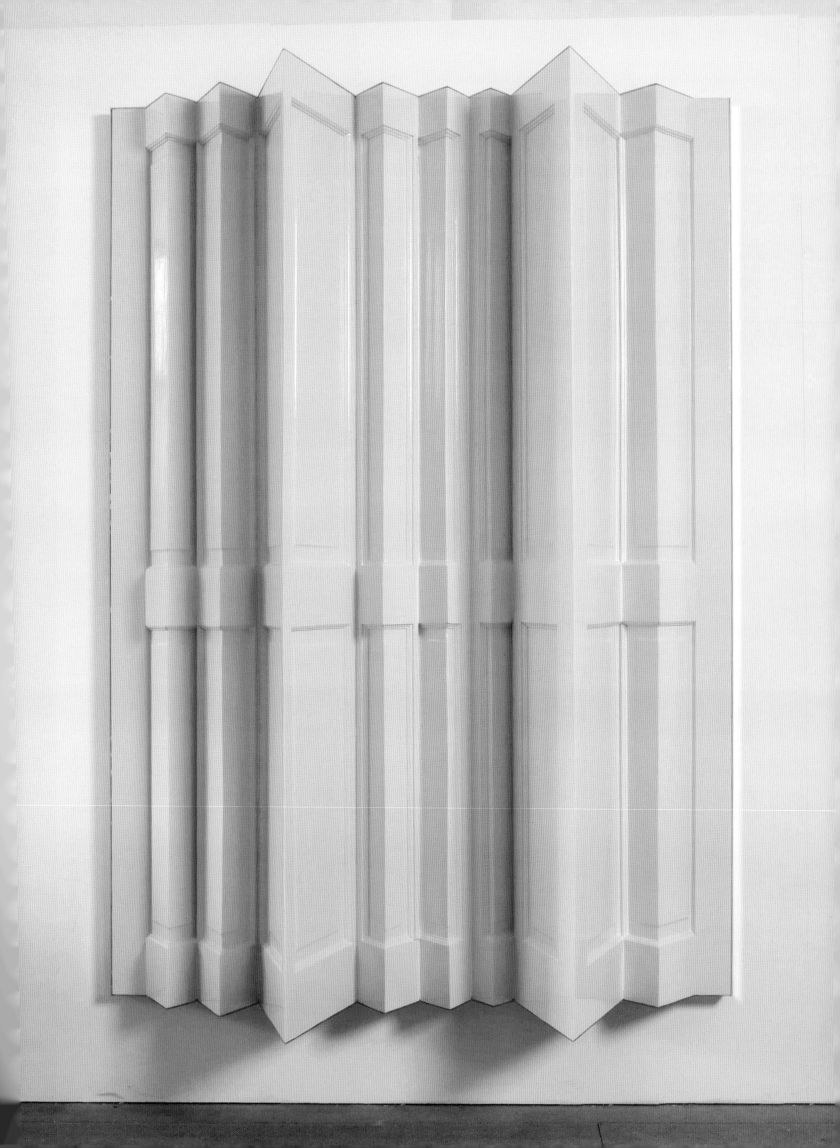

MATERIAL MEANINGS; OR, TO RENDER VISIBLE
Sophie Woodward with research by Loren Olson

His availability to all is total. He accumulates continuously desire and lack of desire, choice and lack of choice; that is, he finds himself in a type of life that overcomes the formulations of thousands of experiences.
—Germano Celant, *Arte Povera*

"Here we have a man whose job it is to gather the day's refuse in the capital. Everything that the big city has thrown away, everything it has lost, everything it has scorned, everything it has crushed underfoot he catalogues and collects. He collates the annals of intemperance, the capharnaum of waste. He sorts things out and selects judiciously: he collects, like a miser guarding a treasure, refuse which will assume the shape of useful or gratifying objects between the jaws of the goddess of Industry." This description is one extended metaphor for the poetic method, as Baudelaire practiced it. Ragpicker and poet: both are concerned with refuse.
—Walter Benjamin, *Selected Writings, Vol. 4*

Jim Lambie is committed to the dilation of experience, which is to say his work does not operate merely in the theoretical realm but instead engages in sensuous and direct encounters.[1] He performs these interventions in daily life by immersing his viewers in complete worlds, articulated from the fabric of their own. Operating as poet-sorcerer—dressed, of course, in rags—the artist conjures up disorienting vistas from the deeply familiar. Lambie's work is often discussed in relation to Op art, Postminimalism, Minimalism, and Pop. It is, however, from within the Italian avant-garde counter to the latter two, Arte Povera, that his work draws its most compelling through line.

Lambie hunts in different terrain than his Italian predecessors, with their affection for biological nature: his "natural" world is inhabited by people, who litter the forest floor of their cupboards, closets, dance clubs, and groceries with errant gloves, buttons, bags, belts, and broken record players. Unlike a Surrealist with a fetish, or a Pop artist who might import a symbol wholesale to a gallery context or encode messages in an arithmetic of iconography, Lambie selects from the detritus of everyday life with subtlety and ambiguity. Like a peripatetic archaeologist or Walter Benjamin's Parisian arcade drifter, Lambie mines the junk drawer of culture, tossing up glittering tube tops and mirror shards.

These considered materials are freighted with meaning for both artist and viewer. Lambie's coat hangers and safety pins retain their discrete object status in his works,[2] allowing them to carry their personal and collective histories. The weight of these memories gives each assembled work a tugging force, a strategy that parallels Arte Povera's use of historical memory to vivify radical critiques of the present. A sociological lens provides insight into Lambie's nuanced use of materials and assemblies, in which he renders unseen objects visible and creates new sensual possibilities through material juxtapositions.

OBJECTS HIDDEN IN PLAIN SIGHT

In the social sciences, to focus on the mundane is to study unconscious and seemingly ordinary practices and objects. This focus provides insight into how everyday life is organized, how people relate to each other, and how they make sense of the broader world. The field of research is often interchangeably called the everyday, the mundane, or the routine.

Lambie's practice trains a similar attentiveness on the unconsidered aesthetics of the everyday, exposing ordinary objects that, while profoundly resonant, fail to register for viewers in their original context. In routine life, even the spectacular red of a plastic coat hanger goes unattended: Like so many dormant objects,[3] it falls outside the range of items held to have aesthetic value. The viewer's perception, evolutionarily adapted to screen out nonurgent information, renders the object invisible.

While the artist's well-documented relationship with music often manifests in his importation of record covers, as with *Blueboy* (2006) or *Stakka* (1999), these already serve as display objects in their own right. Lambie's alchemical strength is best revealed in his ability to bring an "invisible" framing object into the sphere of primary visual focus.

Framing Objects

Anthropologist Daniel Miller has used the idea of framing—based on E. H. Gombrich's notion of the picture frame—to suggest that, in everyday life, objects we do not really see may in fact frame the meanings we interpret from our environments. These objects are not, however, in and of themselves generally interesting to look at; they are things that allow us to look at something else.

A coat hanger on which a dress or suit is draped helps to frame how the viewer interprets the visible object, clothing. Even out of the wardrobe and hung prominently, the viewer generally regards the hanger only as something that allows us to see the clothing. In works like *Roadie* (1999), Lambie reverses this situation, assigning a succession of hangers in prime importance. The artist's careful arrangement of colors is instantly familiar from the viewer's own closet, where expediency results in a mishmash of styles. Yet the colorway also keys into a downbeat Minimalism, as pronounced in his celebrated *Zobop* series, also begun in 1999.

Mirrors are also objects not usually seen in their own right: they enable viewers to consider their reflection or the suitability of a particular outfit. In Lambie's hands, however, the mirror is a surface to regard. Shattered and pieced together, as with *Hot Corner* (2009) or *The Byrds (Four Hoops)* (2005), it becomes a fantastic shell, glamorous and cheap at once. Sometimes evoking a highly visible disco ball, Lambie's mirrors can even overcome the objects they encrust: in *Danceteria IV* (2006), a bag and chair vacillate between seen objects and a substrate for broken reflections. When punctuated with his signature cutout eyes, as in *Oven Ready* (2006) and *The Citadel* (2010), Lambie's mirrors

serve as a switching plane where viewers are pulled between their own reflection and their awareness of the mirror as an object, reinforced by the many-eyed gaze that returns their own. In these works, and more profoundly in pieces such as *Metal Box (Karma Chameleon)* (2015), *Perm and Blow Dry* (2001), and *Bleached Highlights* (2002), Lambie builds on the Arte Povera tradition of Michelangelo Pistoletto, where as viewers we suddenly find ourselves drawn into the world beyond the broken or silkscreened looking glass. This reference is most direct in Lambie's 2004 exhibition *Mental Oyster*, where the outline of a brick wall over glass parallels the iron gates silkscreened on mirror works of Pistoletto's. Where Pistoletto most often uses figures to lead the viewer in, Lambie anchors his reflective planes with familiar objects, like paint-dipped shoes. Like his Arte Povera forebear, Lambie's lo-fi magic opens up space while remaining firmly an object, now rendered visible: in *Shaved Ice* (2012/2014), the revelation of mirrors between the ladder slats bring them to the fore; in *The Doors (Futura Deluxe)* (2003), the appearance of a sudden opening in the floor is cut short by the telltale beveled edge of a decorative domestic mirror.

Safety pins take on a contemporary folkloric significance in Lambie's pieces, just as artists within Arte Povera often employed items that evoked Italian artisanship. Drawn from the punk tradition, where objects that are not usually visible or considered appealing become the aesthetic focus, safety pins carry a powerful history of their own. When used in sculptures such as *Blueboy* (2006), this read is enhanced by the presence of other objects signaling music. In works such as *Pin Number 3379* (2016) and *Pin Number 1858* (2012), the meaning of the safety pin has multiplied and grown subtler. Still loaded with punk connotations, the functional item becomes conspicuous when hundreds hold together the surface of the canvas. The objects are both engaged in their primary use and imported to the aesthetic sphere of abstract mark making.

Zippers are used to a similar effect in *Zip Code (No. 1)* (2011), where an object that is most often literally concealed on a garment is given top billing. Lambie's selection of bright colors, stark against a white ground, directs the viewer's attention. More discrete choices, like the taut and dimpled canvas where the zippers connect, refer to the conditions under which a zipper becomes visible in quotidian circumstances: we notice a zipper only when it is broken or if the body beneath bursts through.

Objects between Framing and Display

Even within the class of domestic objects designed to be viewed and visible, disruption can occur by changing the contexts of visibility. Lambie's material choices often include items in this category, granting pieces already incorporated in social display heightened attention. Clothing, shoes, and accessories are hybrid domestic objects. Crumpled at the bottom of the wardrobe, even the brightest heels and sweaters go unnoticed. They are part of a public presentation of the self and the body in seen contexts but can also form part of the unseen hidden contexts of the home. Lambie activates the latter, latent aspect of these, often to an absurd effect, connecting him to the lineage of Arte Povera and particularly to works like Michelangelo Pistoletto's *Venus of the Rags* (1967).

As a display item, a plain brown belt is denied its ordinary, functional meaning, opening up new possibilities. When multiple brown belts are hung together, as with *Into the Knight* (2010), these unseen items of everyday life come into focus. Lambie pushes this effect further in *Seat Belt (Spellbound)*, and *Seat Belt (Ned Kelly)* (both 2009). A pile of belts reanimates as a humble chair, merging two unseen object categories into a highly visible hybrid one. Here, too, Lambie formally connects with the legacy of Arte Povera, particularly Luciano Fabro's *Speculum Italiae* (1971). In later works, such as *Belt Buckle (Vodoo Ray)* (2011), the artist radically shifts color and scale to comedic extents. The belts still carry their connotations as garments—like Lambie's safety pins, peculiarly "supporting" objects that hold other items together—but at an amplitude that reveals the objects' more threatening embedded meanings, such as the belt as lash.

Like a belt, a pair of shoes may be both an unseen item of clothing even when worn and an object meant to catch attention. Here again,

Lambie adroitly shifts his chosen materials between their status as framing objects and foregrounded ones. In works such as *Zero Concerto* (2015), the odd shoe is familiar from domestic scenes, where its single status makes it strange. It is stranger still in the context of a gallery, where the shoe's utilitarian aesthetics are suddenly visible in contrast to the brightly patterned floor. More complex is Lambie's use of the demure dress shoe in *Ultratheque (Poppers Remix)* (2014) and *Medicine Man* (2012), where verticality and suspension transform the invisible accessory into a punctum. Within the home, even a pair of glittery heels may become a forgotten aspect of everyday life. Lambie plays with this lack of preciousness in *West End Girls* (2010), featuring the tangled nest prominently, a departure from Jannis Kounellis's careful placement of Italian leather dress shoes in the shapes like a cross.

Aligning again with Kounellis, Lambie mines the armoire for items of clothing, though he transcends simply presenting these in a gallery context. Covered in black duct tape, the workhorse jeans in Lambie's *Blacktronic* (2005) are not only rendered visible but studded with cubes until they become nonfunctional objects of display. In *Shellsuit* (2001), a fairly nondescript jacket is armored in razor-clam shells. Clever wordplay aside, Lambie here connects with Arte Povera's combinatorial matrix of natural and highly industrialized substrates. He carves his own space, however, in pieces like *Digital (New York)* (1999), where leather jackets telegraph cowboys, rock stars, and bikers, dialed up through the attitude conveyed in showing only the backs. While these neutral leathers are relatively discrete on their wearers, they serve as neon synecdoches in the gallery. In *Leatherette*, made the same year, Lambie animates the sleeves of the leather jackets with thrusting force. When stuffed, these become arms balled into fists, exploding from the center as though already engaged in a fight. This piece is more disturbing than *Digital (New York)*, not just for its implied violence but for the haunting vacuum of a figure within. As sociologists Elizabeth Wilson[4] and later Joanne Entwistle[5] note, garments in a museum or gallery context are an eerie experience. The clothes speak of and evoke bodies, and yet their wearers' absence renders the garments incomplete.

More often meant for function than display, chairs are another object that Lambie consistently foregrounds. In everyday life, a chair serves as a seat or a "frame" on which to hang a coat or bag. Under Lambie's ministration, though, chairs are presented upturned in a hodgepodge multitude. Deprived of their use yet still telegraphing an absent sitter, the chairs become stand-ins for a personality. The unpolished, even arbitrary aesthetics of these domestic objects are pronounced in isolation, as in *The Jesus and Mary Chain (Part 1)* (2004). Lambie reverses this strategy in his *Seven and Seven Is or Sunshine Bathed the Golden Glow* (2008), where the chair is now abstracted to an element within a swell, a sophisticated update on the rough-hewn wooden waves of Arte Povera's Mario Ceroli. In other works, Lambie's chairs appear to be in conversation, a parallel with Kounellis's enigmatic circles. Whether appearing to rise from the museum floor or compacted into a perversion of a Minimalist cube, as with *I Remember (Square Dance)* (2009), the bands of chairs command our attention while retaining their object status. Lambie's apparently haphazard groupings convey more delicate meanings, too: the visibility of the object only heightens its perseverance in our lives despite obsolescence, as we often, with nonsensical tenderness, hold on to a chair that has served us well, despite the fact it is broken beyond repair.

TRANSFORMATIONS: OBJECTS IN RELATIONSHIPS AND NEW FORMS

In sociological understandings, the meanings of objects are never fixed, as things can change either through a process of material degradation or through deliberate adjustments to the objects' materiality or func- tionality. In the buttons that feature prominently in Lambie's oeuvre, the capacity for fastening is part of the object's materiality, in that its qualities determine its utility. Dependent upon the color and substrate of which it is made, the button may blend in or attract the eye through its decorative and contrasting nature. Yet capacity and visibility alone do not determine what the button is or what it can do. That depends on its history, how it has materially changed, how it is displayed, and what other things are assembled with it. Here the term *assembled* refers to a key tenet of many forms of material culture theories: understanding how objects relate to each other.

The sublime moment and the "capharnaum of waste"[6] are the two poles around which Lambie martials these assemblies. The artist's acute sensitivities allow him to distil lasting significance from the mundane, or as Baudelaire would have it, "The aim for him is to extract from fashion the poetry that resides in its historical envelope, to distil the eternal from the transitory."[7] Yet Lambie is never grandiloquent, preferring to import these moments in the materials where he first found them.

Reassemblage

In everyday life, assemblages are often accidental, as with the surprising pairings that emerge from a junk drawer. This confused jumble serves as a place, often in the kitchen or living room, where people place objects to get them out of the way. These objects are especially suited to rearrangement, as their functional status is in flux. *Teardrop Boombox (La Scala)* (2016) is such a work—uniting radios with spoons of pigment, and fragmenting both, to create something evocative of a musical scale and notes from the accessories of an artist's studio. In Lambie's *New Wave (Formerly The First Wave)* (2001), the odd glove and the buttons that festoon it each carry cultural meanings that are interrupted as the two materials are assembled. In the artist's lauded *Bed Head* (2002), this idea is developed further, rendering the mattress useless and transforming the buttons into a skin of memory and sensual delectation.

With *Split Endz (Wig Mix)* (2005) Lambie proves that even objects conventionally associated with each other can be made strange through reassembly. His hulking, porous pink wardrobe sprouts a crown of belts, grouped like hairs pulled through a wig cap or a cheap display in a thrift store. A third element, a troupe of nondescript black trainers, becomes highly visible as it strains to keep the armoire aloft. Like Pino Pascali's *Cavalletto* (1968), the individual materials seem to belong to the same world but through careful rearrangement become alien in their disorder. The top-heavy composition and method of attachment echoes Marisa Merz's *Untitled* (1966), where tufts of hemp fall from a wire mesh column.

Lambie appears transfixed by ordinary beauty, relishing the sensuous qualities of material juxtapositions that would otherwise escape our attention. With *Plaza* (1999/2014), Lambie combines cheap plastic bags with paint to import a surreal moment he witnessed to the gallery: milk spilling from a swinging grocery bag. While here he races Kounellis to the bottom, using an even cheaper material than the rough cloth bags of the Italian artist's *Senza Titola* (1969), in his later works Lambie pursues an opposite strategy. Retaining Kounellis's grouping of sacks, Lambie lifts potato bags from the corner store to combine them with bright paint (*Sphinx* [2014]); later still, he chromes them in gold (*Heart of Gold* [2016]).

For his 2005 Turner Prize installation at the Tate, Lambie again reassembled domestic materials meant for display, this time taking as his object decorative porcelain tchotchkes. In works like *The Byrds (Four Hoops)* (2005), Lambie combines Hula-Hoops, mirror shards, and his signature cutout eyes to render all parts of the whole unrecognizable. Elsewhere in the space, the birds are made alien with the addition of equally gaudy handbags. Other works in the series are splattered with paint, recalling generally an exercise in amateur house painting gone awry, and specifically Jannis Kounellis's painted-daubed stuffed parrot in *Untitled (Rimbaud)* (1980).

In *Bookcase (Pretty Vacant)* (2015), these relationships are more complex, with three assemblies of objects then assembled in relation to each other. Suspended from a vernacular painted suitcase affixed to the ceiling, dangling chairs form a makeshift drying rack, under which books, a bucket, and a handful of straws cluster. The objects are familiar both individually and in proximity to each other—they could be the contents of a room. The application of paint, however, gives the books new status as rectangular blocks of color, which, in relation to the concrete-filled bucket they conceal, reveals the objects' quality of volume. The dangling rags recall Luciano Fabro's *Attaccapani di Napoli* (1976–77), where decorative Italian clothing racks support undulating falls of brightly colored fabric. Lambie cuts two steps deeper than his Italian forebear, exchanging a decorative rack for an "invisible"

mass-manufactured one, and then making even this an approximation via a DIY assembly of chairs.

Fabro's legacy can also be felt in the bit of blue cloth connecting the glittering plinth to the column of Lambie's *Machine* (2004). Like Giovanni Anselmo's *Torsione* (1968), the twisted fabric paradoxically controls the more dominant elements in its relationship. Here, however, the individual identities of the objects have been lost: scintillating tube tops are almost completely unrecognizable when totem-stacked, and the gilded door that forms the base of the plinth remains so only for the signatory impressions in the wood, which in this context, suddenly appear arbitrary. In Lambie's hands, objects without apparent connection work to make each other strange.

Physical Alteration

The meanings or capacities of objects may also be altered through the material transformation of things, as they fall apart or are deliberately changed. A step beyond assembly, such changes allow for a separation of attributes from the object itself. As Lambie often chooses familiar substrates, the effect is particularly uncanny. In *Span Dancing (Full Room)* (2003), the artist removes the handles from dozens of handbags. While the straps themselves have not changed, as objects they have lost their capacity to hold a bag. Further separated from the peg, chair, or shoulder on which they might rest, the complete object of which they were part and their relationship to the human body are now altered, exposing the straps as somehow unfamiliar. Lambie began experimenting with this effect early on, dipping carrots in orange paint to expose the strangeness of their color (*18 Carrots*) or covering shirts in aluminium and duct tape (*Two Shirts*) (both 1996) to shear the objects of their original, intrinsic capacities.

A familiar object is "remade" by the presence of unexpected materials. While foreign in a gallery, duct tape and aluminum foil are invisibly quotidian in a domestic context. These favorites of home construction are used to fix broken parts, though the assemblages they join are inevitably tenuous. They are also a favorite substrate of teenage bedroom constructions, a fact Lambie blithely toys with in his early *The Kid with the Replaceable Head* (1996). This mask made from underpants only pretends to be naïve: the briefs take on the howl of Marisa Merz's *Testa (Head)* (1984–95) and share a spirit of playful armament with a sewn helmet Pino Pascali kept in his studio.

While Pascali's armored helmet is rendered in soft cloth, the suit of armor Lambie crushed to crown *Into the Knight* is real hard metal. This transformation strips the object not only of recognizable form but of that form's attendant quality, toughness. Throughout his 2010 Modern Institute show *Metal Urbain*, Lambie collapses powerful machines. The columns that support the objects appear to be the same devices that enacted the destruction, as in Giovanni Anselmo's *Senza Titolo (Struttara Che Mangia)* (1968), which compresses its object between granite blocks. Under pressure, a suit of armor and a washing machine are formally indistinguishable, though they somehow manage to retain the aura of their distinct functional selves. In the persistence of meaning despite transformation and obsolescence, as well as in the shrinelike forms the complete assemblies take, *Into the Knight*, *Sunset* (2010), and other works in this series are in line with Pino Pascali's *Teatrino (Little Theatre)* (1964). Where, for Pascali, the transformed objects retain the theater and the church, for Lambie it is history and home.

The flattened suit of armor reappears in Lambie's magnificent *Metal Urbain* (2010), the show's titular work. Here, the smashed carapace suggests fossilized remains, partially excavated from the concrete blocks that entomb them. Even at his greatest remove from domestic materials, the artist draws on object memories in the explosion of color roiling under the gray slabs. Peeling wheatpaste posters are reinvented as sheets of fluorescent, glossy, and chromed metal. This manifold form, frequent in Lambie's work since 2009, retains the archaeological valences of layered signage, abstracted to sterility. Like Pino Pascali, who in his 1968 piece *Bachi da Setola* martialed pipe cleaners into room-filling silkworms, Lambie exaggerates the native color and scale of each poster. When transformed further, assembled with a host of similar forms to describe a prone shape, the meaning shifts: As with Marisa Merz's pneumatic, segmented aluminium piece *Untitled (Living*

Sculpture) (1966), there is something of a fallen hero, human, in the industrial sheaves of metal on the gallery floor.

Sprung from their daily rotation within a bike tire, the spokes in Lambie's *Many Suns* (2014) are rendered nonfunctional in relation to their original object status. Physically transformed and reassembled, they have acquired a new role as a frame for a reflective surface. While Michelangelo Pistoletto often presented gathered or stacked mirrors, it is Lambie's unique territory to intervene with their frames. His DIY gesture releases the tension of the spokes' and rim's internal relationship, poetically transforming a specific loadbearing object to a universal symbol for the sun.

Lambie's power to transform through simple gestures is magnified in his 2016 Modern Institute show, *Electrolux*. The application of matte pastel paint mutes the features of a washing machine, though every contour remains the appliance's own. This combination of characteristics suggests a cast, evoking Arte Povera practitioners' return to traditional modes of artisan production. Where their 1960s casts reserved industrial elements for facture, with Lambie, they are final forms. Or would be, as the appearance of a cast is yet another illusion. Lambie intervenes on real washing machines to produce this triple presence, enhancing the visibility of the object while divorcing its function. The new painted skin, which has more in common with the texture and color of foam, even separates the washing machine from its quality of heaviness. The unheeded appliance, rendered a non-object, reveals itself as something more significant: a stalwart, a site of eternal return, of endless cycling. Titles like *Mirage* (2016) suggest Lambie operates for hallucinatory effect, where the simplicity of the physical transformation he enacts belies the magnitude of its attendant perceptual shifts.

MATERIAL MEMORY

The lives of things have occupied material culture scholars in different ways, whether they are concerned with the "social lives of things"[8] as objects change meanings in different contexts or the relative agency of things themselves[9] as they, or their material components, bring about effects and impact their users. Despite different theoretical and empirical perspectives, these studies all indicate that our lives are, at least in part, constituted by ordinary objects and their properties.

Lambie's peculiar skill may lie in his ability to speak the same language as objects, beguiling the viewer with familiarity and disorienting them with its reversal. His artistic practice plucks out those surreal moments where invisible things—objects hidden in plain sight—become all-consuming. He works within the envelope of the everyday to foreground certain objects as he casts back others. The shamanistic presence of many of Lambie's objects, unprecious though they may be, is embedded in their deep domestic roots, and yet the artist never asks that we celebrate their lowly origins, a step forward from Arte Povera. He is instead using the best tools available to communicate his message, drawing from a tool kit with which all viewers are well acquainted.

The mathom drawer, as well as attics or cupboards full of dormant things, speak to the creativity of domestic life. As bricoleurs of the everyday, individuals draw on the materials available to them.[10] The tool kit may be a wardrobe of clothes or a trunk in the attic. These groupings of domestic materials offer possibilities as well as limitations, as they present a finite set of objects. However, freed from their intrinsic orientation toward other things, these objects' meanings may be shifted through reassembly. Lambie's practice engages this creativity of everyday life, where we build fragile and significant connections between previously unrelated things.

In this sense, Lambie is a bricoleur par excellence, an artist who, given the same materials as others, sees far more possibilities in each combinatorial matrix. It is significant that Lambie should choose for himself such an ordinary creativity—that is, that he should choose to elevate to artistic practice the same tools available to all. This leveling is not only a tour-de-force display of brute creativity but conveys Lambie's deeply sympathetic appreciation for others. Lambie speaks to us in the language that shapes us about the tender, tenuous nature of identity.

1 I am here inspired by Germano Celant, to whom I owe the phrasing. Germano Celant, introduction to *Arte Povera* (New York: Praeger, 1969).

2 Daniel Miller, *Material Culture and Mass Consumption* (Oxford: Basil Blackwell, 1987).

3 Sophie Woodward, "The Hidden Lives of Domestic Things: Accumulations in Cupboards, Lofts, and Shelves," in *Intimacies, Critical Consumption, and Diverse Economies*, eds. Emma Casey and Yvette Taylor (London: Palgrave Macmillan, 2015), 216–32.

4 Elizabeth Wilson, *Adorned in Dreams: Fashion and Modernity* (London: Virago Press, 1985).

5 Joanne Entwistle, *The Fashioned Body: Fashion, Dress and Modern Social Theory* (Cambridge: Polity Press, 2000).

6 Walter Benjamin, *Walter Benjamin: Selected Writings, Volume 4: 1938–1940*, eds. Howard Eiland and Michael W. Jennings (Cambridge, MA: Belknap Press of Harvard University, 2002), 48.

7 Charles Baudelaire, "The Painter of Modern Life," in *Selected Writings on Art and Literature*, trans. P. E. Charvet (1972, repr., New York: Penguin, 2006).

8 Arjun Appadurai, ed., *The Social Life of Things: Commodities in Cultural Perspective*, Cambridge Studies in Social and Cultural Anthropology (Cambridge, UK: Cambridge University Press, 1986).

9 Alfred Gell, *Art and Agency: An Anthropological Theory* (Oxford: Clarendon Press, 1998).

10 Claude Levi-Strauss, *The Savage Mind* (London: Weidenfeld and Nicholson, 1966).

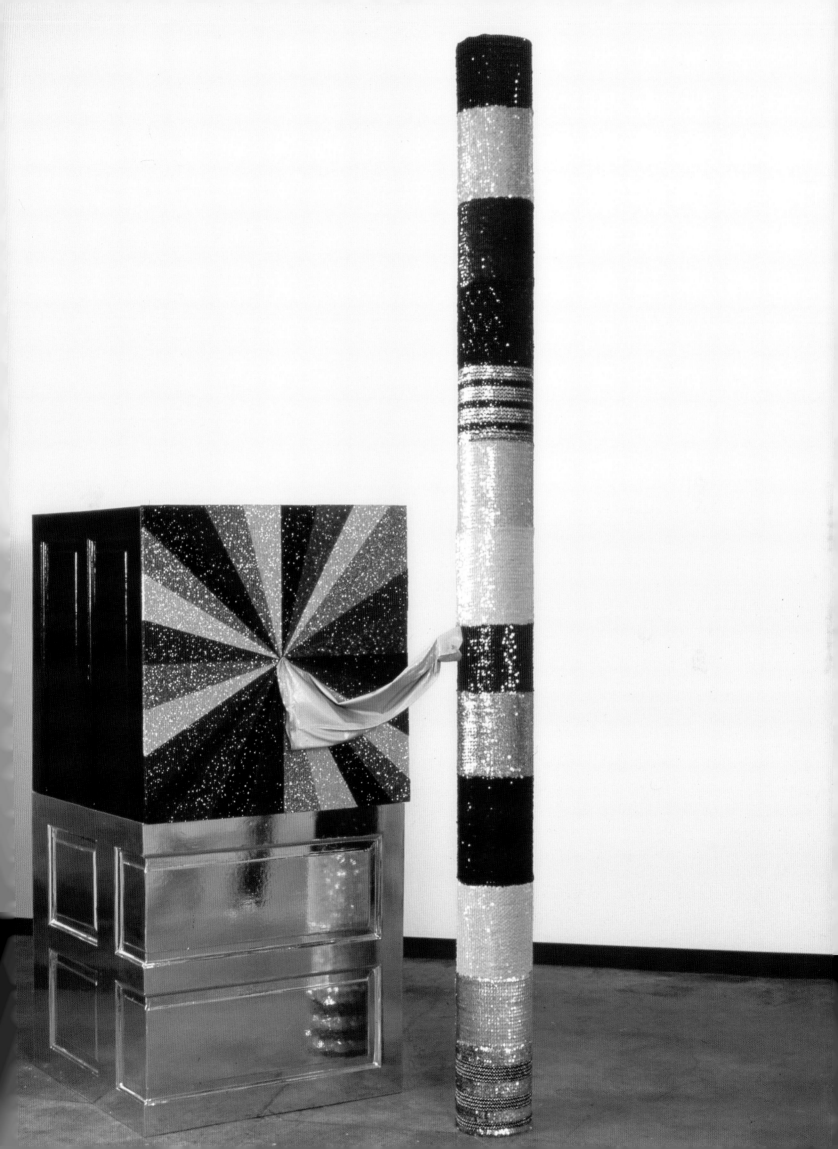

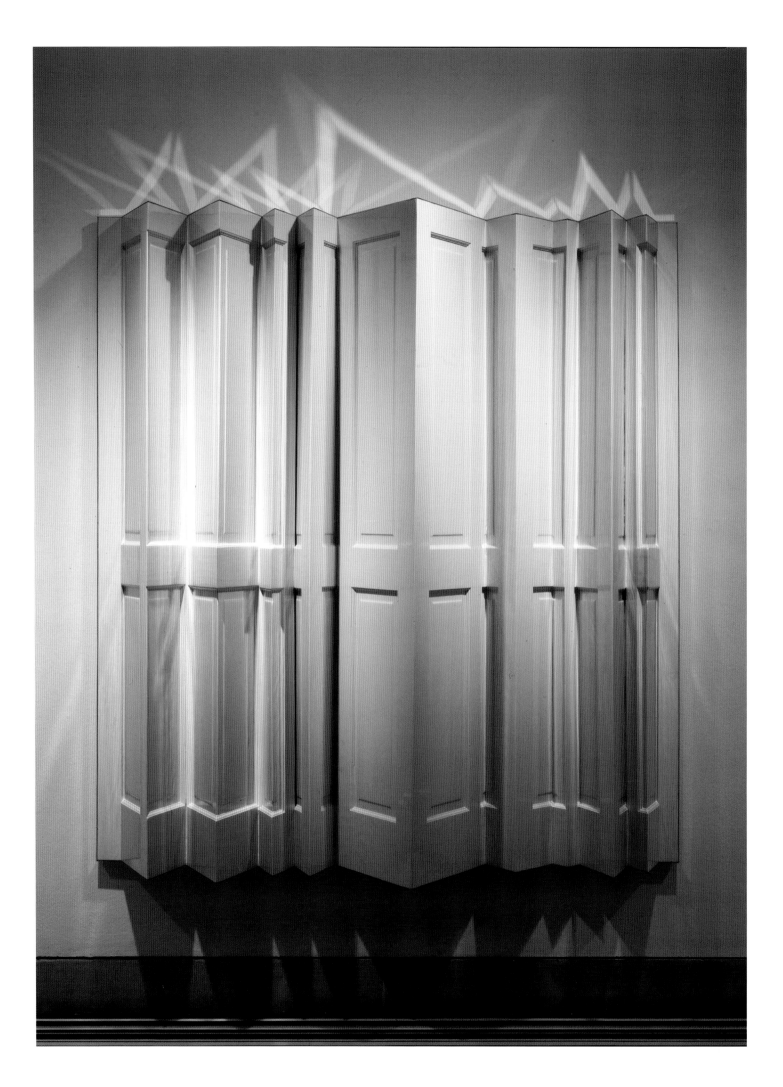

previous: Machine, 2004. Wood, vinyl, glitter, plastic tube, pallettes, cubes. Dimensions variable

opposite: The Doors (Morrison Hotel), 2005. Wooden door, mirrors, gloss paint. 198 × 155 × 198 cm

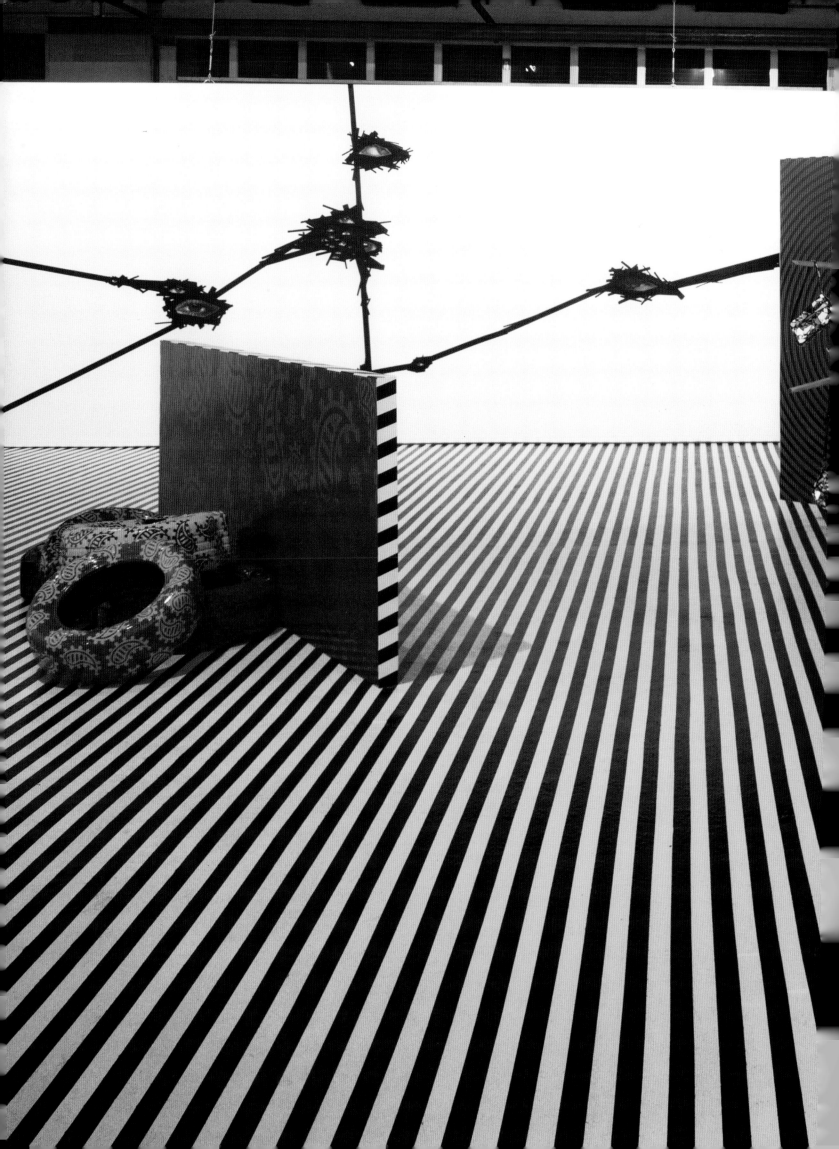

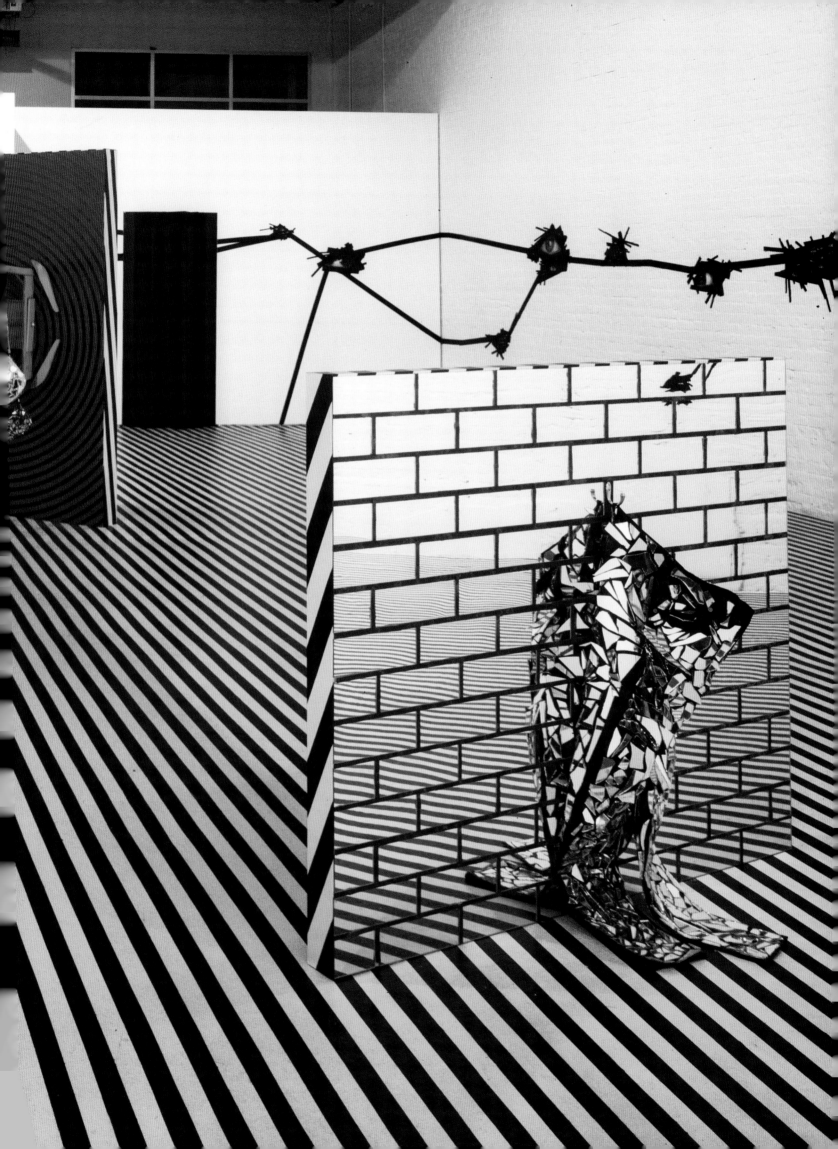

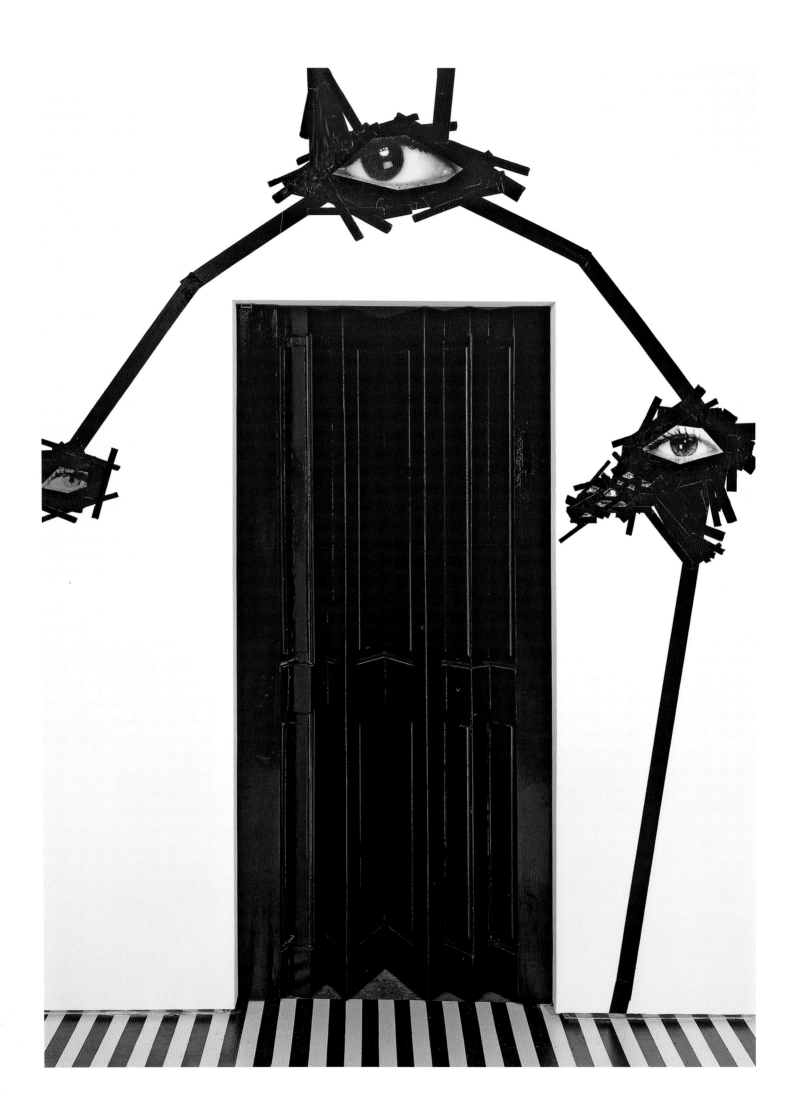

previous: Installation view *Mental Oyster*, Anton Kern Gallery, New York, 2004

opposite: The Doors (Light My Fire), 2004. Wood, gloss paint. 198 × 91 × 38 cm

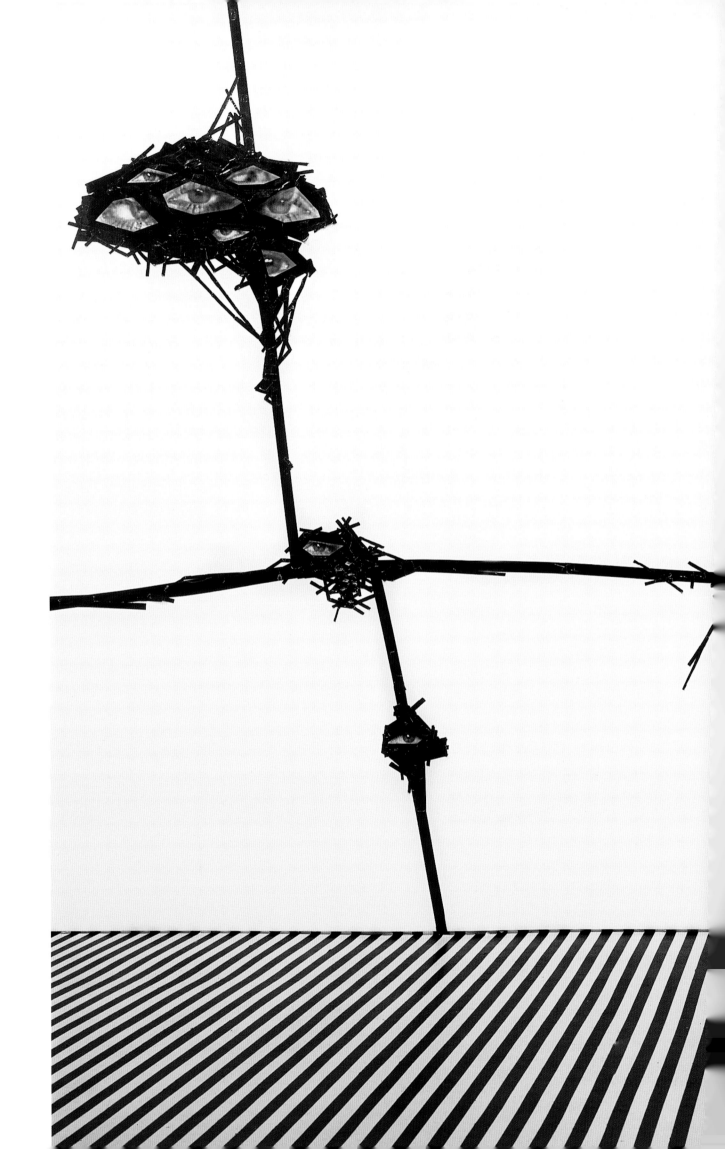

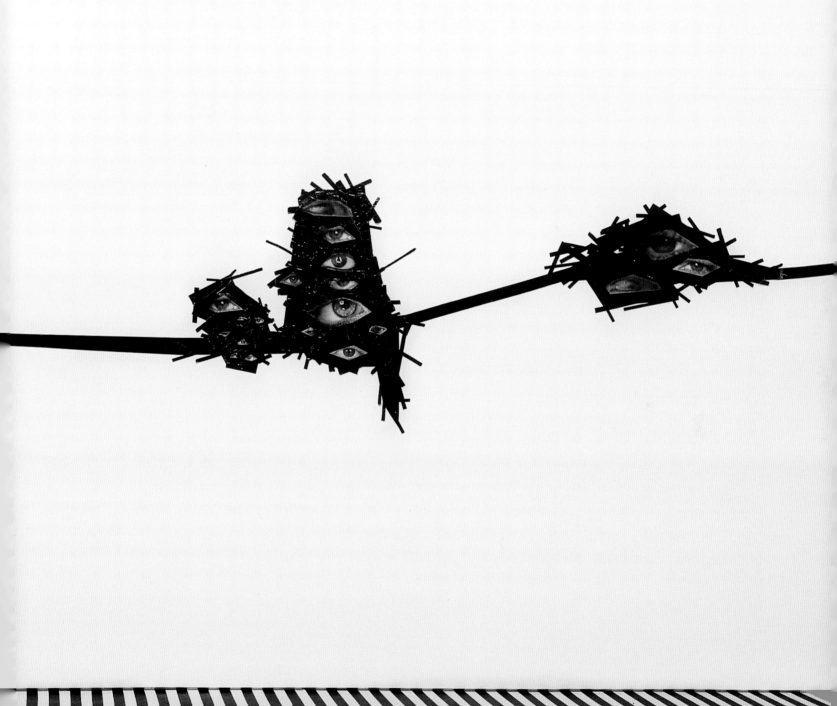

previous: Screamadelica (Surround Sound), 2004. Gaffer tape, transfers. Dimensions variable

184

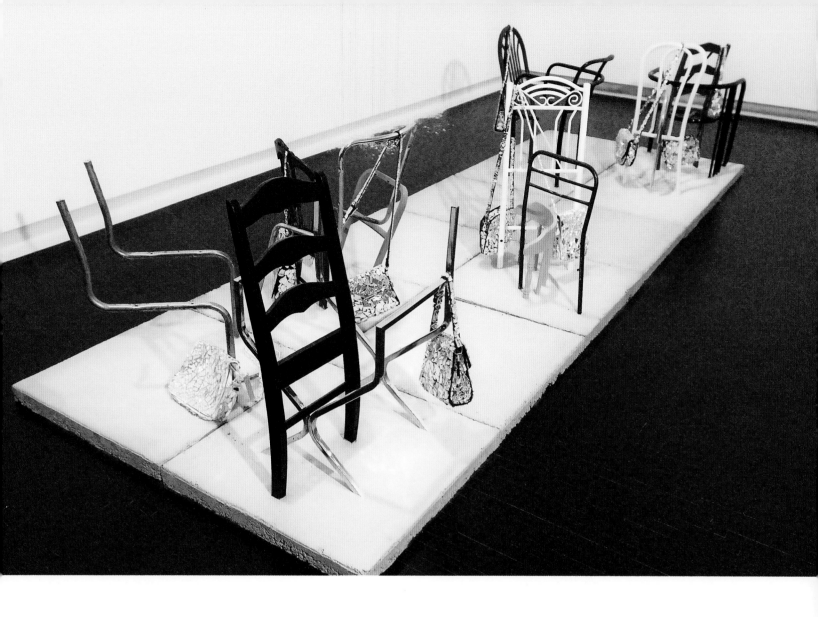

The Jesus and Mary Chain (Part 1), 2004. Concrete, mirror, handbags, chairs. Dimensions variable

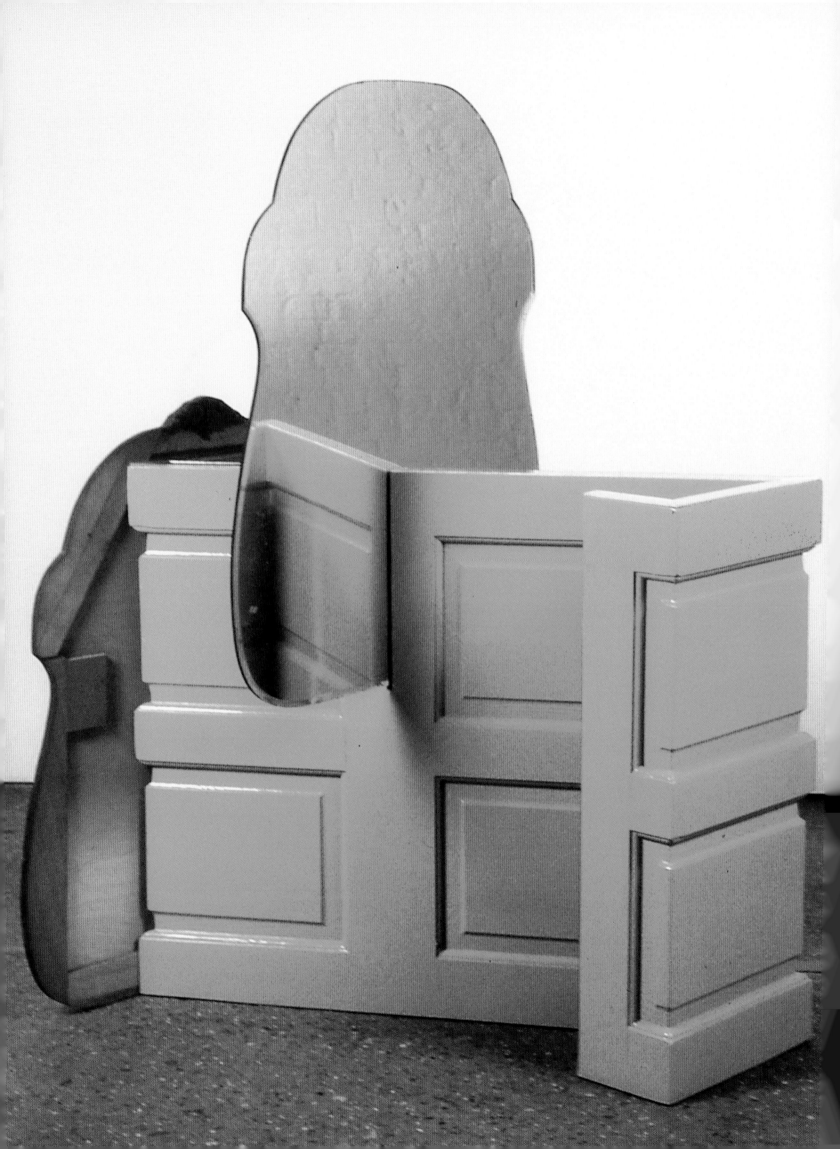

The Doors (Nervous Acid), 2003. Wooden door, mirrors, gloss paint. 86.4 × 91.4 × 66 cm

Zobop Colour (Tate), 1999.
Colored vinyl tape. Dimensions variable

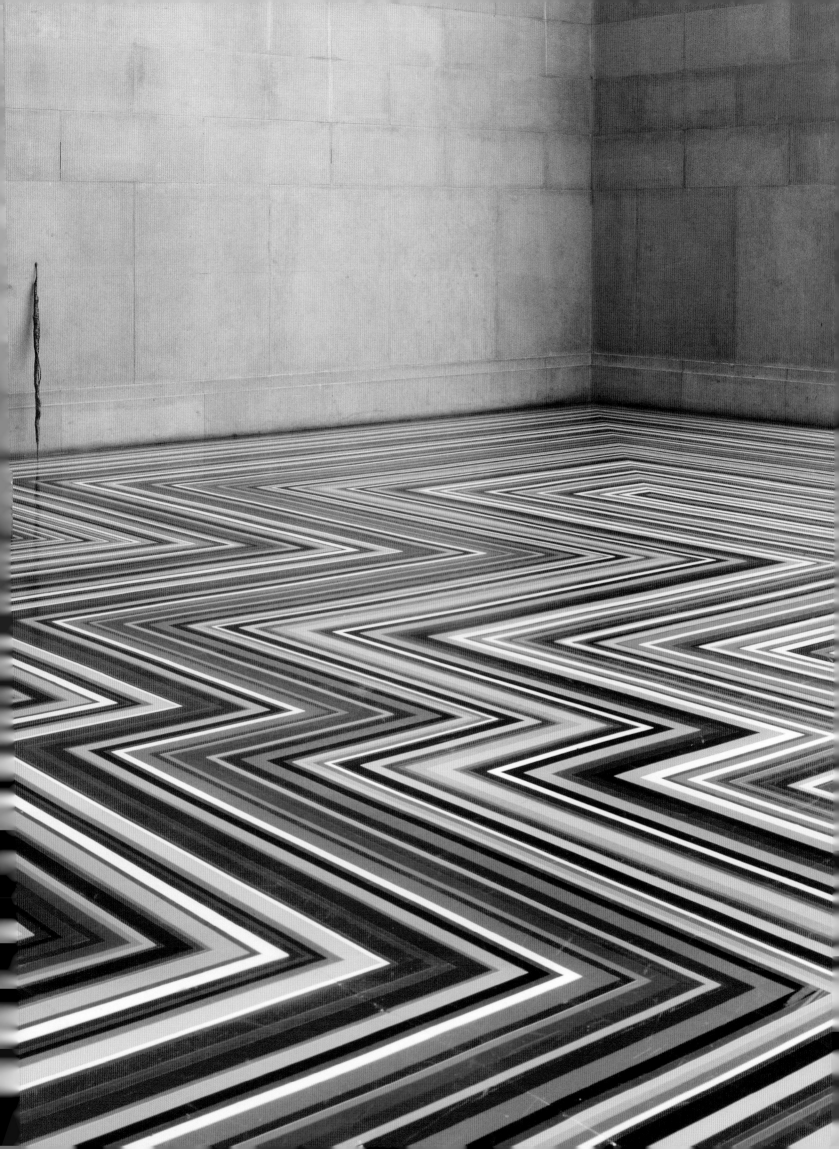

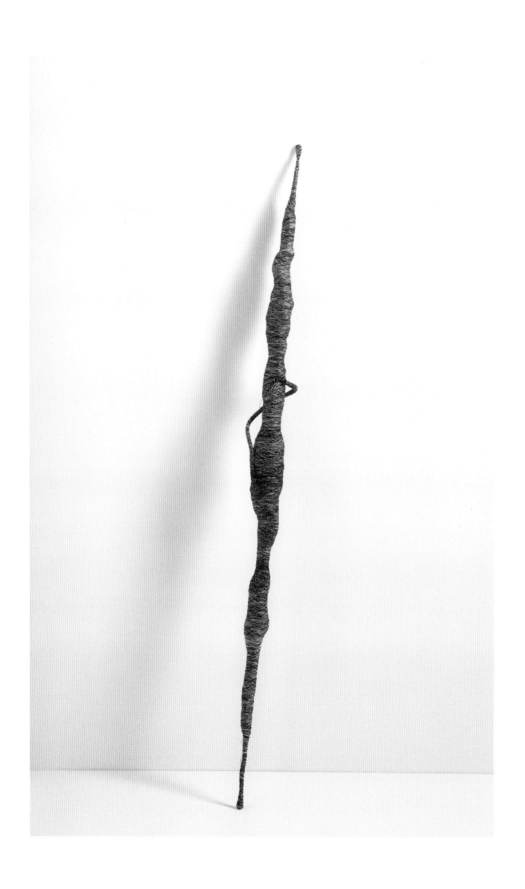

Psychedelic Soul Stick 43, 2003. Bamboo, wire, thread, guitar strap, cigarette packet, sock, badges. 121.9 × 10.2 × 7 cm

opposite: The Doors (Humanizer), 2003. Gloss paint, wood, mirror. 170.6 × 82 × 20 cm

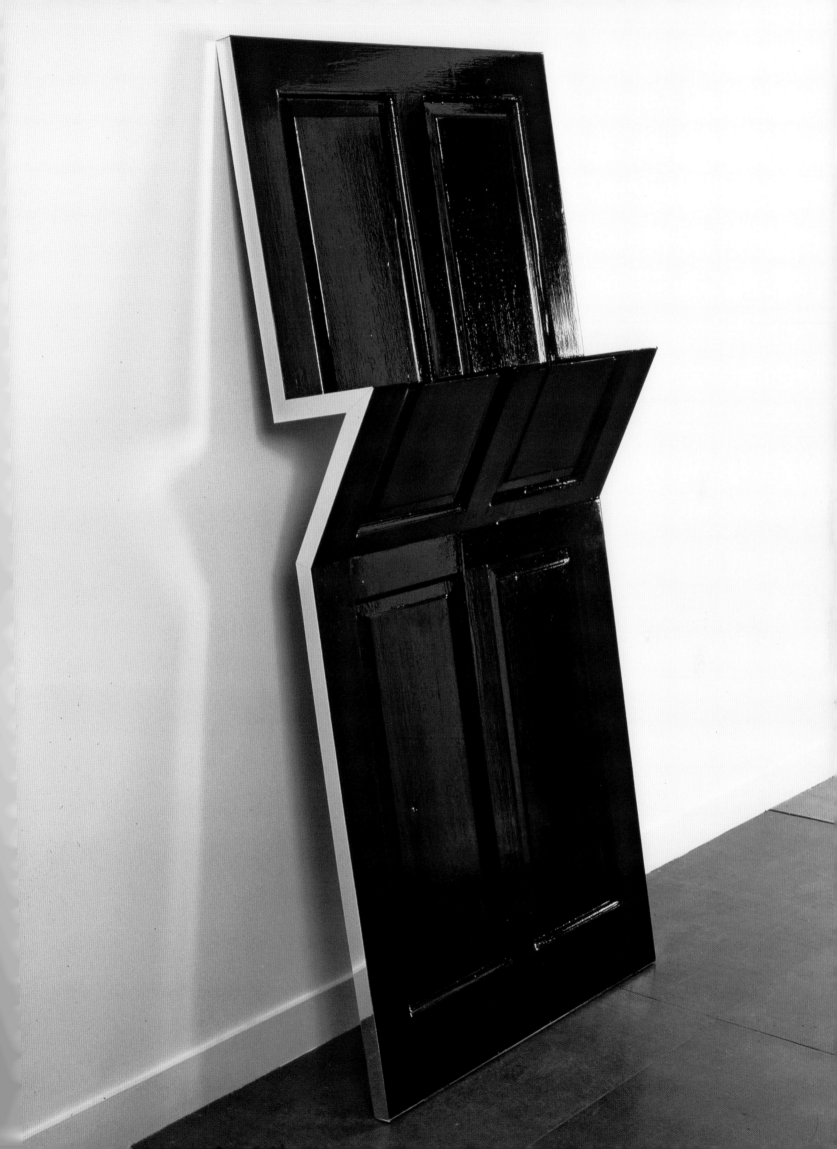

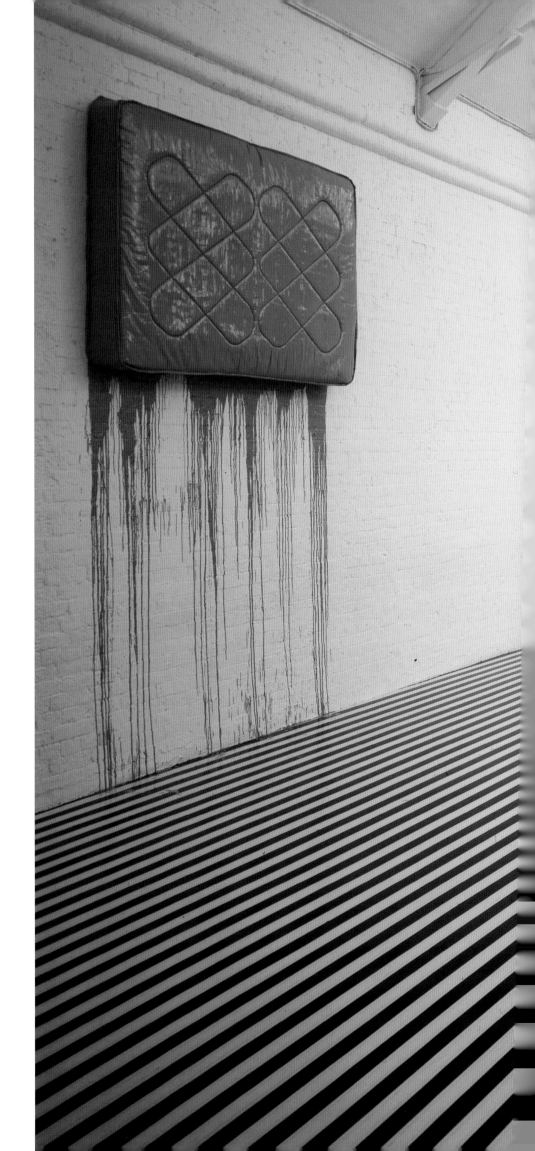

Installation view *Male Stripper*,
Modern Art Oxford, Oxford, 2003

overleaf: Installation view *Kebabylon*,
Inverleith House, Edinburgh, 2003

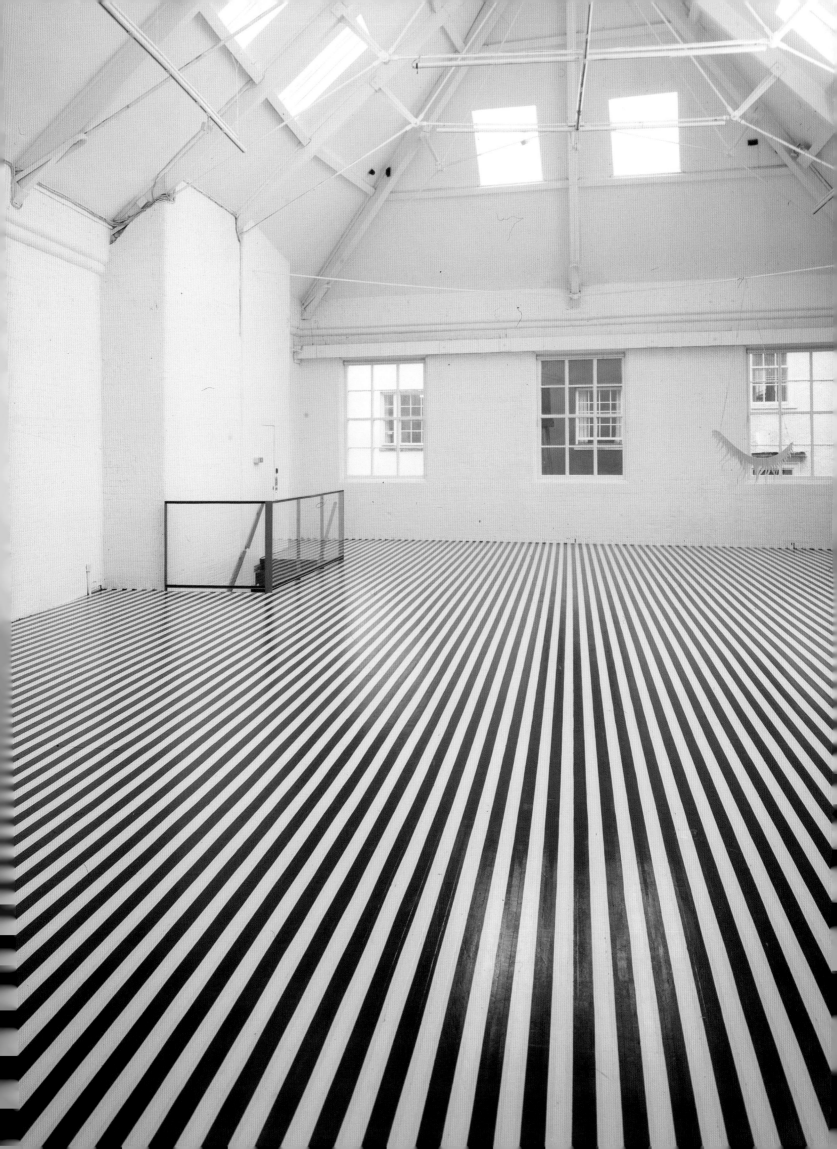

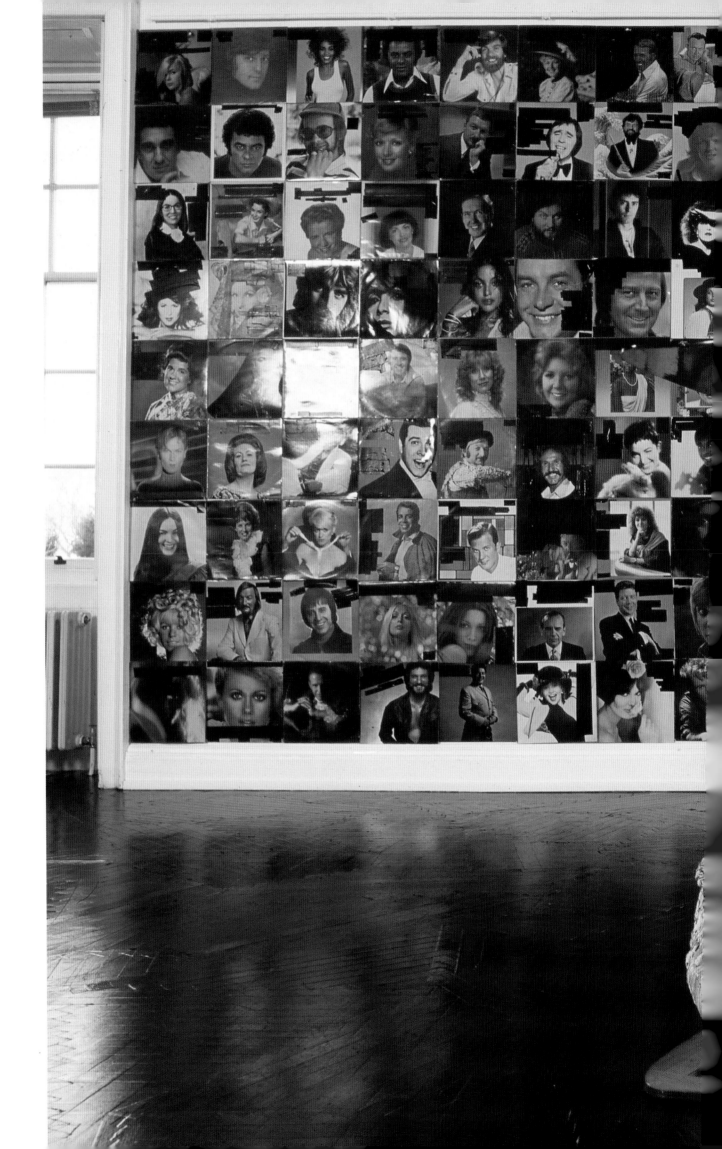

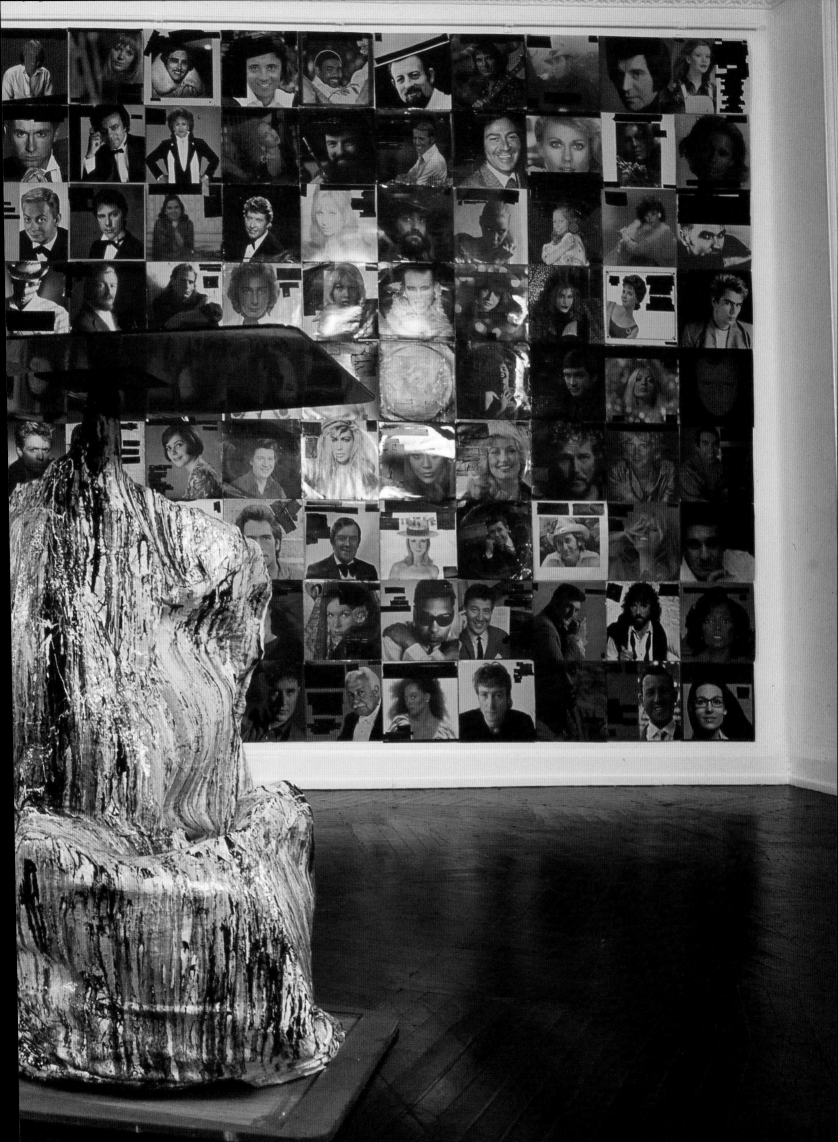

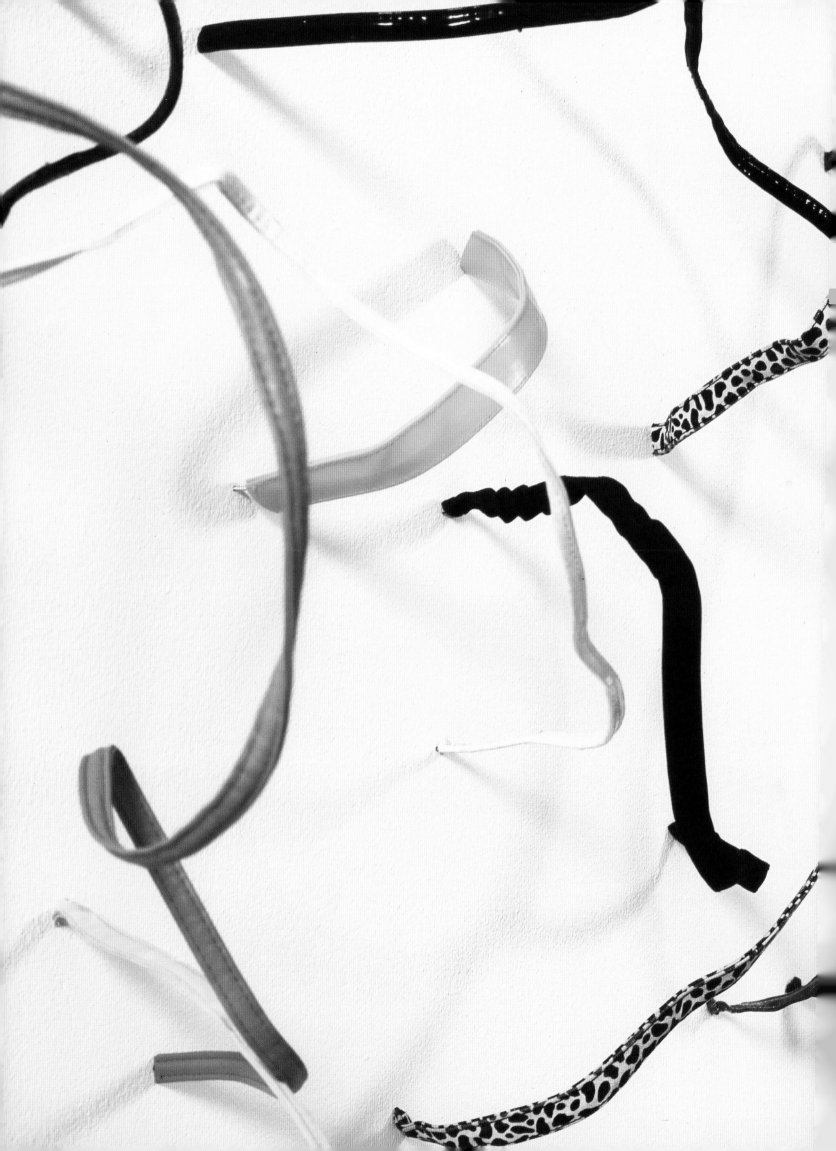

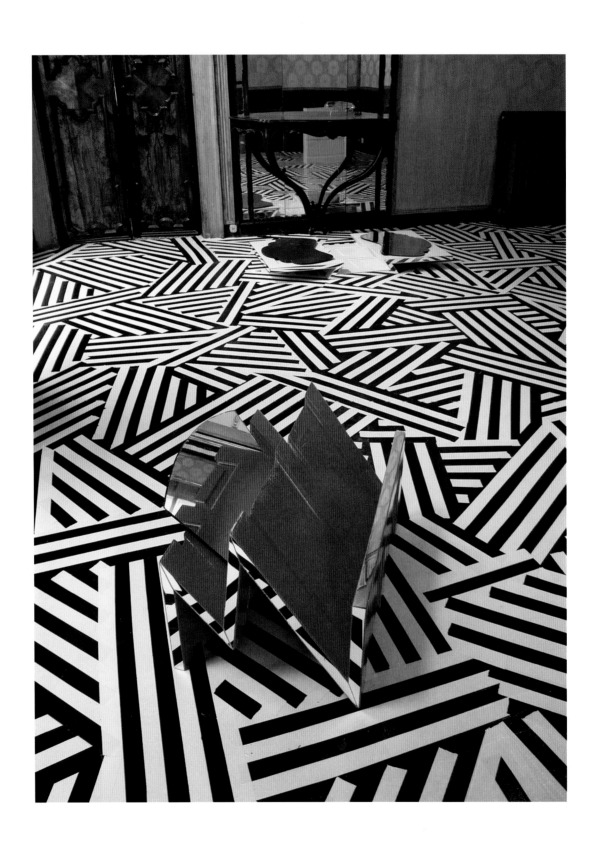

previous: Span Dancing (Full Room)(detail), 2003. Handbag straps, wire. Dimensions variable

Installation view *ZENOMAP - New Works from Scotland for the Venice Biennale*, 50th Venice Biennale, Venice, 2003

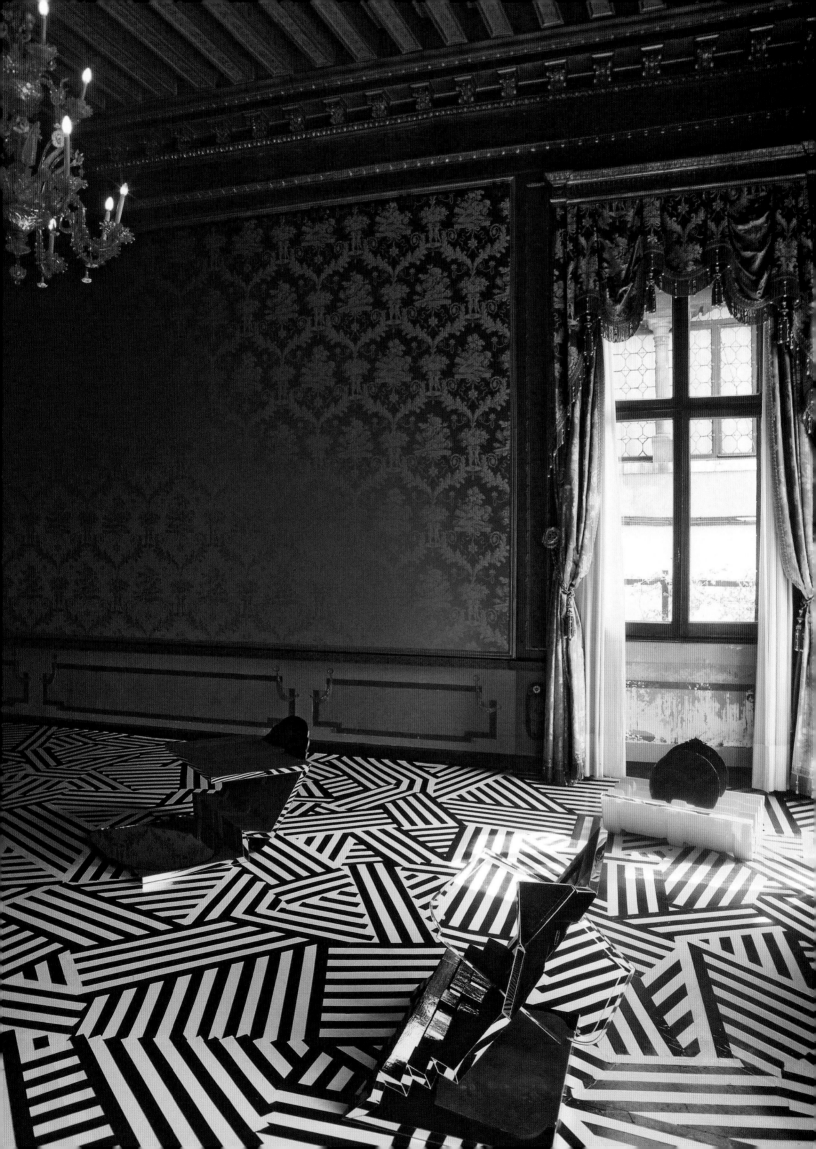

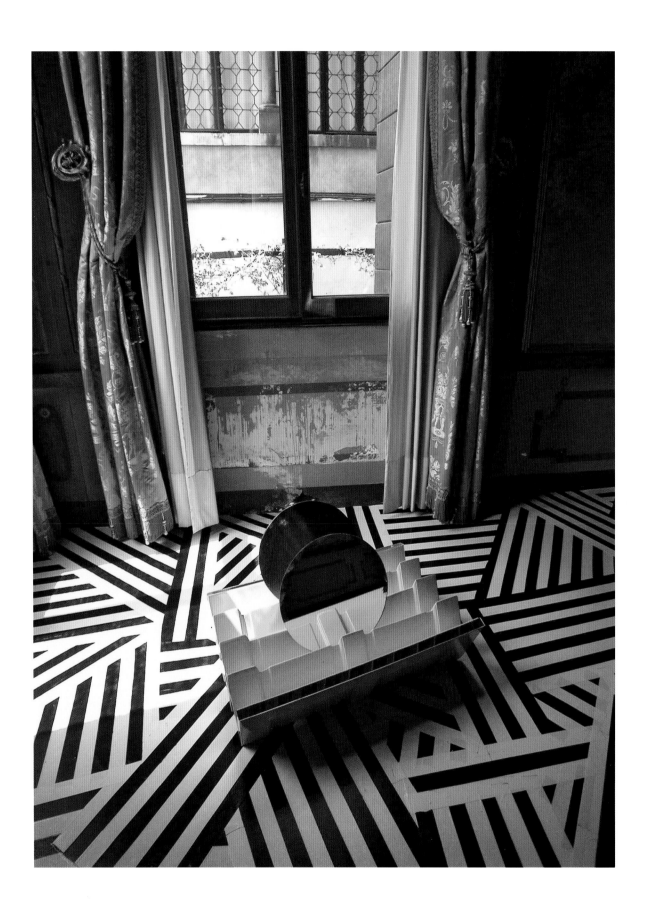

The Doors (Sun Palace), 2003. Wooden door, mirrors, gloss paint, mirror strips. 51 × 57 × 77 cm

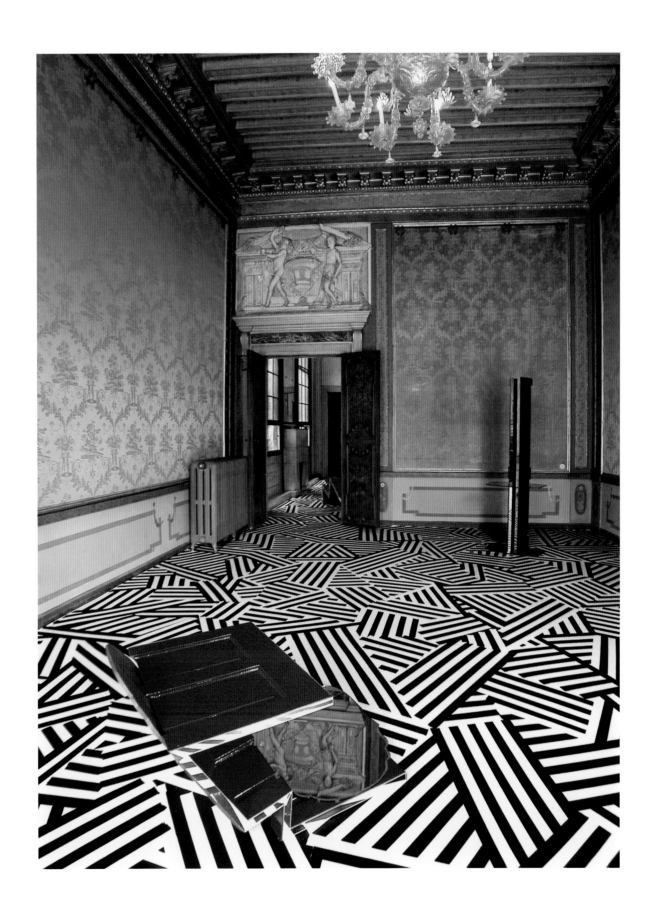

Installation view *ZENOMAP - New Works from Scotland for the Venice Biennale*, 50th Venice Biennale, Venice, 2003

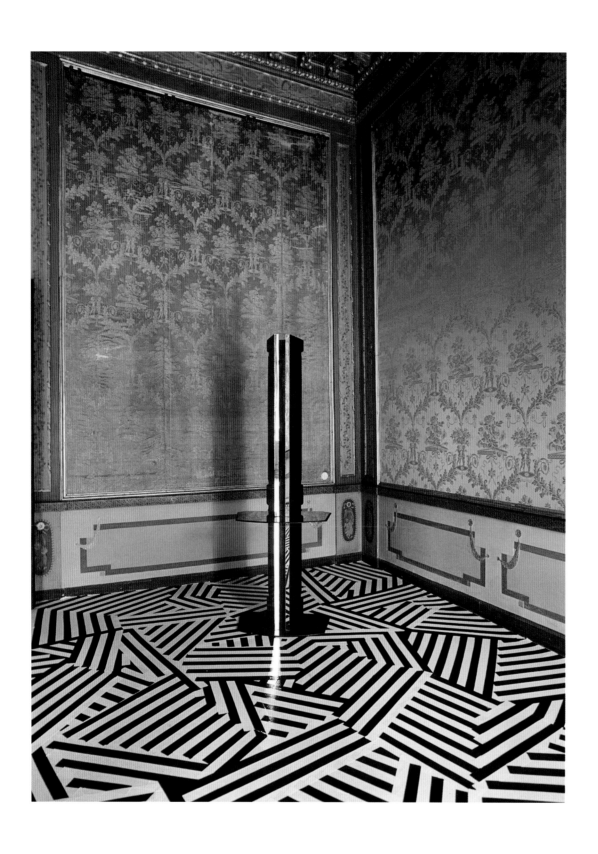

The Doors (Freak-a-Zoid), 2003. Wooden door, mirrors, gloss paint, mirror strips. 200 × 45 × 70 cm

The Doors (Futura Deluxe)(detail), 2003. Wooden door, mirrors, gloss paint. 64 × 120 × 77 cm

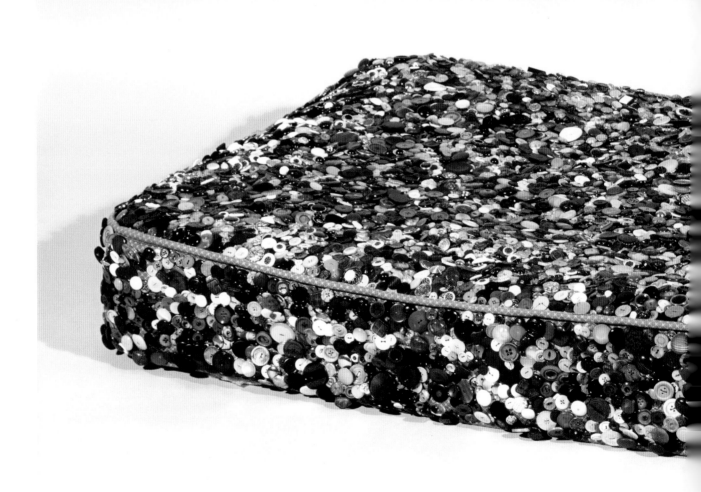

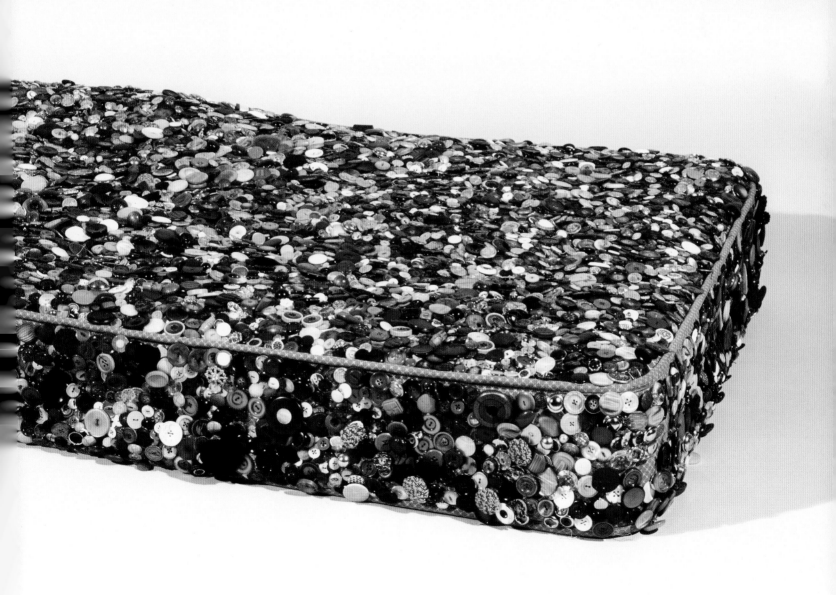

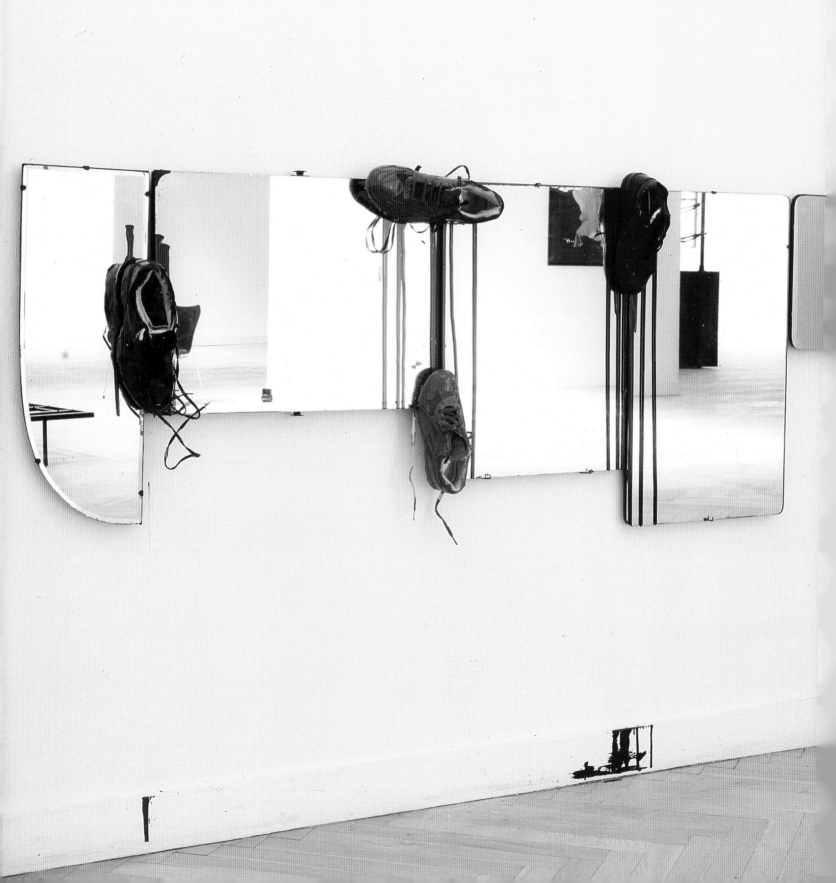

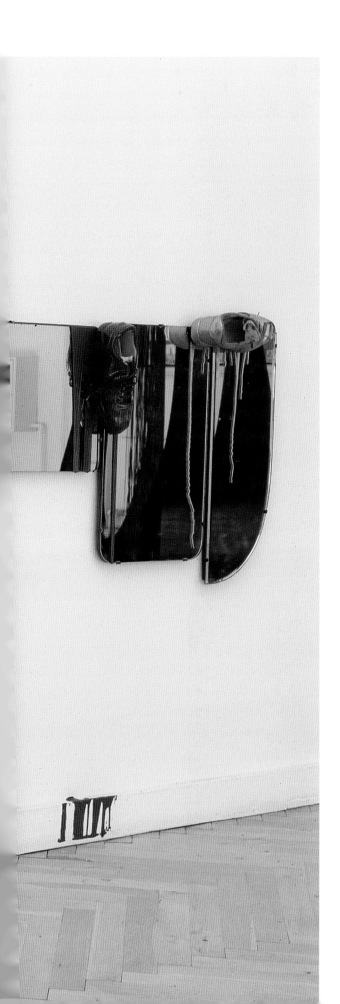

previous: Bed Head, 2002.
Mattress, buttons, thread. 19 × 191 × 93 cm

Bleached Highlights, 2002.
Mirrors, trainers, gloss paint. 74 × 300 × 20 cm

It's Automatic I & II (detail), 2002. Ceramic, gloss paint. Dimensions variable

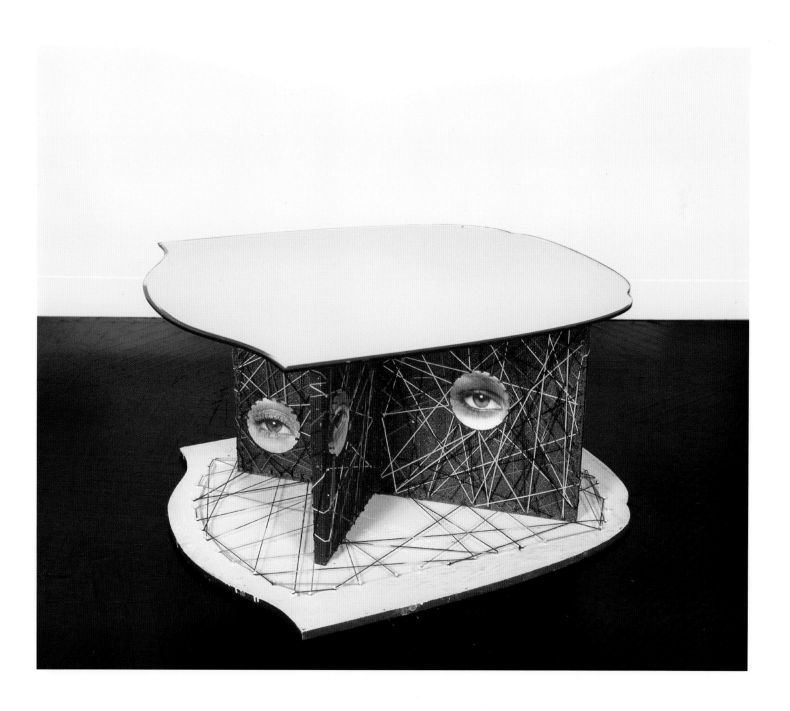

We Become One With The Drum, 2002. Mirror, wool, MDF. 39.5 × 68 × 84 cm

previous: Vitalic Muscle, 2002. Mirror, duct tape, wire mesh. 65 × 135 × 29 cm

French Kiss, 2002. Wood, mirror, metal hooks, mirrored perspex. 81 × 66 × 56 cm

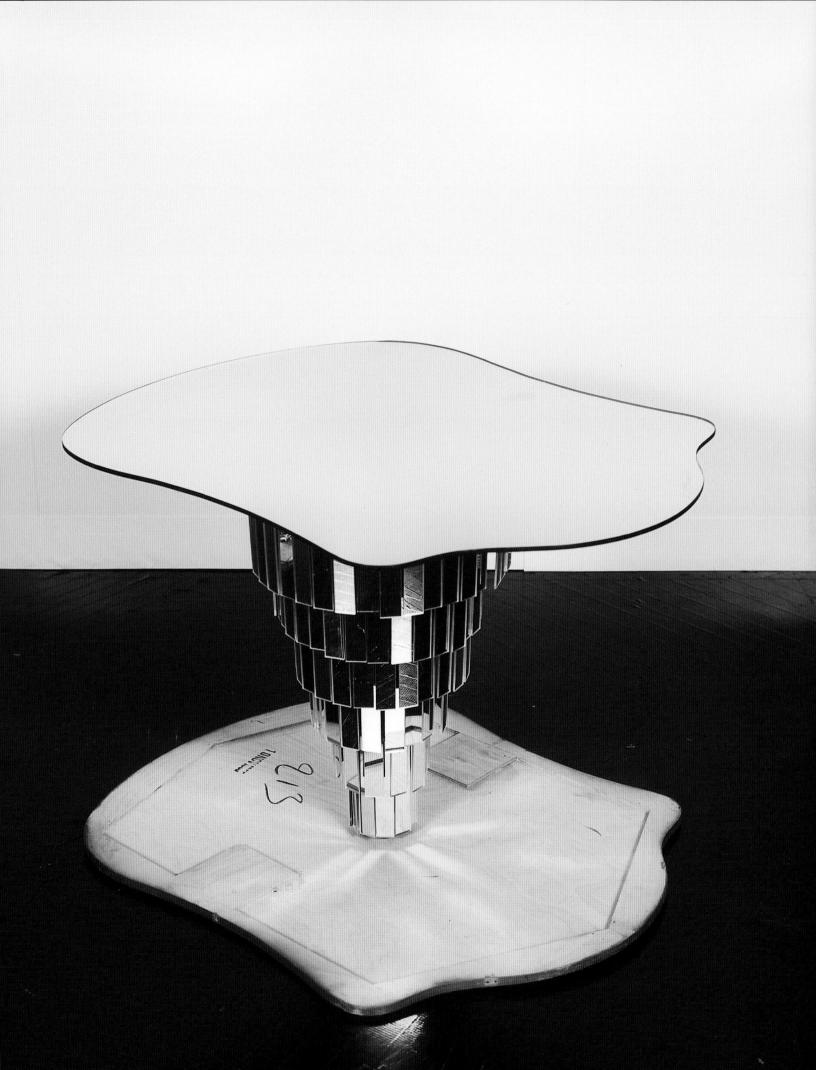

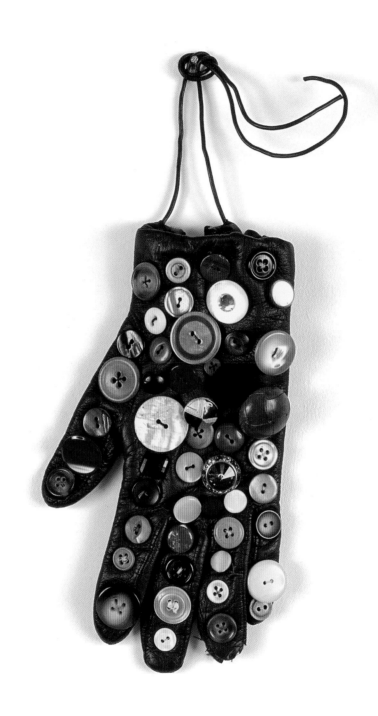

New Wave (formerly The First Wave), 2001. Glove, buttons. 25 × 15 cm

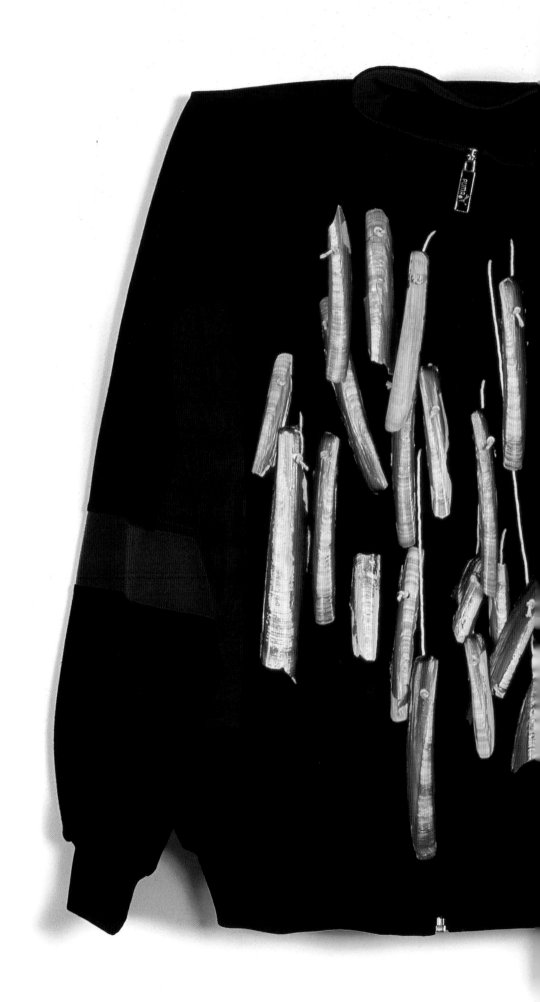

217 Shellsuit, 2001. Jacket, strings, shells. 65 × 59 cm

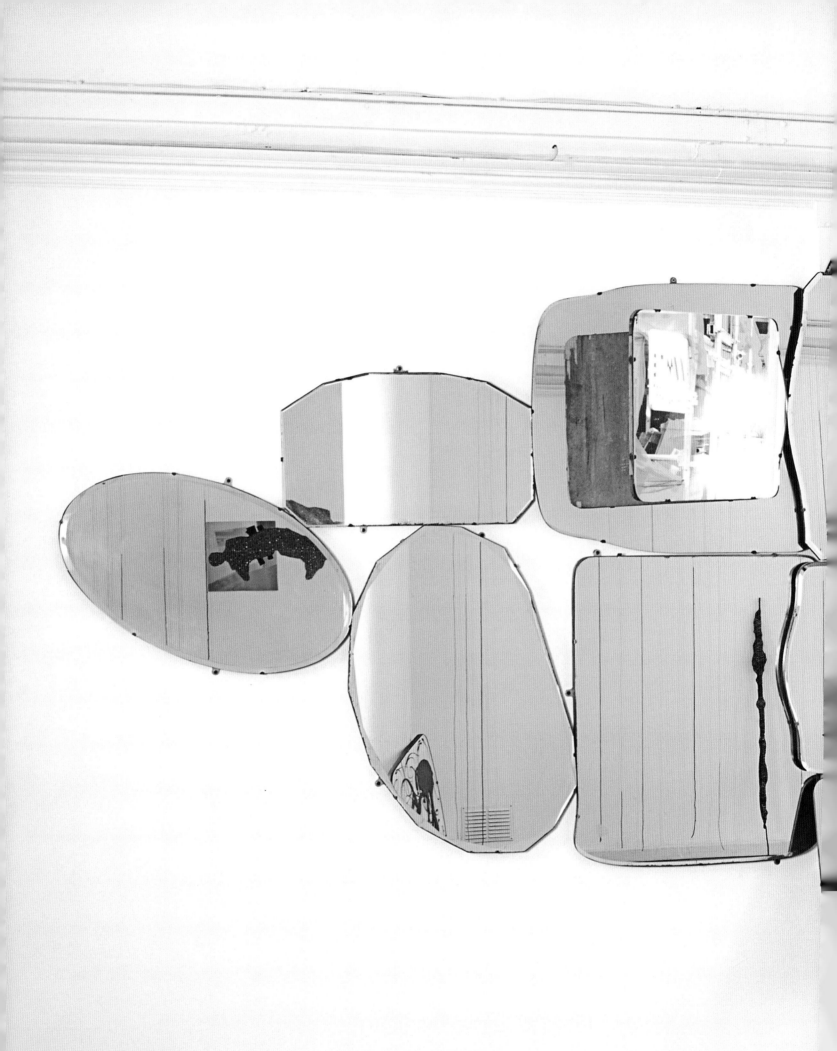

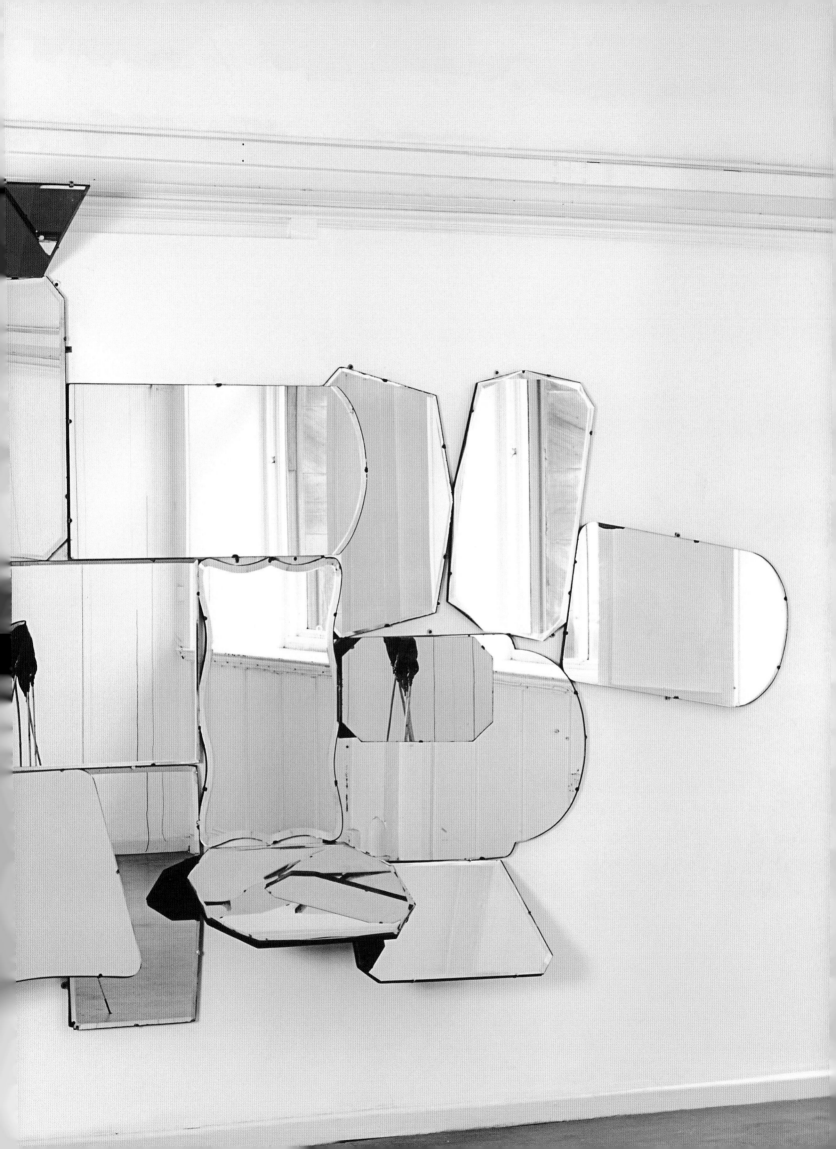

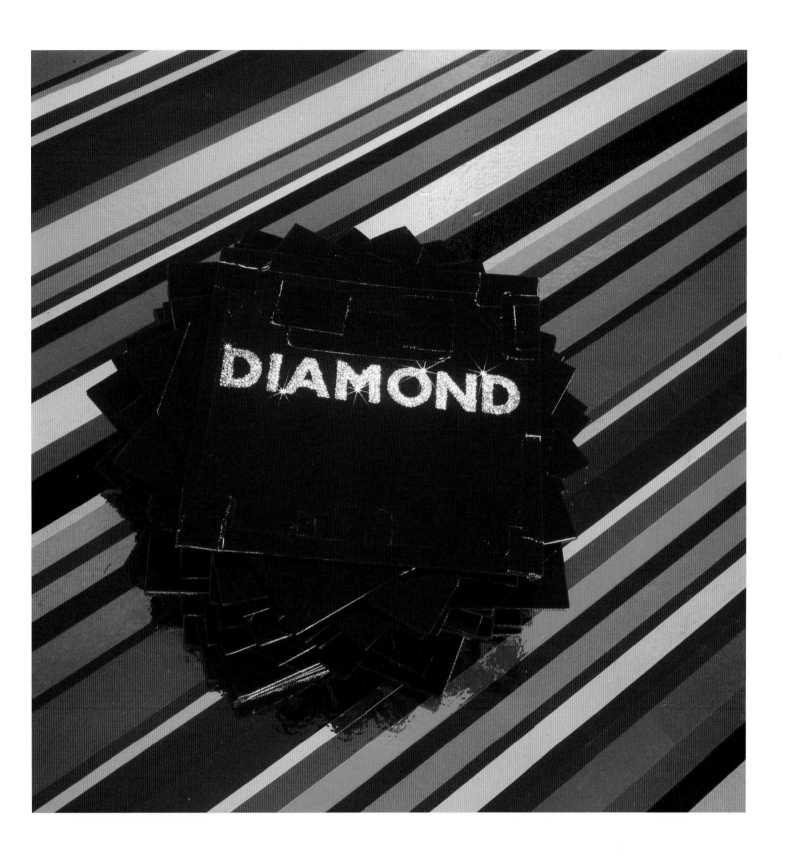

Diamond, 2000. Record sleeves, duct tape. 14 × 50 × 50 cm

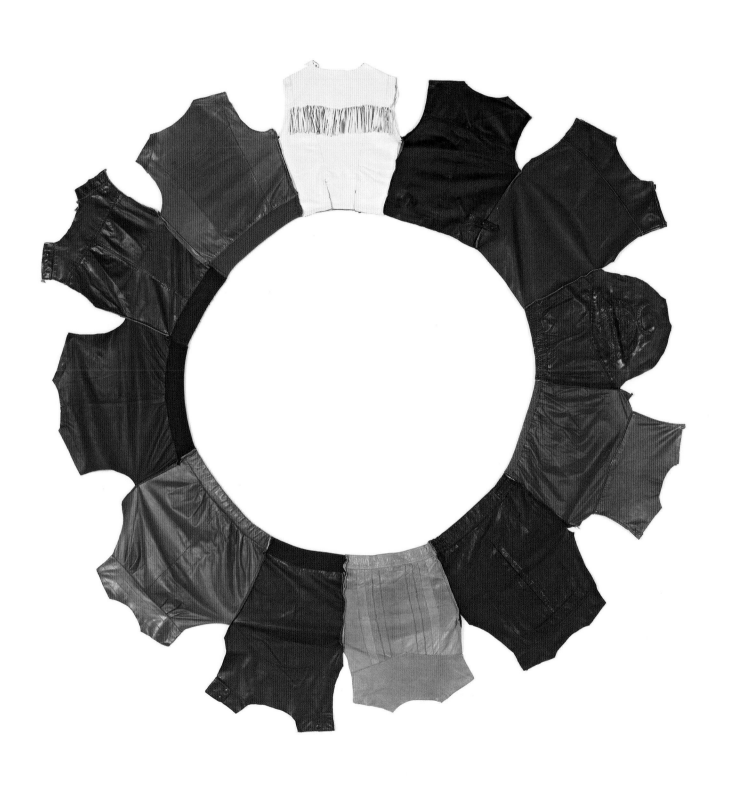

Digital (New York), 1999. Leather jackets, velcro. 271 cm diameter

opposite: Leatherette, 1999. Leather, wadding. 61 × 91.4 × 96.5 cm

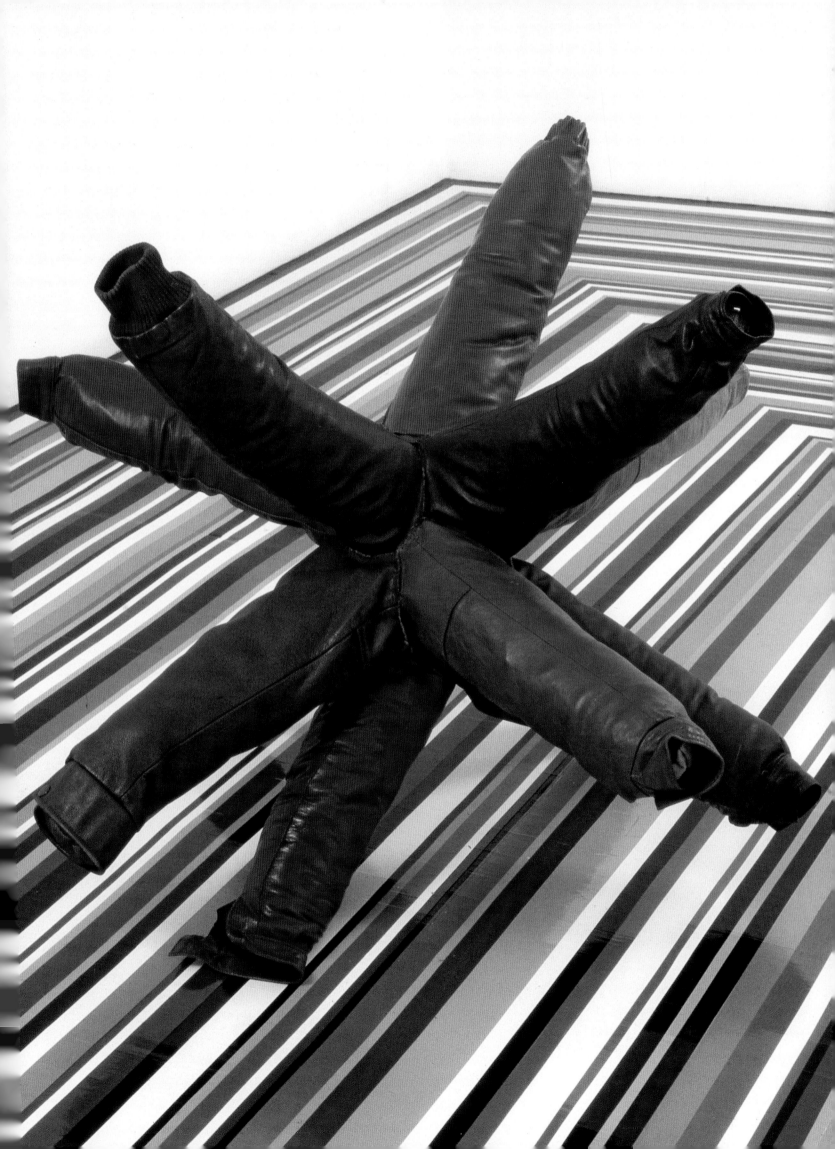

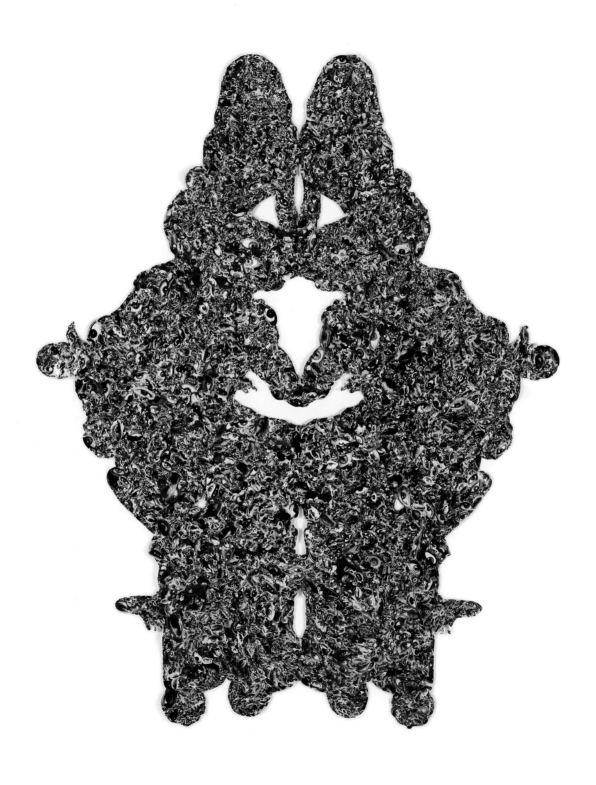

225 Weird Glow, 1999. Collage eye poster. 100 × 100 cm

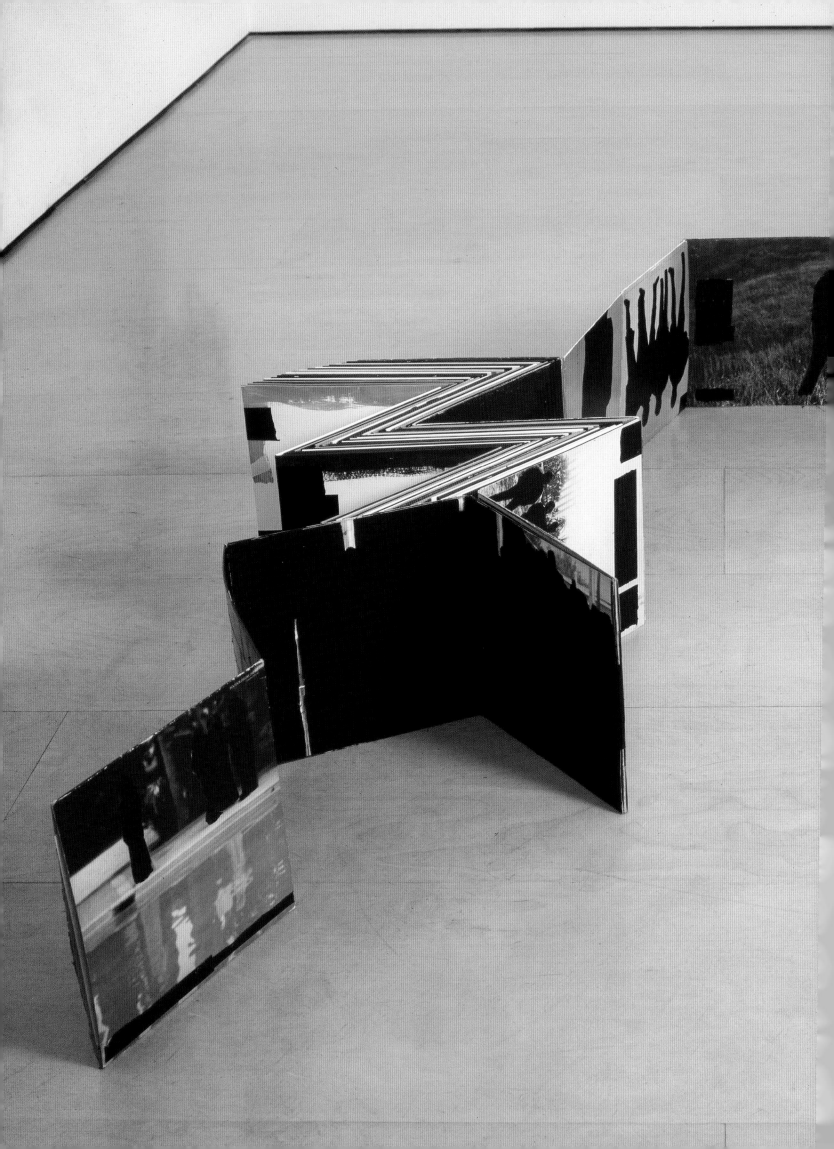

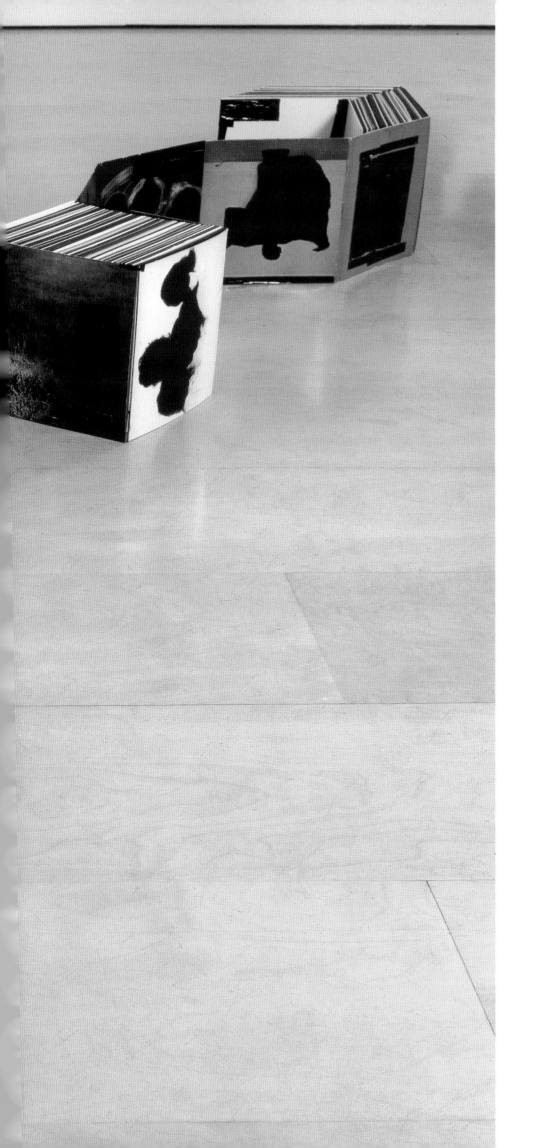

Stakka, 1999.
Album covers, tape, blank record
sleeves, acrylic paint.
31 × 348 × 89 cm

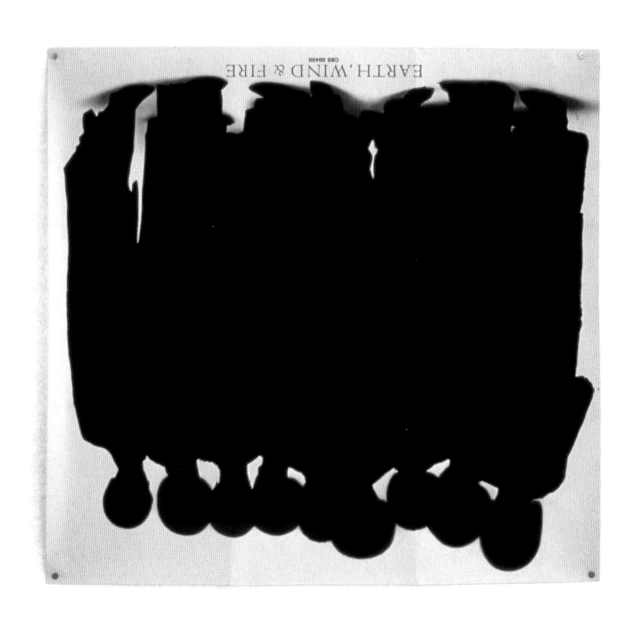

Earth, Wind and Fire, 1998. Acrylic paint on poster. 50 × 70 cm

opposite: Psychedelic Soul Stick 1, 1999. Bamboo, thread, wire, mixed media. 150 × 10 cm

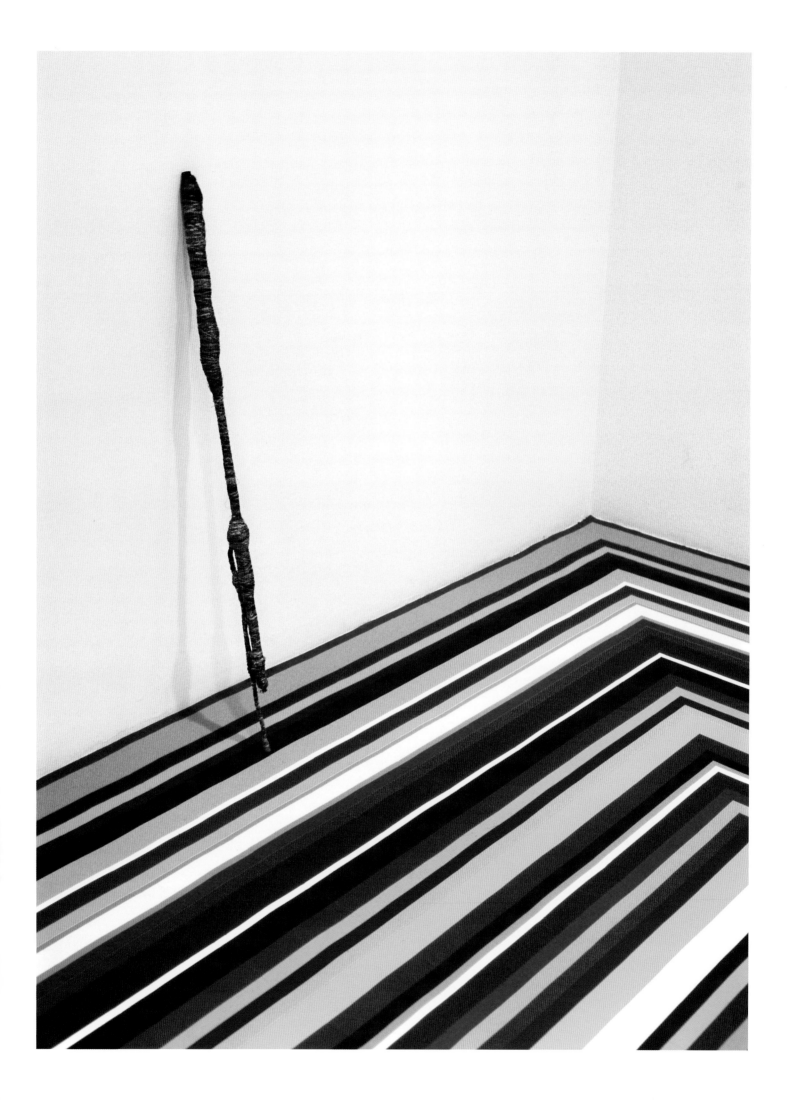

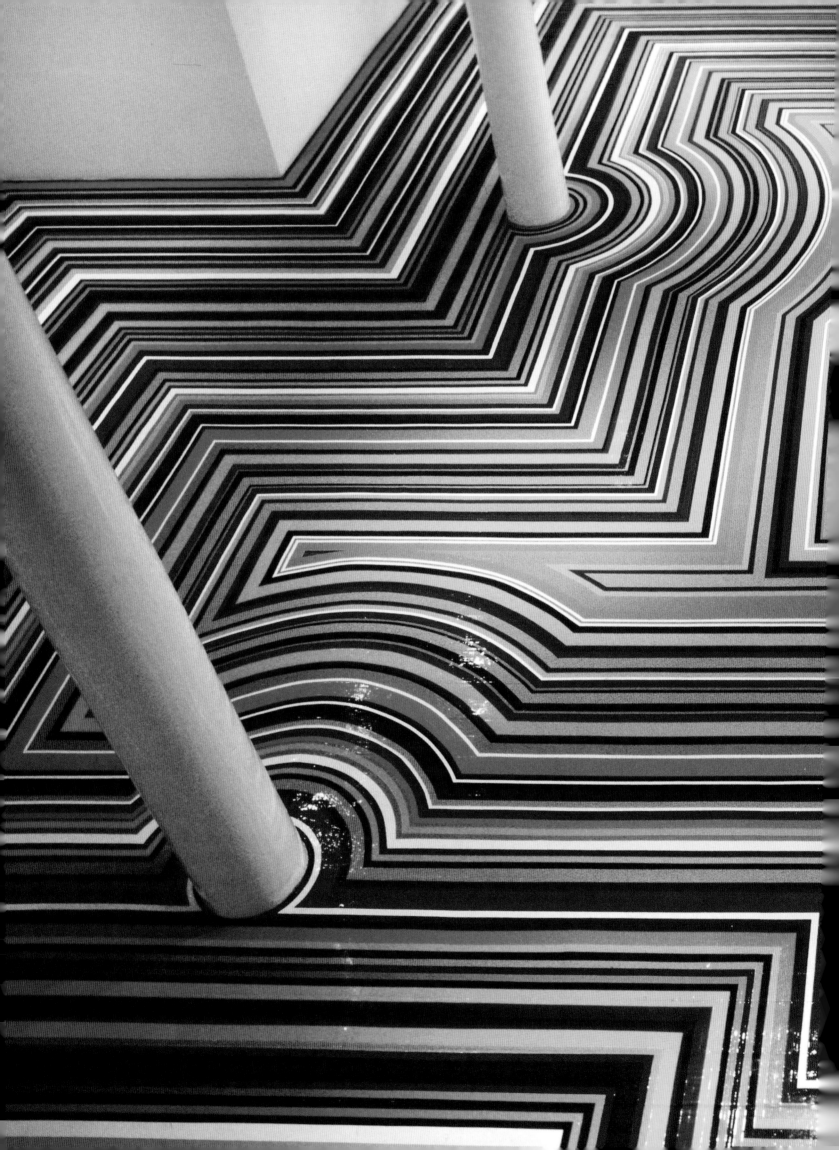

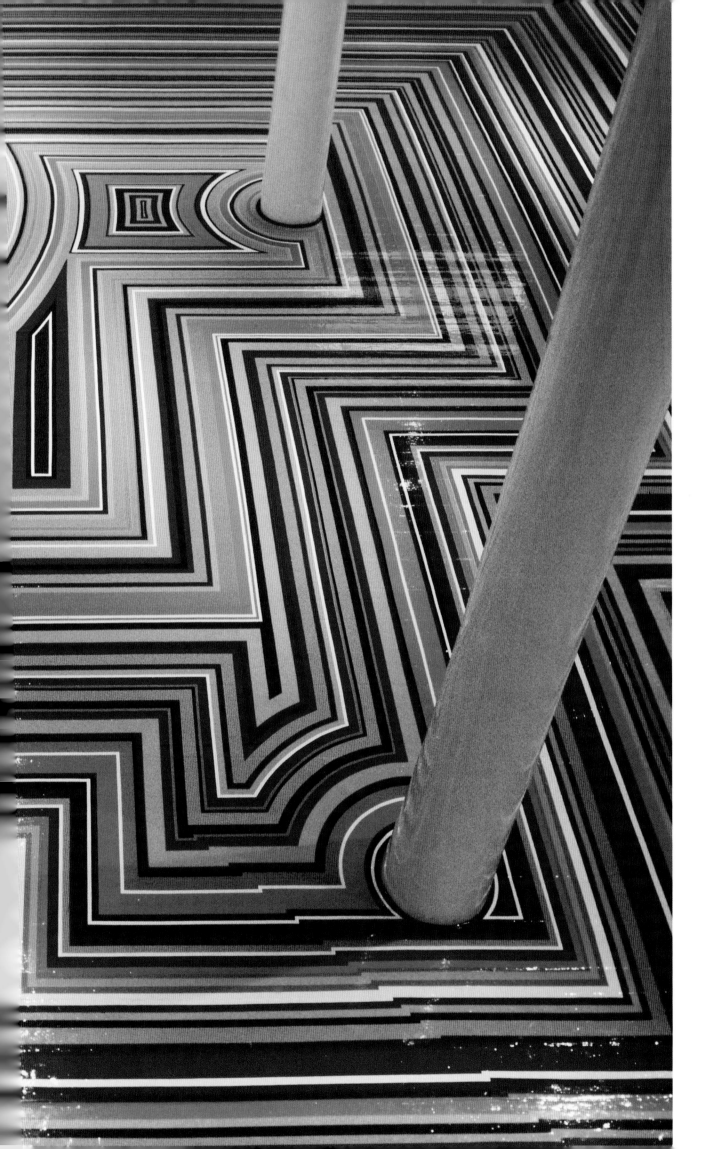

previous: Zobop Colour, 1999. Colored vinyl tape. Dimensions variable

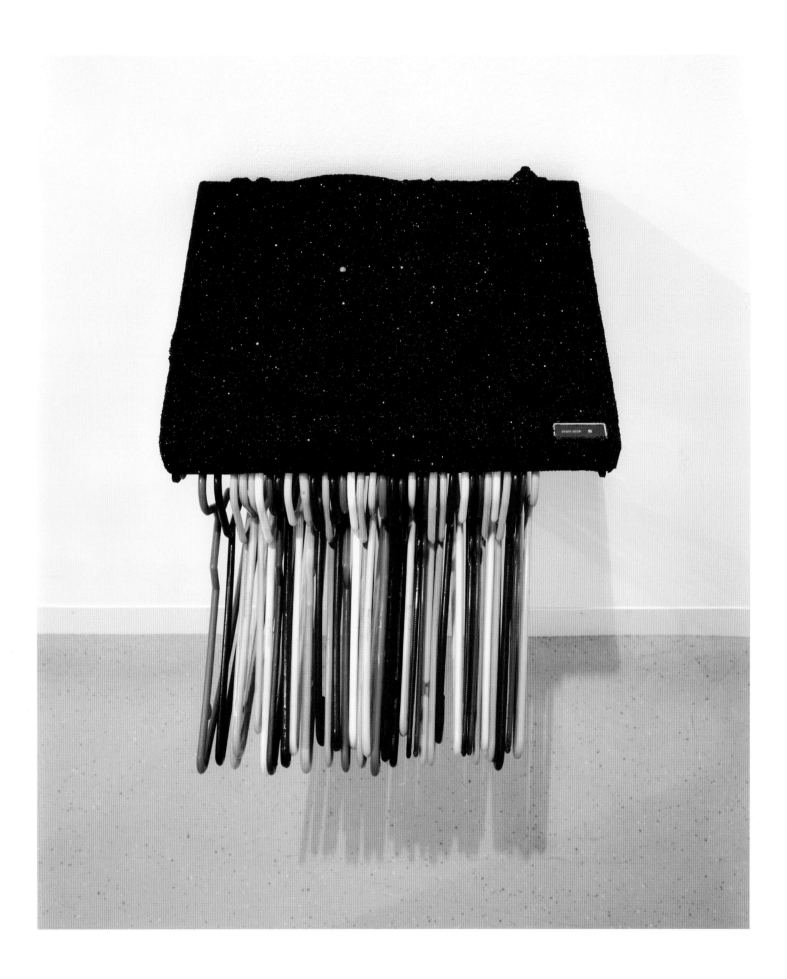

233 Roadie, 1999. Record player, coat hangers, and mixed media. 38 × 42 × 56 cm

GREEK
COURT W1
CITY OF WESTMINSTER

GARR

FIRE
EXIT
DUMPING OF REFUSE
IS PROHIBITED

OFFENDERS WILL BE REPORTED
TO WESTMINSTER COUNCIL

CLOSED CIRCUIT T.V.
SURVEILLANCE IS OPERATION
WITH ON-SITE RECORDING

FIRE EXIT NO RUBBISH
DO NOT OBSTRUCT BY ORDER OF
 WESTMINSTER CO

H

ANORA

LAMA
FARMERS

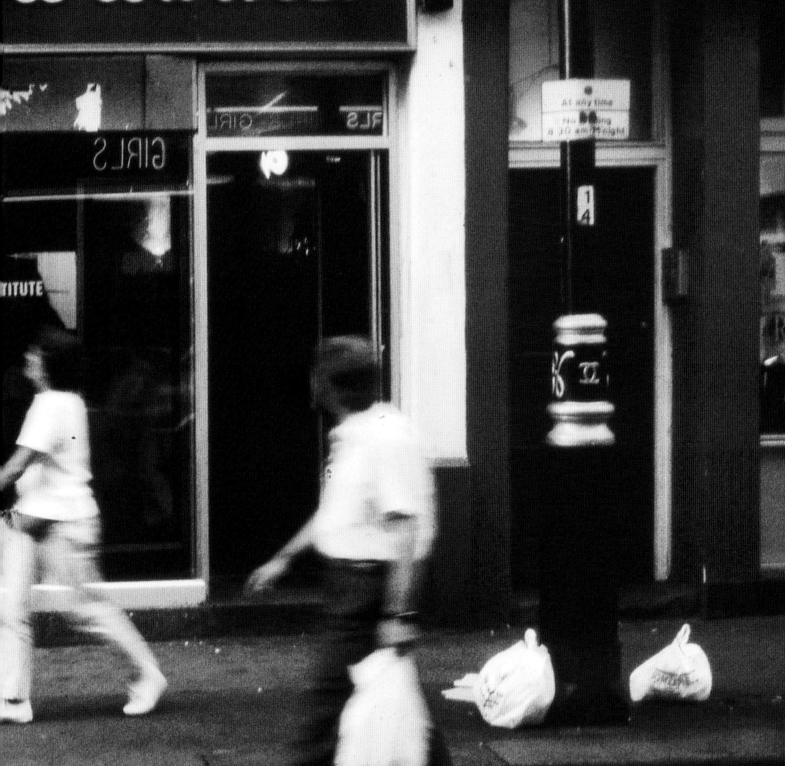

previous: Ultralow,
The Modern Institute, video screening
at Carnival, London, 1998

Ultralow (still), 1998/2007
Video. Duration 21 min

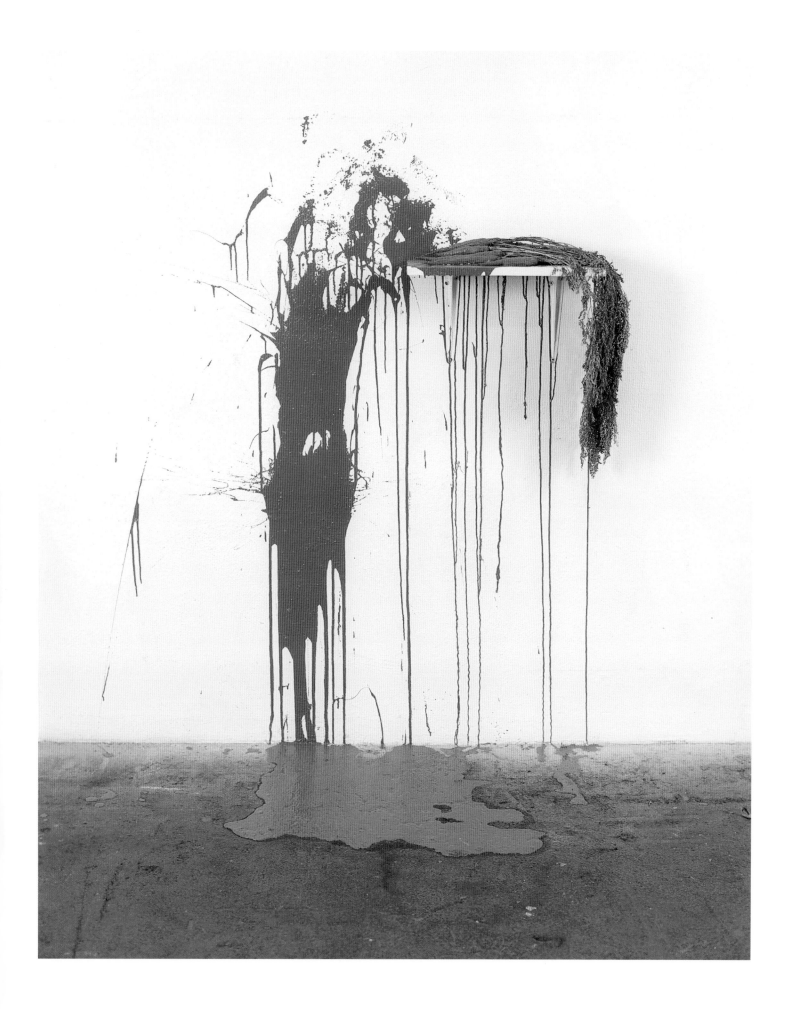

18 Carrots, 1996. Carrots, paint. Dimensions variable

Two Shirts, 1996. Duct tape, aluminium foil, shirts. 34 × 62 × 8 cm installed dimensions

243 The Kid with the Replaceable Head, 1996. Aluminium foil, underpants. 30 × 30 × 23 cm

CHECKLIST *OF* ARTWORKS

Cover
METAL BOX (YOU CAN'T HIDE
YOUR LOVE FOREVER), 2011
125 × 187.5 × 33 cm
49.2 × 73.8 × 13 in
Collection of Aishti Foundation,
Beirut, Lebanon
Photo Ruth Clark

Endpapers
SPIN DRY, 2014
214 × 182 × 61 cm
84.3 × 71.7 × 24 in
Collection of Maurice Marciano,
Los Angeles
Photo Ruth Clark

Endpapers, front
ULTRA-GLOW (detail), 2016
222 × 161 × 43 cm
87.4 × 63.4 × 16.9 in
Courtesy of The Modern Institute/
Toby Webster Ltd, Glasgow
Photo Max Slaven

Endpapers, back
INDIAN SUMMER (detail), 2016
222 × 161 × 39 cm
87.4 × 63.4 × 15.4 in
Courtesy of The Modern Institute/
Toby Webster Ltd, Glasgow
Photo Max Slaven

Poetry Club images
Page 9
PARAPHERNALIA PHOTO SHOOT, 2014
Photo Jason Macphail

Pages 10–11
SO LOW, March 28, 2015
Photo Katie Shannon

Pages 12–13
Clockwise from top left:
1. GERARD MALANGA
AND PAM HOGG,
April 4, 2014
2. SO LOW, March 28, 2015
Photo Katie Shannon
3. PRIMAL SCREAM,
June 14, 2014
Photo Ryan S McGill
4. THE POETRY CLUB
Photo Kirsty Mellon
5. HENRY GRIMES' THE MAGIC
SCIENCE QUARTET,
October 2, 2015
Photo Malcolm Cochrane
6. VOX POP PRESENTS CASUAL
ENCOUNTERS,
April 12, 2015
Photo Kirsty Mellon
7. GO KART MOZART,
February 23, 2013
Photo Mark Dickie
8. PERFECT BOYFRIENDS,
March 14, 2014
Photo Perfect Boyfriends
Center left to right:
1. Photo Ryan S. McGill
2. Photo Ryan McGoverne
3. Photo Malcolm Cochrane

Pages 14–15
Clockwise from top left:
1. LINTON KWESI JOHNSON,
April 8, 2016
Photo Malcolm Cochrane
2. PATTI SMITH,
August 12, 2013
Photo Ryan S. McGill
3. GABRIELLA BENNETT, PARAPHERNALIA,
November 14, 2014
Photo Ryan S. McGill

Pages 16–17
Left: RICHARD HELL,
April 20, 2012
Photo Mark Dickie
Right: JOHN GIORNO,
June 14, 2014
Photo Ryan S. McGill

Page 25
ULTRA-GLOW, 2016
222 × 161 × 43 cm
87.4 × 63.4 × 16.9 in
Courtesy of The Modern Institute/
Toby Webster Ltd, Glasgow
Photo Max Slaven

Page 26
Installation view ELECTROLUX,
The Modern Institute, Osborne
Street, Glasgow, 2016
Courtesy of The Modern Institute/
Toby Webster Ltd, Glasgow
Photo Max Slaven

Pages 28–29
LATITUDE, 2016
220 × 350 × 52 cm
86.6 × 137.8 × 20.5 in
Courtesy of The Modern Institute/
Toby Webster Ltd, Glasgow
Photo Max Slaven

Pages 30–31
Installation view ELECTROLUX,
The Modern Institute, Osborne
Street, Glasgow, 2016
Courtesy of The Modern Institute/
Toby Webster Ltd, Glasgow
Photo Max Slaven

Page 33
HEART OF GOLD, 2016
84 × 66.5 × 52.5 cm
33.1 × 26.2 × 20.7 in
Private Collection, New York
Photo Ruth Clark

Page 34
ZOBOP (PRISMATIC), 2016
Edition of 3 + 1 AP
Installation view Bonnington House,
Edinburgh, 2016
Collection of Robert and Nicky Wilson
Photo Ruth Clark

Page 35
ZOBOP (PRISMATIC)
(detail), 2016
Dimensions variable
Edition of 3 + 1 AP
Collection of Robert and Nicky Wilson
Photo Ruth Clark

Pages 36–37
TEARDROP BOOMBOX
(LA SCALA), 2016
270 × 180 × 60 cm
106.3 × 70.9 × 23.6 in
Courtesy of Gerhardsen Gerner,
Berlin/Oslo and The Modern Institute/
Toby Webster Ltd, Glasgow
Photo Matthias Kolb

Page 38
THIS IS TOMORROW, 2008
203.6 × 157.7 × 51 cm
80.2 × 62.1 × 20.1 in
Tamares Real Estate Holdings, Inc.
in collaboration with the
Zabludowicz Collection
Photo Ruth Clark

Page 39
ZOBOP (FLUORESCENT), 2006
Dimensions variable
Edition of 3 + 1 AP
Installation view 20 YEARS: ZABLUDOWICZ
COLLECTION, 2015
Courtesy of Zabludowicz Collection
Photo Stuart Whipps

Page 41
Installation view ZERO CONCERTO,
Roslyn Oxley9 Gallery, Sydney, 2015
Courtesy of The Modern Institute/
Toby Webster Ltd, Glasgow and
Roslyn Oxley9 Gallery, Sydney
Photo Jessica Maurer

Page 42
BOOKCASE (PRETTY VACANT), 2015
Dimensions variable
Installation view, TRAIN IN VEIN,
Anton Kern Gallery, New York, 2015
Courtesy of Anton Kern Gallery, New York
Photo Thomas Müller

Pages 44–45
BOOKCASE (PRETTY VACANT)
(detail), 2015
Dimensions variable
Courtesy of Anton Kern Gallery, New York
Photo Thomas Müller

Page 47
METAL BOX (KARMA CHAMELEON), 2015
125 × 125 × 31 cm
49.2 × 49.2 × 12.2 in
Collection of Joan and David Genser
Photo Ruth Clark

Page 88
METAL BOX (DREAM BABY DREAM),
2011
62.5 × 62.5 × 16 cm
24.6 × 24.6 × 6.3 in
The Pier Arts Centre Collection, Orkney
Photo Mike Davidson

Page 89
KNIGHTCLUBBER (RAVE ON), 2011
169.5 × 42.5 × 36 cm
66.7 × 16.7 × 14.2 in
Installation view BEACH BOY, Pier Arts
Centre, Orkney, 2011
Private Collection
Photo Mike Davidson

Page 91
DIGITIZED, 2011
317.5 × 139.7 × 17.8 cm
125 × 55 × 7 in
Collection of Suzanne Butler
and Didier Loulmet
Photo Thomas Müller

Page 93
ZIP CODE (N°1), 2011
243.8 × 182.9 cm
96 × 72 in
Courtesy of Anton Kern Gallery,
New York
Photo Thomas Müller

Page 94
BELT BUCKLE (VOODOO RAY), 2011
33 × 19.1 × 13.7 cm
13 × 7.5 × 5.4 in
Courtesy of Anton Kern Gallery,
New York
Photo Thomas Müller

Page 95
Installation view SPIRITUALIZED,
Anton Kern Gallery, New York, 2011
Courtesy of Anton Kern Gallery,
New York
Photo Thomas Müller

Page 97
METAL BOX (BIRD ORCHID
(AUTUMN)), 2012
187.5 × 187.5 × 32 cm
73.8 × 73.8 × 12.6 in
Francesco Dalla Rovere Collection
Photo Ruth Clark

Pages 98–99
Installation view METAL URBAIN,
The Modern Institute, Osborne
Street, Glasgow, 2010
Courtesy of The Modern Institute/
Toby Webster Ltd, Glasgow
Photo Keith Hunter

Page 100
INTO THE KNIGHT, 2010
166 × 43 × 51 cm
65.4 × 16.9 × 20.1 in
Rocío and Boris Hirmas Collection
Photo Ruth Clark

Page 101
SUNSET, 2010
152 × 186 × 81 cm
59.8 × 73.2 × 31.9 in
David Roberts Collection, London
Photo Ruth Clark

Pages 102–103
METAL URBAIN, 2010
360 × 160 × 90 cm
141.7 × 63 × 35.4 in
Courtesy of the artist and The Modern
Institute/Toby Webster Ltd, Glasgow
Photo Ruth Clark

Pages 104–105
METAL BOX, 2010
125 × 187.5 × 27 cm
49.2 × 73.8 × 10.6 in
Collection of Mr Yang Bin, China
Photo Ruth Clark

Pages 106–107
A FOREST, 2010
Dimensions variable
Permanent installation
Jupiter Artland, Edinburgh
Photo Keith Hunter

Page 109
METAL BOX (I WISH), 2009
83.3 × 62.5 × 18 cm
32.8 × 24.6 × 7.1 in
Private Collection

Page 110
SEAT BELT (NED KELLY), 2009
83 × 54 × 58 cm
32.7 × 21.3 × 22.8 in
Installation view TELEVISION,
Sadie Coles HQ, London, 2009
Private Collection
Photo Andy Keate

Page 112
GYPSY (STEVIE NICKS), 2009
152.5 × 108 × 3.5 cm
60 × 42.5 × 1.4 in
Private Collection
Photo Andy Keate

Page 113
SEAT BELT (SPELLBOUND), 2009
83 × 42 × 63 cm
32.7 × 16.5 × 24.8 in
Installation view TELEVISION,
Sadie Coles HQ, London, 2009
Courtesy of Sadie Coles HQ, London
Photo Andy Keate

Page 115
PRIVATE LIFE (GRACE JONES), 2009
64 × 50 × 3.5 cm
25.2 × 19.7 × 1.4 in
Dick Page and James Gibbs Collection
Photo Andy Keate

Page 117
WEST END GIRLS, 2010
10 × 40 × 30 cm
3.9 × 15.7 × 11.8 in
Private Collection, London
Photo Gareth Brown

Pages 118–119
THE CITADEL, 2010
121 × 213 cm
47.6 × 83.9 in
Collection of Kevin and Melinda Johnson
Photo Donald Felton

Page 121
HOT CORNER, 2009
102 × 141 × 70 cm
40.2 × 55.5 × 27.6 in
Collection of Ellie and Mark Lainer
Photo Photographic Services, Basel

Page 123
RADIATOR (BLACK), 2009
97 × 77 × 10 cm
38.2 × 30.3 × 3.9 in
Private Collection Toby Webster, Glasgow
Photo Ruth Clark

Pages 124–125
TRAIN IN VAIN, 2008
Dimensions variable
Installation view UNKNOWN PLEASURES,
Hara Museum of Contemporary Art,
Tokyo, 2008
Collection of Hara Museum of
Contemporary Art
Photo Hirotaka Yonekura

Pages 126–127
Installation view UNKNOWN PLEASURES,
Hara Museum of Contemporary Art,
Tokyo, 2008
Courtesy of Sadie Coles HQ, London
Photo Hirotaka Yonekura

Page 129
Installation view UNKNOWN PLEASURES,
Hara Museum of Contemporary Art,
Tokyo, 2008
Courtesy of Sadie Coles HQ, London
Photo Hirotaka Yonekura

Page 130
FOUND FLOWER PAINTING (IAN CURTIS),
2008
91 × 77 cm
35.8 × 30.3 in
Private Collection
Photo Shiraku Yuichi

Page 131
MAYBELLINE, 2008
210 × 95 × 30 cm
82.7 × 37.4 × 11.8 in
Installation view UNKNOWN PLEASURES,
Hara Museum of Contemporary Art,
Tokyo, 2008
Courtesy of Sadie Coles HQ, London
Photo Hirotaka Yonekura

Page 132
SECRET AFFAIR (SILVER), 2007
215 × 113.4 × 8 cm
84.6 × 44.6 × 3.1 in
Installation view RECONSTRUCTION 2,
Sudeley Castle, Winchcombe, 2007
Private Collection

Page 135
SECRET AFFAIR (BLUE), 2007
215 × 113.4 × 8 cm
84.6 × 44.6 × 3.1 in
Installation view *RECONSTRUCTION 2*,
Sudeley Castle, Winchcombe, 2007
Private Collection, Wiltshire

Pages 136–137
ZOBOP (FLUORESCENT) (detail), 2006
Dimensions variable
Edition of 3 + 1 AP
Installation view *LA INVENCIÓN DE LO
COTIDIANO*, Colección Jumex-Museo
Nacional de Arte, 2008
La Colección Jumex, México
Photo Francisco Kochen

Page 139
ZOBOP (FLUORESCENT), 2006
Dimensions variable
Edition of 3 + 1 AP
Installation view *LA INVENCIÓN DE LO
COTIDIANO*, Colección Jumex-Museo
Nacional de Arte, 2008
La Colección Jumex, México
Photo Francisco Kochen

Page 140
UNTITLED, 2008
450 × 200 × 30 cm
177.2 × 78.7 × 11.8 in
Courtesy of The Modern Institute/
Toby Webster Ltd, Glasgow
Photo John Brash

Page 141
PSYCHEDELIC SOUL STICK 69, 2008
110 × 10 cm × 10 cm
43.3 × 3.9 × 3.9 × in
Installation view *EIGHT MILES HIGH*,
Austrailian Centre for Contemporary Art,
Melbourne, 2008
Courtesy of The Modern Institute/
Toby Webster Ltd, Glasgow
Photo John Brash

Pages 142–143
SEVEN AND SEVEN IS OR SUNSHINE
BATHED THE GOLDEN GLOW, 2008
216 × 350 × 270 cm
85 × 137.8 × 106.3 in
Installation view *FOREVER CHANGES*,
Gallery of Modern Art, Glasgow, 2008
Courtesy CSG CIC Glasgow
Museums Collection
Photo Keith Hunter

Pages 144–145
Installation view *FOREVER CHANGES*,
Gallery of Modern Art, Glasgow, 2008
Courtesy of The Modern Institute/
Toby Webster Ltd, Glasgow
Photo Keith Hunter

Page 146
SONIC REDUCER 7, 2008
20 × 35.5 × 35.5 cm
7.9 × 14 × 14 in
Installation view *FOREVER CHANGES*,
Gallery of Modern Art, Glasgow, 2008
Tamares Real Estate Holdings, Inc.
in collaboration with the Zabludowicz
Collection
Photo Keith Hunter

Page 147
THE SPELL, 2008
66 × 66 × 66 cm
26 × 26 × 26 in
Installation view *FOREVER CHANGES*,
Gallery of Modern Art, Glasgow, 2008
Private Collection
Photo Keith Hunter

Page 149
PSYCHEDELIC SOUL STICK 65, 2007
110 × 10 × 10 cm
43.3 × 3.9 × 3.9 in
Andrew Hamilton Private Collection
Photo Ruth Clark

Page 151
DURUTTI COLUMN, 2007
144 × 80 × 41 cm
56.7 × 31.5 × 16.1 in
Museum of Art, Rhode Island School
of Design, Providence
Photo Andy Keate

Pages 152–153
PHUTURE DAYS, 2006
84 × 250 × 180 cm
33.1 × 98.4 × 70.9 in
La Colección Jumex, México
Photo Ruth Clark

Pages 154–155
RAINBOW ROOM, 2002
Dimensions variable
Thyssen-Bornemisza Art Contemporary
Collection, Vienna
Photo Michael Strasser

Page 156
OVEN READY, 2006
8 parts; 83.5 × 69 × 2.7 cm,
32.9 × 27.2 × 1.1 in each
Collection of Beth Rudin DeWoody
Photo Ruth Clark

Page 157
PSYCHEDELIC SOUL STICK 58 (detail),
2006
106.8 × 7.6 × 7.4 cm
42 × 3 × 2.9 in
Collection of Erling Kagge, Oslo
Photo Ruth Clark

Page 158
Installation view *TURNER PRIZE*,
Tate Britain, London, 2005
Courtesy of Anton Kern Gallery,
New York, Galleria Franco Noero, Turin,
The Modern Institute/Toby Webster Ltd,
Glasgow and Sadie Coles HQ, London
Photo Andy Keate

Page 159
THE BYRDS (FOUR HOOPS), 2005
139 × 77 × 74 cm
54.7 × 30.3 × 29.1 in
Private Collection
Photo Ruth Clark

Page 161
BLACKTRONIC, 2005
130 × 45 × 30 cm
51.2 × 17.7 × 11.8 in
Private Collection
Photo Andy Keate

Page 162
SPLIT ENDZ (WIG MIX), 2005
184 × 137 × 120 cm
72.4 × 53.9 × 47.2 in
Private Collection
Photo Andy Keate

Page 163
THE DOORS (GLORIA G.L.O.R.I.A), 2005
193 × 252 × 80 cm
76 × 99.2 × 31.5 in
Private Collection
Photo Andy Keate

Page 165
BLUEBOY, 2006
37 × 38 × 35 cm
14.6 × 15 × 13.8 in
Collection of Victoria Wyman
Photo Ruth Clark

Page 166
DANCETERIA IV, 2006
122 × 99 × 48 cm
48 × 39 × 18.9 in
Private Collection

Page 169
THE DOORS (LOVE ME TWO TIMES), 2005
199 × 142 × 42.5 cm
78.3 × 55.9 × 16.7 in
Collection of Erling Kagge, Oslo
Photo Ruth Clark

Page 175
MACHINE, 2004
2 parts: 167 × 84 × 84 cm,
65.7 × 33.1 × 33.1 in
Tube 288 cm, 113.4 in; diameter 23 cm, 9.1 in
Private Collection, Italy

Page 176
THE DOORS (MORRISON HOTEL), 2005
198 × 155 × 198 cm
78 × 61 × 78 in
The Rachofsky Collection and the Dallas
Museum of Art through the TWO × TWO
for AIDS and Art Fund

Pages 178–179
Installation view *MENTAL OYSTER*,
Anton Kern Gallery, New York, 2004
Courtesy of Anton Kern Gallery, New York
Photo Adam Reich

Page 222
DIGITAL (NEW YORK), 1999
271 cm diameter
106.6 in diameter
Courtesy of Anton Kern Gallery,
New York and The Modern Institute/
Toby Webster Ltd, Glasgow
Photo Adam Reich

Page 223
LEATHERETTE, 1999
61 × 91.4 × 96.5 cm
24 × 36 × 38 in
Installation view BLACK GLOSS,
Anton Kern Gallery, New York, 2000
Private Collection, New York
Photo Adam Reich

Page 225
WEIRD GLOW, 1999
100 × 100 cm
39.4 × 39.4 in
Tate Collection
Photo Andy Keate

Pages 226–227
STAKKA, 1999
31 × 348 × 89 cm
12.2 × 137 × 35 in
Installation view WEIRD GLOW,
Sadie Coles HQ, 1999
Jose and Servane Martos Collection
Photo Andy Keate

Page 228
EARTH, WIND AND FIRE, 1998
50 × 70 cm
19.7 × 27.6 in
Private Collection

Page 229
PSYCHEDELIC SOUL STICK 1, 1999
150 × 10 cm
59.1 × 3.9 in
Private Collection Toby Webster, Glasgow

Pages 230–231
ZOBOP COLOUR, 1999
Dimensions variable
Edition of 3 + 1 AP
Installation view VOIDOID, Transmission
Gallery, Glasgow, 1999
Collection of Scottish National Gallery
of Modern Art, Edinburgh

Page 233
ROADIE, 1999
38 × 42 × 56 cm
15 × 16.5 × 22 in
Private Collection

Pages 234–235
ULTRALOW, The Modern Institute,
video screening at Carnival, London, 1998
Courtesy of The Modern Institute/
Toby Webster Ltd, Glasgow

Pages 236–237
ULTRALOW (still), 1998/2007
Duration 21 min
Edition of 6
Arts Council Collection, Southbank
Centre, London

Page 239
18 CARROTS, 1996
Dimensions variable
Courtesy Anton Kern Gallery, New
York, Galleria Franco Noero, Turin,
The Modern Institute/Toby Webster Ltd,
Glasgow and Sadie Coles HQ, London

Pages 240–241
TWO SHIRTS, 1996
Installed dimensions:
34 × 62 × 8 cm
13.4 × 24.4 × 3.1 in
Collection of Aishti Foundation, Beirut

Page 243
THE KID WITH THE
REPLACEABLE HEAD, 1996
30 × 30 × 23 cm
11.8 × 11.8 × 9.1 in
Courtesy Sadie Coles HQ, London

JIM LAMBIE
Born in Glasgow, Scotland, 1964. Lives and works in Glasgow.
BA, Honors, Environmental Art, Glasgow School of Art, Glasgow, 1994.

SELECTED SOLO EXHIBITIONS

2016
ELECTROLUX
The Modern Institute,
14–20 Osborne Street, Glasgow

LA SCALA
Gerhardsen Gerner, Berlin

DERRICK ALEXIS COARD,
GLASGOW INTERNATIONAL
Project Ability gallery, Trongate 103, Glasgow
Installed in collaboration with Jim Lambie

2015
TRAIN IN VEIN
Anton Kern Gallery, New York

ZERO CONCERTO
Roslyn Oxley9 Gallery, Sydney

SUN RISE SUN RA SUN SET
Rat Hole Gallery, Tokyo

2014
Fruitmarket Gallery, Edinburgh
Part of GENERATION 2014

ANSWER MACHINE
Sadie Coles HQ, London

Barrowland Park, Glasgow

2013
THE FLOWERS OF ROMANCE
Pearl Lam Galleries, Hong Kong

2012
SHAVED ICE
The Modern Institute, 3 Aird's Lane, Glasgow

Gerhardsen Gerner, Berlin

EVERYTHING LOUDER THAN
EVERYTHING ELSE
Galleria Franco Noero, Turin

2011
SPIRITUALIZED
Anton Kern Gallery, New York

BEACH BOY
Pier Arts Centre, Orkney

Goss-Michael Foundation, Dallas

2010
BOYZILIAN
Galerie Patrick Seguin, Paris

Jupiter Artland, Edinburgh

METAL URBAIN
The Modern Institute,
14–20 Osborne Street, Glasgow

2009
Nervous Track: A Vibrant World
Atelier Hermès, Seoul

TELEVISION
Sadie Coles HQ, London

2008
UNKNOWN PLEASURES
Hara Museum of Contemporary Art, Tokyo

EIGHT MILES HIGH
Australian Centre for Contemporary Art,
Melbourne

ROWCHE RUMBLE
Atle Gerhardsen, Berlin

FESTIVAL SECRET AFFAIR
Inverleith House, Edinburgh

RSVP: JIM LAMBIE
Museum of Fine Arts, Boston

FOREVER CHANGES
Gallery of Modern Art, Glasgow

2007
THE PRISMATICS
Anton Kern Gallery, New York

2006
BYRDS
Anton Kern Gallery, New York

DIRECTIONS: JIM LAMBIE
Hirshhorn Museum and Sculpture Garden,
Washington, DC

P.I.L.
Mizuma Art Gallery, Tokyo

2005
THE BYRDS
The Modern Institute/Toby Webster Ltd,
Glasgow

CONCENTRATIONS 47: JIM LAMBIE
Dallas Museum of Art, Dallas

SHOULDER PAD
Sadie Coles HQ, London

2004
MENTAL OYSTER
Anton Kern Gallery, New York

MARS HOTEL
Galleria Franco Noero, Turin

MY BOYFRIEND'S BACK
Konrad Fischer Galerie, Düsseldorf

GRAND FUNK
OPA, Mexico

2003
KEBABYLON
Inverleith House, Edinburgh

MALE STRIPPER
Museum of Modern Art, Oxford

2002
ACID TRAILS
Art Basel, Miami Beach

The Modern Institute, Glasgow

SALON UNISEX
Sadie Coles HQ, London

2001
BOY HAIRDRESSER
Anton Kern Gallery, New York

JIM LAMBIE
Galleria Franco Noero, Turin

The Modern Institute/Toby Webster Ltd,
Glasgow

2000
BLACK GLOSS
Anton Kern Gallery, New York

Konrad Fischer Galerie, Düsseldorf

FICTIONAL
Triangle, Paris

1999
WEIRD GLOW
Sadie Coles HQ, London

ZOBOP
The Showroom, London

VOIDOID
Transmission Gallery, Glasgow

1998
ULTRALOW
The Modern Institute, video screening at
Carnival, London

SELECTED GROUP EXHIBITIONS

2016
I STILL BELIEVE IN MIRACLES
Inverleith House, Edinburgh

JENNIFER HERREMA AND JIM LAMBIE
VoidoidARCHIVE, Glasgow

GENEROSITY. THE ART OF GIVING
National Gallery of Prague, Prague

2015
BELOW ANOTHER SKY
British Council, London, British Council touring
exhibition. Touring to Aberdeen Art Gallery,
Aberdeen; Glasgow Print Studio, Glasgow

DEVILS IN THE MAKING
Gallery of Modern Art, Glasgow

PLATFORM
Holden Gallery, Manchester

SUMMER EXHIBITION 2015
Royal Academy of Arts, London

A SECRET AFFAIR: SELECTIONS FROM THE
FUHRMAN FAMILY COLLECTION
FLAG Art Foundation, New York

ZABLUDOWICZ COLLECTION: 20 YEARS
Zabludowicz Collection, London

THE CURVES OF THE NEEDLE
BALTIC 39, Newcastle upon Tyne

2014
YOU IMAGINE WHAT YOU DESIRE
Sydney Biennale, Sydney

THAT PETROL EMOTION
Metropolitan Art Society, Beirut

PRIVATE UTOPIA: CONTEMPORARY WORKS
FROM THE BRITISH COUNCIL COLLECTION
British Council touring show, British Council
touring exhibition. Touring to Tokyo Station
Gallery, Tokyo (2014); Itami City Museum of
Art, Itami (2014); The Museum of Art, Kochi
(2014); Okayama Prefectural Museum of Art,
Okayama (2015)

2013
YOU ARE HERE
Worcester Art Museum, Worcester

A CONSPIRACY OF DETAIL
Mackintosh Museum, Glasgow School of Art

SOMETHING ABOUT A TREE
FLAG Art Foundation, New York
Curated by Linda Yablonsky

PULL DOWN THE FUTURE
SWG3, Glasgow
Collaborative Exhibition
Lawrence and Jim Lambie

2012
LOST LINE: CONTEMPORARY ART
FROM THE COLLECTION
Los Angeles County Museum of Art, Los Angeles

RELIEFS, OBJECTS AND SCULPTURES FROM
THE MARLI HOPPE-RITTER COLLECTION
Museum Ritter, Waldenbuch, Germany

AKA PEACE
Institute of Contemporary Arts, London

DECADE: CONTEMPORARY COLLECTING
2002–2012
Albright-Knox Art Gallery, Buffalo

2011
THE SCULPTURE SHOW
Scottish National Gallery of Modern Art,
Edinburgh

INDUSTRIAL AESTHETICS: ENVIRONMENTAL
INFLUENCES ON RECENT ART FROM
SCOTLAND
Times Square Gallery, Hunter College,
New York

MADE IN THE UK: CONTEMPORARY ART
FROM THE RICHARD BROWN BAKER
COLLECTION
RISD Museum, Rhode Island School
of Design, Providence

VANISHING POINTS: PAINT AND PAINTINGS FROM THE DEBRA AND DENNIS SCHOLL COLLECTION,
Bass Museum of Art, Miami Beach

SPACE ODDITY
Centro Cultural Andratx, Mallorca

2010
HIGHLIGHTS FROM THE COLLECTION
Goss-Michael Foundation, Dallas

UNDONE: MAKING AND UNMAKING IN CONTEMPORARY SCULPTURE
Henry Moore Institute, Leeds

THE NEW DECOR
Hayward Gallery, London

2009
TONITE
The Modern Institute/Toby Webster Ltd, Glasgow

COMPASS IN HAND: SELECTIONS FROM THE JUDITH ROTHSCHILD FOUNDATION CONTEMPORARY DRAWINGS COLLECTION
Museum of Modern Art, New York

RUNNING TIME: ARTISTS FILMS IN SCOTLAND 1960 TO NOW
Dean Gallery, Edinburgh

THE KALEIDOSCOPIC EYE: THYSSEN-BORNEMISZA ART CONTEMPORARY COLLECTION
Mori Art Museum, Tokyo

COLOUR CHART: REINVENTING COLOUR, 1950 TO TODAY
Tate Liverpool, Liverpool

2008
THYSSEN-BORNEMISZA ART CONTEMPORARY COLLECTION AS ALEPH
Kunsthaus Graz, Universalmuseum Joanneum, Graz

COLOR CHART: REINVENTING COLOR, 1950 TO TODAY
Museum of Modern Art, New York

FILMS
Sadie Coles HQ, London

Towada Art Project, Towada Art Centre

LA INVENCIÓN DE LO COTIDIAO
La Colección Jumex, México, Museo Nacional de Arte

2007
PASSION COMPLEX: SELECTED WORKS FROM THE ALBRIGHT-KNOX ART GALLERY
21st Century Museum of Contemporary Art, Kanazawa

SYMPATHY FOR THE DEVIL: ART AND ROCK AND ROLL SINCE 1967
Museum of Contemporary Art, Chicago

OFF THE WALL
Scottish National Gallery of Modern Art, Edinburgh

RECONSTRUCTION 2
Sudeley Castle, Winchcombe

MELTING POINT
Tokyo Opera City Art Gallery, Tokyo

DOMESTIC IRONY: A CURIOUS GLANCE AT PRIVATE ITALIAN COLLECTIONS
Museion, Bolzano

UNMONUMENTAL: THE OBJECT IN THE 21ST CENTURY
New Museum, New York

HALF SQUARE, HALF CRAZY
Villa Arson, Nice

BREAKING STEP
Museum of Contemporary Art, Belgrade

2006
IN THE DARKEST HOUR THERE MAY BE LIGHT
Serpentine Gallery, London

THIS IS NOT FOR YOU: SCULPTURE AS TROPES OF CRITICALITY
Thyssen-Bornemisza Art Contemporary, Vienna

ABSRACT ART NOW: STRICTLY GEOMETRICAL?
Wilhelm-Hack-Museum, Ludwigshafen am Rhein

IMPLOSION
Anton Kern Gallery, New York

STRANGE POWERS
Creative Time, New York

HOW TO IMPROVE THE WORLD: 60 YEARS OF BRITISH ART
Hayward Gallery, London

ALL HAWAII ENTRÉES/LUNAR REGGAE
Irish Museum of Modern Art, Dublin

2005
THE TURNER PRIZE
Nominee
Tate Britain, London

EXTREME ABSTRACTION
Albright-Knox Art Gallery, Buffalo

OMAGGIO AL QUADRATO
Galleria Franco Noero, Turin

EXPERIENCING DURATION
Biennale d'Art Contemporain de Lyon, Lyon

MINIMALISM AND AFTER IV
DaimlerChrysler Contemporary, Berlin

2004
54TH CARNEGIE INTERNATIONAL
Carnegie Museum of Art, Pittsburgh

STALEMATE
Museum of Contemporary Art, Chicago

INTO MY WORLD: RECENT BRITISH SCULPTURE
The Aldrich Contemporary Art Museum, Ridgefield

BOROS COLLECTION
ZKM Museum for Contemporary Art, Karlsruhe

SODIUM & ASPHALT
Museo Tamayo, Mexico City
British Council exhibition. Touring to Museo de Arte Contemporáneo de Monterrey, Mexico

2003
OBJECTS IN MIRROR ARE CLOSER THAN THEY APPEAR
Badischer Kunstverein, Karlsruhe

LOVE OVER GOLD
Gallery of Modern Art, Glasgow

BAD BEHAVIOUR
Longside Gallery, Yorkshire Sculpture Park
Arts Council Collection. Touring to Aberystwyth Arts Centre; The Metropole Arts Centre; The Glynn Vivian Art Gallery; Newcastle University, Hatton Art Gallery; Millennium Court Arts Centre; Djanogly Art Gallery; Tullie House, Carlisle

BASIC INSTINCT: MINIMALISM PAST, PRESENT, AND FUTURE
Museum of Contemporary Art, Chicago

GRAYSCALE/CMYK
Royal Hibernian Academy, Dublin

DAYS LIKE THESE: TATE TRIENNIAL
Tate Britain, London

INDIVIDUAL SYSTEMS
Venice Biennale, Venice

ZENOMAP—NEW WORKS FROM SCOTLAND FOR THE VENICE BIENNALE
50th Venice Biennale, Venice

PLUNDER: CULTURE AS MATERIAL
Dundee Contemporary Arts, Dundee

THE UNHOMELY
Kettles Yard, Cambridge

PAINTING NOT PAINTING
Tate St Ives, Cornwall

2002
ELECTRIC DREAMS
Barbican Centre, London

HELLO MY NAME IS . . .
Carnegie Museum of Art, Pittsburgh

LIFE IS BEAUTIFUL
Laing Art Gallery, Newcastle upon Tyne

NEW
Scottish National Gallery of Modern Art, Edinburgh

JIM, JONATHAN, KENNY, FRANCES AND SOL
Stedelijk Museum, Amsterdam

GREYSCALE/CMYK
Tramway, Glasgow

MY HEAD IS ON FIRE BUT MY HEART IS FULL OF LOVE
Charlottenborg Museum, Copenhagen

EARLY ONE MORNING
Whitechapel Gallery, London

2001
TAILSLIDING
Bergen Kunsthall, Bergen
British Council touring exhibition. Touring to
Bergen Kunsthall, Bergen; Contemporary Art
Centre, Vilnius; Museum of Contemporary
Art, Tallinn; House of Arts, Brno; Museum
of Contemporary Art, Belgrade; Turku Art
Museum, Turku

PAINTING AT THE EDGE OF THE WORLD
Walker Arts Center, Minneapolis

HERE + NOW: SCOTTISH ART 1990–2001
Dundee Contemporary Arts, Dundee

Aberdeen Art Gallery, Aberdeen

2000
DREAM MACHINES
Dundee Contemporary Arts, Dundee
Hayward touring exhibition. Touring to
Mappin Art Gallery, Sheffield; Camden
Arts Centre, London

RAUMKÖRPER
Basel Kunsthalle, Basel

HOXTON HQ
Sadie Coles HQ at Hoxton House, London

THE BRITISH ART SHOW 5
Hayward Gallery touring exhibition. Touring
to Inverleith House, Royal Botanical Gardens,
Edinburgh; Southampton City Art Gallery,

Southampton; National Museum of Wales,
Cardiff; Birmingham Museum and Art Gallery,
Birmingham (2001)

*WHAT IF: ART ON THE VERGE OF
ARCHITECTURE AND DESIGN*
Moderna Museet, Stockholm

1999
CREEPING REVOLUTION
Foksal Gallery Foundation, Warsaw

THE QUEEN IS DEAD
Stills Gallery, Edinburgh

TO BE CONTINUED…
Walsall Public Projects, England

1998
ALL OR NOTHING
La Friche Gallery, Triangle, Marseille

The Modern Institute/Toby Webster Ltd,
Glasgow

HOST
Tramway, Glasgow
With Elizabeth Go

SLANT 6
Jacob Javits Center, New York

1997
THIS IS…THESE ARE
Norwich Gallery, Norwich

EUROPEAN COUPLES AND OTHERS
Transmission Gallery, Glasgow

1996
INSANESTUPIDPHATFUCTPERVERT
Concrete Skates, Glasgow
Touring exhibition. Touring to Cubitt, London

WORLD OF PONCE
Southpark, Glasgow
Curated by Toby Webster

ART FOR PEOPLE
Transmission Gallery, Glasgow

SICK BUILDING
Transmission Gallery at Globe Space,
Copenhagen

BRAIN MAIL
Broad Studio 17, CalArts, California

*GIRLS HIGH: ARTISTS CELEBRATE TEN YEARS
OF ENVIRONMENTAL ART IN GLASGOW*
The Old Fruitmarket, Glasgow School of Art,
Glasgow

1995
JONNIE WILKES & JIM LAMBIE
115 Dalriada, Glasgow

*SUN HUNG LOW: MARY REDMOND &
JIM LAMBIE*
Assembly Gallery, Glasgow
Mary Redmond and Jim Lambie

IN STEREO
Transmission Gallery, Glasgow

PUBLIC COLLECTIONS

Albright-Knox Art Gallery, Buffalo

Aberdeen Art Gallery and Museums Collection,
Aberdeen

Arts Council Collection, London

British Council Collection, London

Carnegie Museum of Art, Pittsburgh

Cincinnati Art Museum, Cincinnati

Cleveland Museum of Art, Cleveland

Contemporary Art Society, London

Daimler Contemporary, Berlin

Dallas Museum of Art, Dallas

Deste Foundation, Athens

Gallery of Modern Art, Glasgow

Galleria Civica d'Arte Moderna e
Contemporanea, Turin

Government Art Collection, London

Hammer Museum, Los Angeles

Hara Museum of Contemporary Art, Tokyo

Hirshhorn Museum and Sculpture Garden,
Washington, DC

Instituto Horizontes, Belo Horizonte

Jupiter Artland, Edinburgh

Kunsthalle Basel, Basel

Kunstsammlung NRW, Düsseldorf

Los Angeles County Museum of Art,
Los Angeles

Middlesbrough Institute of Modern Art,
Middlesbrough

Mora Foundation, London

Museum of Modern Art, New York

Museum of Fine Arts, Boston

National Gallery of Australia, Parkes

Linda Pace Foundation, San Antonio

Palm Springs Art Museum, Palm Springs

Pier Arts Centre, Orkney

Rhode Island School of Design, Providence

Scottish National Gallery of Art, Edinburgh

Tate, London

Thyssen-Bornemisza Art Contemporary,
Vienna

Towada Art Center, Towada, Aomori

Walker Art Center, Minneapolis

Worcester Art Museum, Worcester

SELECTED BIBLIOGRAPHY

2016
"JIM LAMBIE: PERCEPTIONS OF DOMESTICITY." *Aesthetica*, November 28.

2015
Steadman, Ryan. "AN ARTIST WHO MAKES ART LIKE A ROCK STAR." *New York Observer*, November 14.

2014
"ALBUM PATHWAY INTENDED AS A HOMAGE TO CITY'S BARROWLAND." *The Herald*, June 23.

2013
Fox, Dan. "THEN & NOW: BRITISH ART AND THE 1990s." *Frieze*, no. 159, November 23.

Russeth, Andrew. "JIM LAMBIE TALKS MUSIC, DJING AND HIS GLASGOW CLUB." *Gallerist*, May 8.

2011
Lowndes, Sarah. "SLOW DAZZLE: A BRIEF ACCOUNT OF THE GLASGOW ART SCENE." *Spike Art Quarterly*, Spring.

2010
Amazeen, Lauren Dyer. "JIM LAMBIE." *Artforum*, September.

Coles Alex. "THE NEW DÉCOR." *Art Monthly*, no. 339, September.

2009
Lubbock, Tom. "POWERFUL PIGMENTS: AN EXHIBITION DEDICATED TO COLOR." *The Independent*, June 7.

Coomer, Martin. "JIM LAMBIE." *Art World*, no. 11, June.

Maerkle, Andrew. "JIM LAMBIE: UNKNOWN PLEASURES." *Art World*, no. 11, June.

2008
Searle, Adrian. "VISUAL ART: WHAT NOT TO MISS IN 2009." *The Guardian*, December 29.

Higgs, Matthew. "JIM LAMBIE: FOREVER CHANGES." *Artforum* 47, no. 4, November 30.

Burton, Johanna. "PRIMARY SOURCES." *Artforum*, April.

Chie, Sumiyoshi. "JIM LAMBIE: THE HOMEMADE MAGICIAN." *ART iT*, no. 20.

2007
"RSVP: JIM LAMBIE." *Map*, no. 12.

2006
Velasco, David. "CRITIC'S PICKS." Artforum.com, August 31.

Calcutt, John. "JIM LAMBIE." *The Guardian*, February 5.

2005
Macmillan, Duncan. "CONFRONTING AN ART SCENE . . ." *The Scotsman*, October 25.

MacMillan, Ian. "AWOP BOPA LOOBOP ZOBOP BAM BOOM." *Modern Painters*, May.

Sholis, Brian. "JIM LAMBIE." *Artforum*, April.

Mulholland, Neil. "USE YOUR ILLUSIONS." *Tate etc.*, no. 4.

2004
Smith, Roberta. "JIM LAMBIE." *The New York Times*, April 30.

Schambelan, Elizabeth. "JIM LAMBIE." *Artforum*, Summer.

2003
Smith, Sarah. "JIM LAMBIE: L'ART DE L'OBJET DÉPLACÉ." *O2*, no. 31, November 30.

Tufnell, Rob. "JIM LAMBIE. UNPLUGGED." *Art in Progress*, no. 7, October.

Ratnam, Niru. "JIM LAMBIE: THE ART WORLD'S VERY OWN PSYCHEDLIC DJ." *i-D*, September 30.

Searle, Adrian. "STRIPE TEASE." *The Guardian*, September 23.

Fox, Dan. "50TH VENICE BIENNIALE." *Frieze*, no. 57, September.

Triming, Lee. "JIM LAMBIE: LOW KICK AND HARD BOP (INTERVIEW)." *Flash Art*, May–June.

Falconer, Morgan. "DAYS LIKE THESE." *Art Review*, April.

Thatcher, Jennifer. "JIM LAMBIE: KEBABYLON." *Contemporary*, no. 50, April.

Troncy, Eric. "DÉCRYPTAGE." *Numéro*, no. 41, February 28.

Bracewell, Michael. "SCOTLAND ROCKS." *Tate Magazine* 6.

2002
Grant, Catherine. "EARLY ONE MORNINGFLASH." *Flash Art*, no. 226, October.

Charlesworth, JJ. "NOT NEO BUT NEW." *Art Monthly*, no. 259, October.

Farquharson, Alex. "DRASTIC PLASTIC." *Frieze*, no. 68, June.

Morton, Tom. "EARLY ONE MORNING." *Frieze*, no. 71, February.

Mulholland, Neil. "HERE + NOW: SCOTTISH ART 1990–2001." *Frieze*, no. 64, January 31.

Glossop, Claire. "RECONSIDERING NEW GENERATION." *Sculpture Journal* 7.

2001
Gioni, Massimiliano. "NEW YORK CUT UP." *Flash Art*, December.

Daily, Megan. "THE BOY HAIRDRESSER." *Artforum*, December.

Smith, Roberta. "BOY HAIRDRESSER." *The New York Times*, September 14.

2000
Arning, Bill. "JIM LAMBIE." *Art in America*, September.

Cotter, Holland. "JIM LAMBIE." *The New York Times*, February 18.

Mahoney, Elisabeth. "DREAM MACHINES." *Art Monthly*, no. 235.

Levin, Kim. "JIM LAMBIE." *The Village Voice*, February.

Brown, Neal. "PAPERMAKE." *Frieze*, no. 50.

Lack, Jessica. "DREAM ON." *Tate etc.*

1999
Saltz, Jerry. "HUNGRY HEARTS." *The Village Voice*, September 14.

Musgrove, Dave. "MULTIPLES." *Art Monthly*, no. 228.

Sinclair, Ross. "JIM LAMBIE." *Frieze*, no. 46.

Bird, Nicky. "THE QUEEN IS DEAD." *Art Monthly*, no. 226.

Dawes, Mark. "GLASGOW." *Circa*, no. 87.

McLaren, Duncan. "JIM LAMBIE: ZOBOP." *Zingmagazine*, no. 11.

Shave, Stuart. "NORTH FACE." *i-D*, no. 187.

1998
Nesbitt, Rebecca Gordon. "URBAN MYTHS." *Contemporary Visual Arts*, no. 17.

1997
Plagens, Peter. "GLASGOW GETS CONCEPTUAL." *Newsweek*.

1995
Wright, Richard. "JONNIE WILKES AND JIM LAMBIE." *Circa*, no. 75, March.

SELECTED PUBLICATIONS

2014
NOT JUST FOR ME:
A SAMPLE OF THE POETRY CLUB
Fruitmarket Gallery, Edinburgh

2010
THE NEW DÉCOR
Hayward Gallery, London

2009
UNKNOWN PLEASURES
Hara Museum of Contemporary Art, Tokyo
and DaimlerChrysler Foundation, Tokyo

2008
EIGHT MILES HIGH: JIM LAMBIE
Australian Centre for Contemporary Art,
Southbank

2008
SCOTLAND & VENICE 2003/2005/2007,
Scottish Arts Council, British Council,
Scotland, National Galleries of Scotland,
The Scottish Government, Edinburgh

2005
TURNER PRIZE 2005
Tate Britain, London

2004
JIM LAMBIE: VOIDOID
The Modern Institute, Glasgow;
Sadie Coles HQ, London;
Anton Kern Gallery, New York
in collaboration with Koenig Books, London

2003
JIM LAMBIE: MALE STRIPPER
Modern Art Oxford, Oxford

2002
VITAMIN P: NEW PERSPECTIVES IN PAINTING
Phaidon Press, London/New York

AUTHOR BIOGRAPHIES

Daniel Baumann is the director of Kunsthalle Zürich, Switzerland. Previously, Baumann served as curator from 1996 to 2014 of the Adolf Wölfli Foundation, located at the Museum of Fine Arts Bern, Switzerland. Throughout his curatorial career, Baumann has championed emerging and outsider artists as well as launched projects praised for their refreshingly direct and unpretentious attitude. These include Kunsttangente, a public art project in Basel, Switzerland, where Baumann served as director from 2003 to 2010; an ongoing exhibition series in Tbilisi, Georgia, established in 2014; and the Basel exhibition space New Jerseyy, founded by Baumann with Tobias Madison, Emanuel Rossetti, and Dan Solbach in 2008. Baumann curated the 2013 Carnegie International at Carnegie Museum of Art, Pittsburgh, along with Dan Byers and Tina Kukielski.

Suzanne Cotter is director of Museu de Serralves in Porto, Portugal. She previously served as curator for the Guggenheim Foundation on the Guggenheim Abu Dhabi project, where she developed the curatorial direction and collection strategy for the new museum. Cotter cocurated the 10th Sharjah Biennial, Plot for a Biennial, in 2011 in the United Arab Emirates. Prior to her tenure at the Guggenheim, Cotter held several positions at Modern Art Oxford, UK, including senior curator and deputy director. She was

previously exhibitions curator at the Hayward Gallery, the Whitechapel Gallery, and the Serpentine Galleries in London. Awarded the medal of Chevalier de l'Ordre des Arts et des Lettres by France's Ministère de la Culture et de la Communication in 2005, Cotter has curated exhibitions of work by artists including Wolfgang Tillmans, Cecily Brown, Daniel Buren, Giorgio Griffa, Jannis Kounellis, Lucio Fontana, Monir Shahroudy Farmanfarmaian, and Paul Klee.

John Giorno is a poet and performance artist based in New York. In 1965, he founded the not-for-profit production company Giorno Poetry Systems with the goal of connecting poetry and related art forms to a larger audience using innovative ideas, such as communication technology and audiovisual materials and techniques. Inspired by a close relationship with Andy Warhol (Giorno was the protagonist of Andy Warhol's film Sleep), and subsequent relationships with many Pop artists including Robert Rauschenberg and Jasper Johns, Giorno began applying Pop art techniques to his poetry, creating work known as his Poem Prints and Poem Paintings, which he has exhibited nationally and internationally. Giorno's work is also included in numerous museum collections including the Museum of Modern Art, New York, and the Centre Pompidou, Musée National d'Art Moderne, Paris.

Sophie Woodward is an author and lecturer in sociology at the University of Manchester. Woodward received her PhD in social anthropology, material culture, at University College London and publishes critical studies in the areas of consumption, materiality, and sociological research methods. She is the cofounder with Daniel Miller of the interdisciplinary network the Global Denim Project. Woodward's current project aims to explore "dormant things"—items that people keep in spaces in the home such as cupboards and attics that they do not currently use or never have. Previous projects include developing interdisciplinary approaches to expand qualitative research methods to understand materials and material culture.

ACKNOWLEDGMENTS

Jim Lambie would like to thank:
The Modern Institute, Glasgow
Sadie Coles HQ, London
Anton Kern Gallery, New York
Galleria Franco Noero, Turin

Danny Saunders & Baldvin Ringsted

Special thanks to Gael, Lunan, and Van,
and family and friends.

First published in the United States in 2017 by
Skira Rizzoli Publications, Inc.
300 Park Avenue South
New York, NY 10010
www.rizzoliusa.com

For Skira Rizzoli Publications, Inc.:
Charles Miers, Publisher
Margaret Rennolds Chace, Associate Publisher
Loren Olson, Editor
Kayleigh Jankowski, Design Coordinator

Marta Perovic, Gallery Coordinator
Michael Goodman, Copyeditor

Special thanks to:
Anton Kern Gallery, New York
Galleria Franco Noero, Turin
The Modern Institute, Andrew Hamilton/Toby Webster Ltd, Glasgow
Sadie Coles HQ, London

Library of Congress Catalog Control Number: 2016961647

ISBN: 978-0-8478-5906-1

2017 2018 2019 2020 / 10 9 8 7 6 5 4 3 2 1

Printed and bound in China

Designed by Ivor Williams